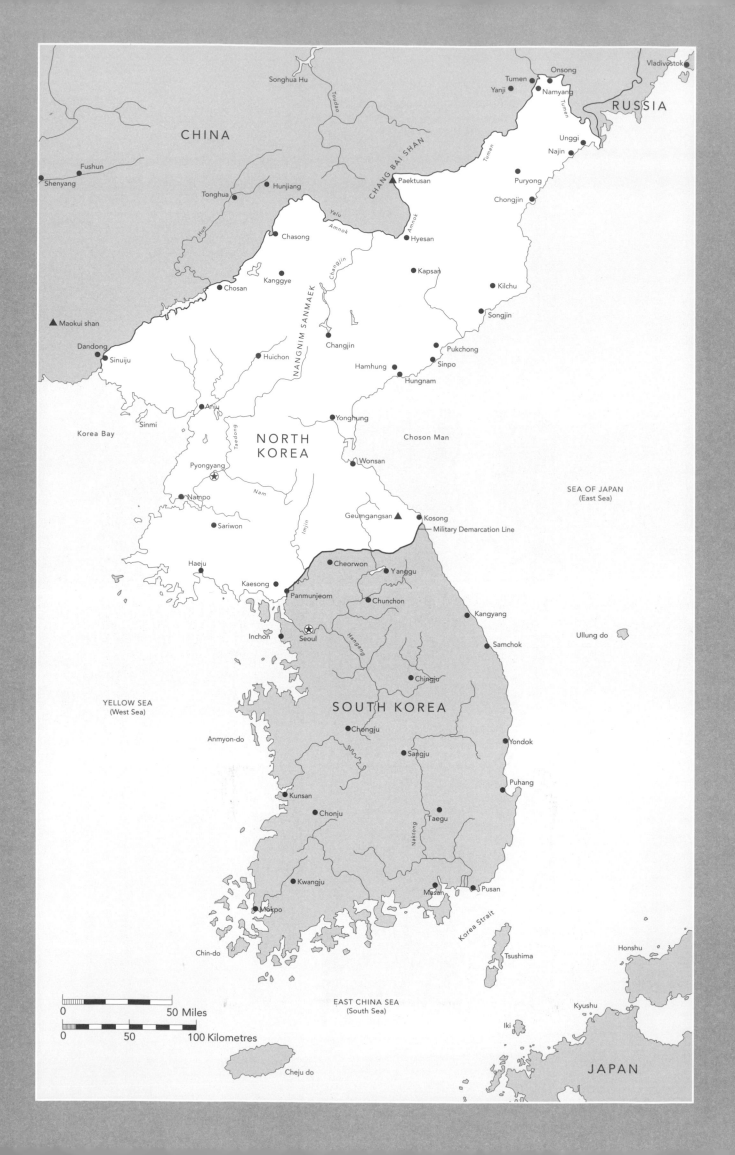

INSIDE
NORTH
KOREA

INSIDE
NORTH

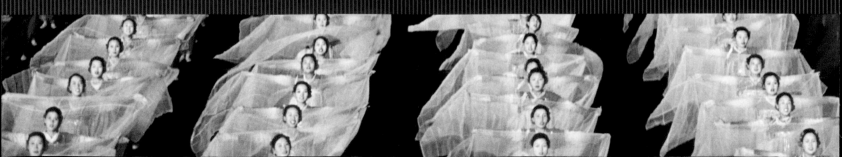

KOREA

Mark Edward Harris

Foreword by Bruce Cumings

CHRONICLE BOOKS
SAN FRANCISCO

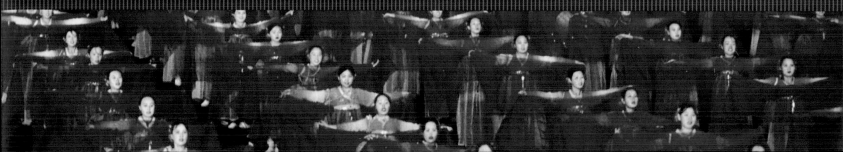

CONTENTS

Acknowledgments
This book would not have been possible without the assistance of
Michelle Kim, Minsuh Son, and Kim Yong-kyu, and the editing skills
of Steve Mockus. I am indebted to them and to the Korean people
I had the good fortune to meet on both sides of the 38th parallel.

Library of Congress Cataloging-in-Publication Data:
Harris, Mark Edward.
Inside North Korea / Mark Edward Harris / foreword by
Bruce Cumings.
 p. cm.
 ISBN-13: 978-0-8118-5751-2
 ISBN-10: 0-8118-5751-4
 1. Korea (North)—Description and travel. 2. Korea (North)—
Pictorial works. I. Title.

 DS932.4.H37 2007
 951.9304'3—dc22

 2006028504

Manufactured in China.

Designed by Roy Brooks, Fold Four

Distributed in Canada by Raincoast Books
9050 Shaughnessy Street
Vancouver, British Columbia V6P 6E5

10 9 8 7 6 5 4 3 2 1

Chronicle Books LLC
680 Second Street
San Francisco, California 94107
www.chroniclebooks.com

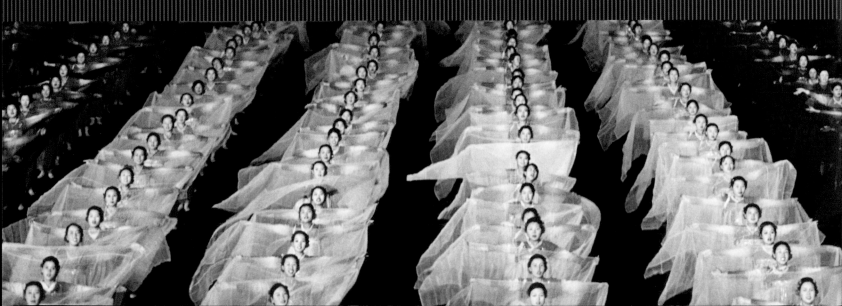

INSIDE THE HERMIT KINGDOM

THE GREAT DIVIDE

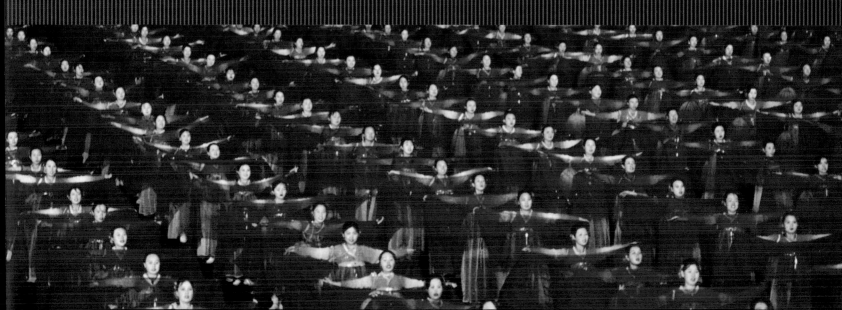

FOREWORD

by Bruce Cumings

Of all the slogans the traveler sees in North Korea, maybe the most poignant is the one that hangs above the main square (and can be seen in many other places): "We have nothing to envy in the world." It simultaneously fits the regime's propaganda about its "paradise" and leads us to ask, how would any North Korean citizen know if there might be something to envy in the rest of the world? They can't even travel from the countryside to Pyongyang without a permit, and only the most reliable can travel abroad.

Mark Edward Harris's wonderful collection of photographs illustrates that North Korea does have some enviable features. When we view the awe-inspiring crater lake on White Head Mountain (Paektusan), revered as the mythical fount of the Korean people, we come to understand that one of the world's most beautiful panoramas—comparable to Mt. Fuji or Mt. Rainier, near Seattle—has been off-limits to Western tourists since 1945 because of the persistent division of this peninsula. The same was true of the Diamond Mountains (Geumgangsan), with scenery as compelling as Yosemite, until a South Korean firm got permission to bring thousands of tourists to see these mountains (and hardly anything else, of course).

Then we see a different kind of monument: a subway station with shiny walls, spic-and-span floors, and extravagant chandeliers. I once toured the subway with an eerie feeling that I was in a cathedral. Each station-sanctuary played out a theme, in lavish marble and painstakingly done inlaid tile: the "harvest" station, for example, shows Kim Il Sung standing amid an abundant corn harvest. The shimmering porcelain was lit by chandeliers made of glass goblets done in lime green, hot pink, and bright orange, meant to represent bunches of fruit. Then I looked at the faces of the people on the subway, some of them friendly, some of them unmistakably scornful, most of them careworn and blank. We see some of them in Harris's book: nothing to envy in the world?

Everywhere there are the ubiquitous Great Leader and his successor son, called the Dear Leader, and a huge flock that projects an

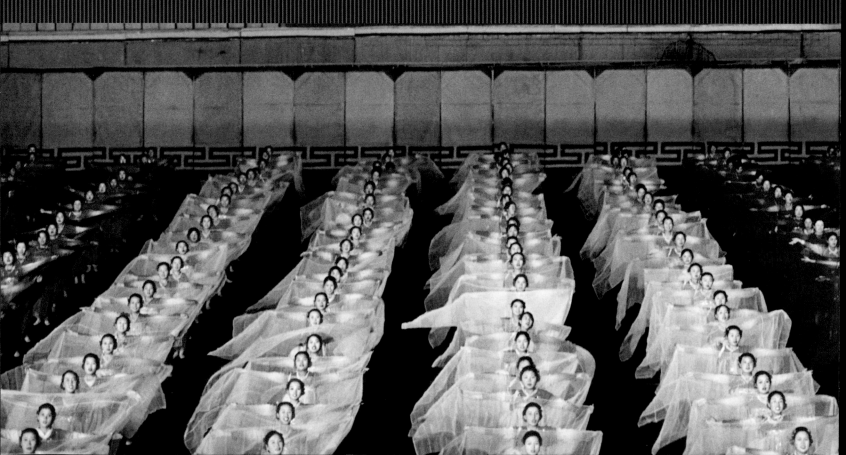

astonishing uniformity in the mass pageants the regime loves to put on, or the stadium card displays it choreographs with unparalleled skill; as Harris shows, these have now become a tourist attraction.

Everywhere, the two Kims greet you from large murals outside government buildings and schools; each room has a plaque over the door showing the dates of their visits. I visited the film studio Harris depicts, and above each door were the dates of visits by father and son. Quotations are everywhere, ranging from rip-offs of Marxist-Leninist slogans to quaint homilies reminiscent of *Mr. Rogers' Neighborhood*. In the finely arranged Folk History Museum, next to a display of food, one can read this from Kim Il Sung: "Koreans can hardly be Korean if they don't eat *toenjang*" (a fermented bean paste, the most characteristic of Korean foods). In one photograph we see a diligent young girl playing piano. I visited a similar scene myself, with a young woman playing Korean classical music on a Japanese piano. Over her head was another slogan from Kim Il Sung: "It is important to play the piano well."

Harris shows us the largest Kim monument, a sixty-foot statue towering over the entry plaza of the Museum of the Korean Revolution. I witnessed kindergarteners assembling before it and bowing while chanting in unison, "Thank you, Father." Inside the museum, the alpha and omega of the revolution is Kim's life, which modern Korean history merely adumbrates. He is shown in the vanguard of a mass uprising against Japanese colonizers in 1919, when he was exactly seven years old. If it is not Kim on display, it is his son, mother, father, grandparents, or first wife (mother of Kim Jong Il). Even his great-grandfather gets into the act, helping torch the unfortunate USS *General Sherman*, which ran aground just short of Pyongyang while trying to open trade with Korea in 1866. This is a communist state, but also a strange kind of communism-in-one-family.

Family bedrooms have portraits of father and son on the wall, usually with an impassive or pensive look, sometimes with a smile. Yet Kim Jong Il often has a dyspeptic, vaguely jaded look on his face. His father, always stolid

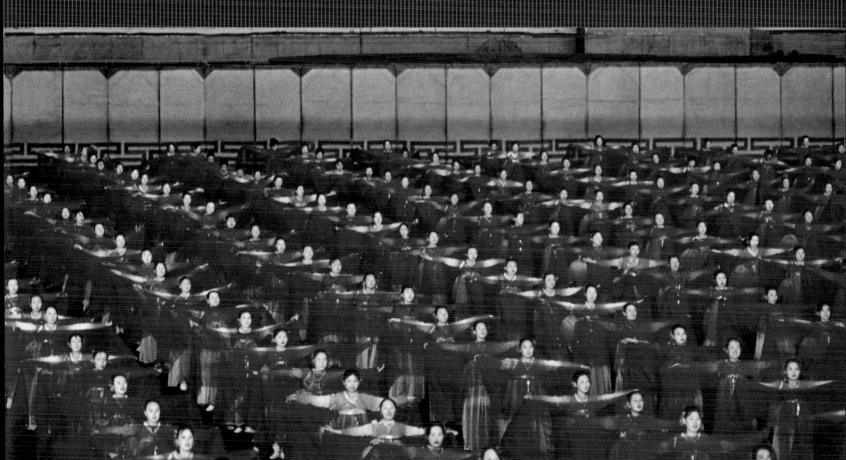

or smiling, would never stand for that. One story has it that a foreign cameraman, unhappy with his Polaroid take of the Great Leader, ripped it up and started to snap another. He was set upon by a phalanx of retainers: "You never destroy a picture of the Leader." The Great Leader's photos are everywhere, and yet none can be ripped up; it is an extreme of Pierre Bourdieu's view that nothing is "more regulated and conventional than photographic practice . . . stilted, posed, rigid, contrived," and that every photograph connotes class ethos*—or, in this case, the maximum representative of a class state.

Yet Harris's photos enable us to move beyond the posed and the formal, to see real people living in a country that has its own daily routines—different from ours, but routines nonetheless. Between the leader and the seemingly uniform mass is a more recognizable and very numerous salariate, whose members depart unheroically at the crack of dawn from three-room apartments in high-rises, flooding onto buses and subway trains. They put in their

day at the office and return in the early evening, the men hurrying home and the working women doing double duty—carrying some fresh vegetables or fish for dinner, or grasping the hand of a child brought home from day care. This could be Seoul, or Tokyo, or any other city where "modern" means being a cog in some bureaucratic wheel.

The Leader, the Son, and the people are ever heroic, says the daily paper, effortlessly accomplishing the next stage of the revolution. Meanwhile, as Harris's photos sometimes show, a catastrophe overtook the country during the past fifteen years, leaving it somewhere between a failed mendicant state and a very poor but still well-armed nation with a bunker mentality born of a thousand threats to its existence, internal and external. Across from the Pyongyang Hotel is a traditional monumental building, not unpleasing to the eye; on its side is an inlaid-tile mural, larger than life, of an attractive Korean woman wearing a radiant orange traditional dress and seeming to leap forward. In her right hand is a pistol.

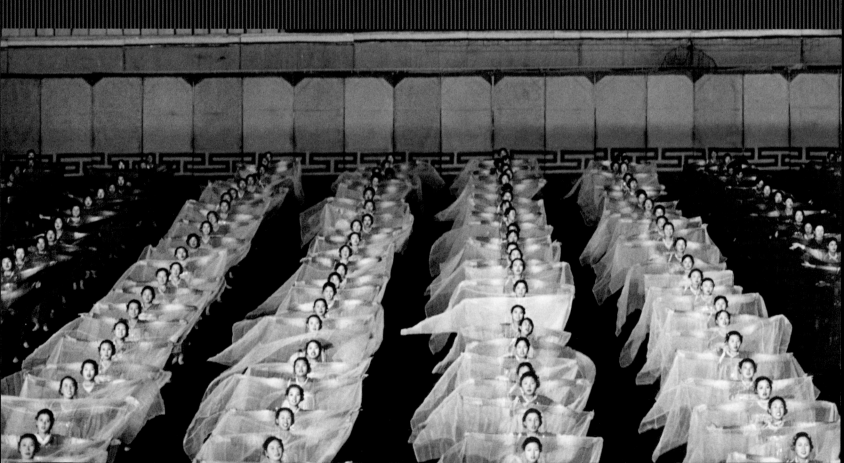

For decades this same woman was featured on the nation's currency, right in the middle of the one-won note.

North Korea was supposed to have gone the way of the eastern European satellite regimes when the Berlin Wall fell in 1989, especially since it is widely thought to be among the worst of such totalitarian regimes, a wretched excess of communism. Yet today it perseveres with the same socialist slogans, flapping red flags, and ideological formalism as if nothing had happened: Here are "the last communists," overcoming the feudal past in the socialist present, building toward the communist future.

But the woman with the pistol probably gives us a better idea of this regime's staying power. Its original leadership came to power after a terrible and thankless struggle against Japanese imperialism in Manchuria in the 1930s, then it fought against the United States for three years in one of the truly catastrophic wars of the 20th century. The result was a garrison state with more than a million men and women under arms at any given time, and enormous underground structures (more than 15,000 in all) that it hopes are impervious to American bombers if they come again. (The U.S. Air Force demolished the country in the 1950s.)

I don't know what the future holds for North Korea, but I doubt it is a future that Kim Jong II or his father would want. Theirs is a politics of the 1930s, formed amid colonialism, the worldwide Great Depression, and the onset of World War II. North Korea's fate now is to be surrounded by former friends and relentless enemies that have prospered mightily in the commercial boom now transforming East Asia. It is anybody's guess whether the regime will disappear tomorrow or finally begin a serious reform program such as China's and stay afloat, but Mark Edward Harris's photographic album will remain an indelible tribute to this odd, exasperating, anachronistic, dangerous, and faintly poignant nation.

* Pierre Bourdieu and associates, *Photography: A Middle-Brow Art*, trans. by Shaun Whiteside (Palo Alto: Stanford University Press, 1990), pp. 7–8.

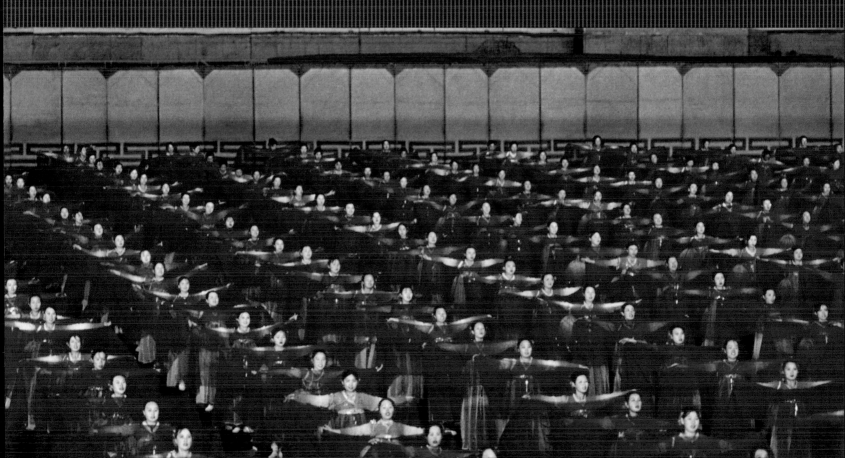

INTRODUCTION

Stepping onto the tarmac at Pyongyang's Sunan Airport, less than eleven miles northwest of North Korea's capital, was the realization of a decade-long effort to visit the most reclusive country on earth.

I've been fortunate enough to travel to some amazing places—walking into East Berlin at Checkpoint Charlie; going underwater to explore the Japanese fleet at the bottom of Truk Lagoon; joining an archaeological dig in the Golan Heights; exploring Vietnam, Cuba, Siberia, the Amazon, and Lebanon's Bekaa Valley. But to travel to North Korea, which has been largely closed to the outside world for more than fifty years, presented special challenges, particularly as an American. North Koreans are taught that the United States instigated the Korean War, and the country's leaders urge its citizens to be in a constant state of preparedness under the threat of a U.S. nuclear strike. In 2002, President George W. Bush named North Korea a member of an "axis of evil." North Korean rhetoric has been no less super-heated, at various times—before and after being declared "evil"—promising to turn the South Korean capital of Seoul, U.S. ally Japan, and the United States itself into a "sea of fire."

Over the years, however, there have been several opportunities when the Democratic People's Republic of Korea (DPRK) has allowed a limited number of Americans in for a limited time. Such a chance most recently coincided with one of the most fascinating of human spectacles, the Arirang Mass Gymnastic Games. I'd traveled to the DMZ (demilitarized zone) twice before, in 1997 and 2003, to photograph conditions near the barrier that separates forty-six million Koreans to the south from twenty-seven million Koreans to the north. I was finally able to visit North Korea for the first time in 2005 (and return in 2006), flying on a Russian-made Koryo Air Ilyushin 62 from Beijing to Pyongyang. Any outsider's time in North Korea is carefully controlled by the state, with visitors kept to minded groups or within well-defined limits (I was warned not to stray more than one hundred meters from

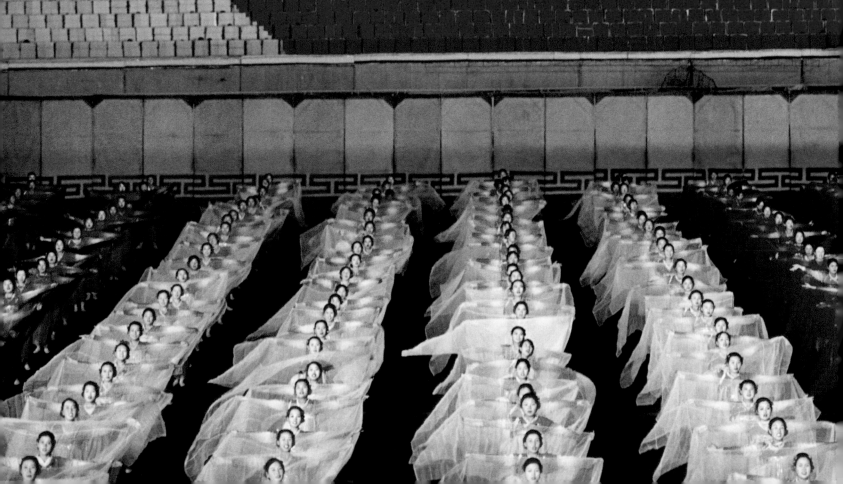

the hotel in Pyongyang when not on a guided excursion). But the public face the DPRK chooses to present to the fortunate few visitors allowed in, and the unscripted moments glimpsed, are all the more fascinating for the country's closed and defensive stance as a "hermit kingdom" (a nickname originating in nineteenth-century Korea's closed-border policy attempting to limit foreign encroachment).

The leash was long enough to allow some human interaction with people other than our guides—photographs of whom were allowed by permission of a smile or a positive shake of the head—but any verbal communication was of grave concern. Our guides were open within limitations—no direct political discussion of any sort—and a genuine fondness grew between us, despite the rhetoric at stops such as the War Museum on the North Korean side of the DMZ. There I was informed by staff that hatred for America was born of the U.S. invasion of the North to begin the Korean War (not, in fact, true). But the speech was followed by a clarification: "It's not the American people we hate, it's the American government." On that visit I was able to come from the North to within a few feet of where I had stood on the south side of the cement Military Demarcation Line (MDL) dividing the two Koreas.

The partition of the country, the isolation of the North, and its often unusual and unpredictable behavior have made it in many ways a strange and foreign place even to South Koreans—and yet, of course, it isn't. They are, after all, the same people. This is a particularly painful reality for the estimated one million families separated by the DMZ, the great divide between North and South.

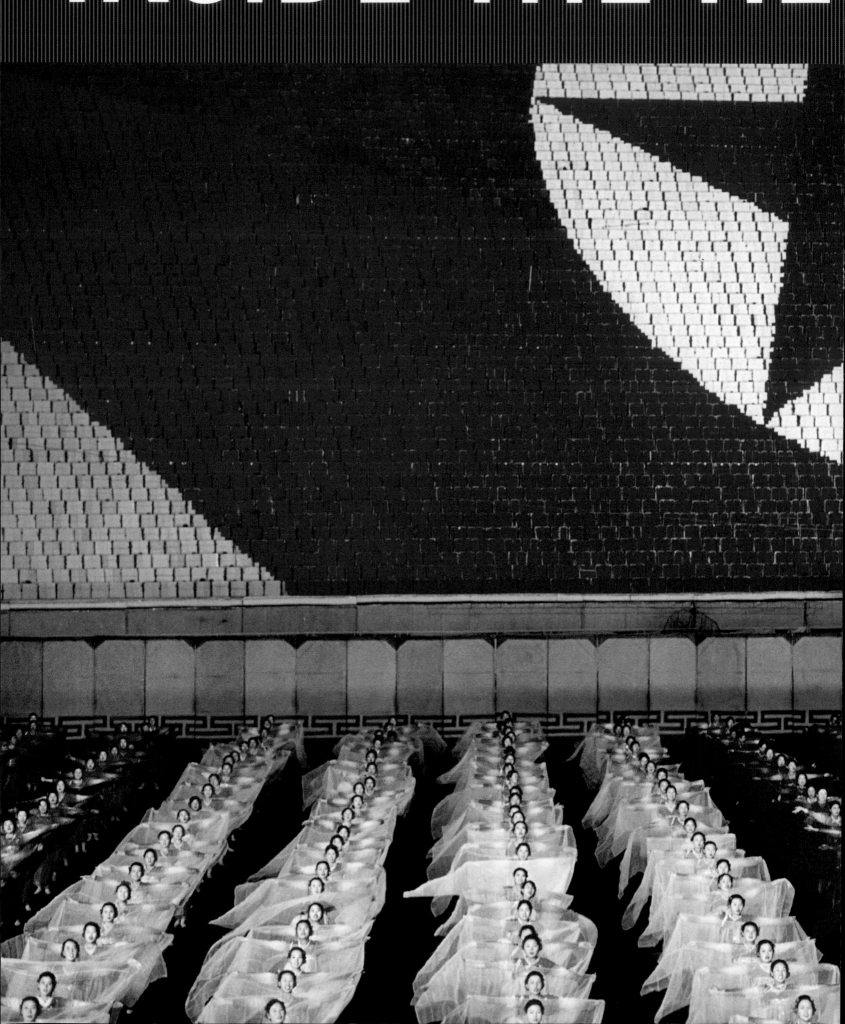

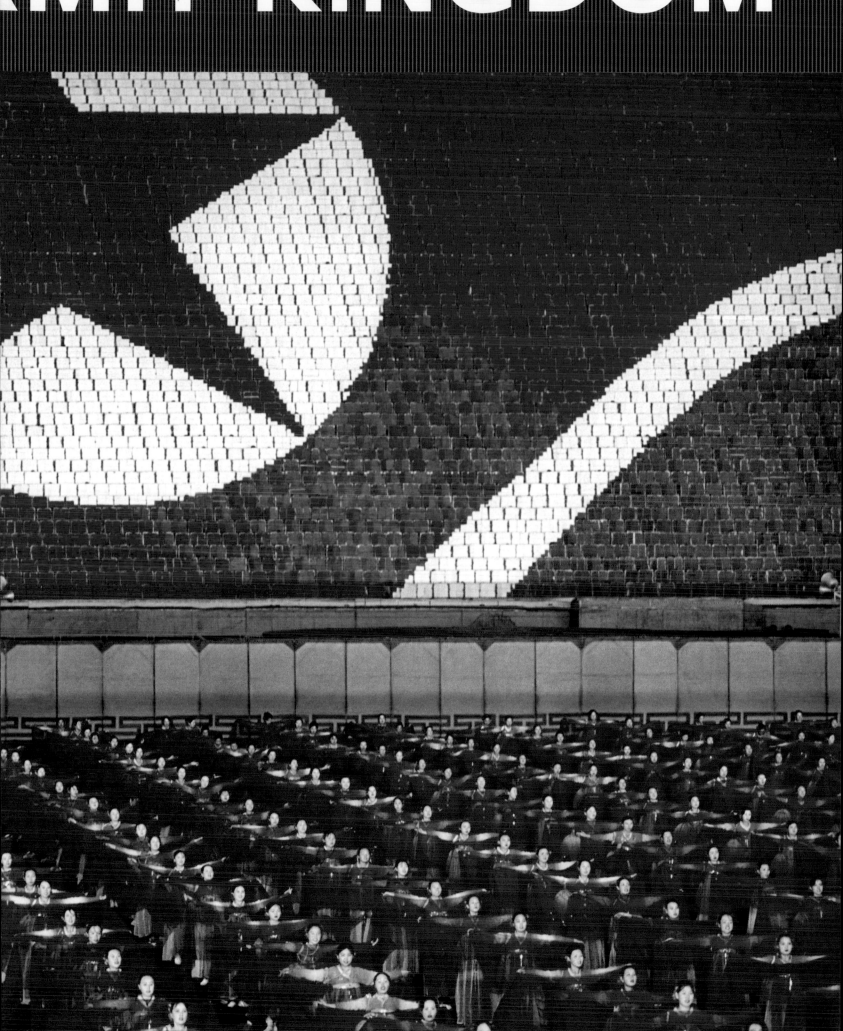

PREVIOUS SPREAD:
Performers at the 2005 Arirang Mass
Games in Pyongyang.

PYONGYANG

PYONGYANG IS THE CAPITAL CITY OF North Korea. The official population of the city is not disclosed; it was reported as 3.8 million in 2003 by Chosen Soren, a pro–North Korean organization based in Japan. During the Three Kingdoms period (BCE 57–676 CE), the Goguryeo kingdom moved its capital to what is now Pyongyang in 427. The modern English name "Korea" derives from the medieval Korean kingdom of Goryeo, which in turn took its name from "Goguryeo."

In the ensuing years, kingdoms came and went with geopolitical upheavals and foreign invasions, including the Japanese invasion of 1592. In 1910, the Korean peninsula was annexed by Japan and was controlled by the country until the end of World War II in 1945. With the end of Japanese rule, Korea was divided in half at the thirty-eighth parallel, with the North occupied by Soviet forces, the South by the United States. Pyongyang became the capital of the Democratic People's Republic of Korea at its establishment in 1948. Though still acting in support of their respective halves of the country, both the United States and the Soviets had withdrawn most of their forces by 1949. Tensions for unification of the country from both north and south—each on their own terms—came to a head when some seventy thousand North Korean troops crossed the thirty-eighth parallel in June 1950, marking the beginning of the Korean War. By the time of the armistice three years later, Pyongyang lay mostly in ruins. The city was rebuilt with Soviet help, many buildings with a Stalinist architectural flavor. Massive Soviet-style monuments and large apartment blocks are located around the capital, as are images of Kim Il Sung (The Great Leader) and Kim Jong Il (The Dear Leader).

While the city's monuments are its most immediately striking feature, the capital is also notable for its wide, mostly empty streets and boulevards. Personal ownership of vehicles is no longer specifically limited, but few cars are visible (fuel shortages are a constant in the DPRK), the streets sparsely occupied by bicycles, pedestrians, and a few city buses. Advertising is also notably absent, though patriotic slogans are common on buildings, monuments, and billboards throughout the city. The relative emptiness is accentuated by regular relocations of as many as a million of Pyongyang's residents to the countryside to help with annual harvests. At night, the city is mostly dark, the result of electricity shortages and scheduled blackouts, ostensibly for security reasons (though power in international hotels and the lighting on key monuments is maintained). Sounds can carry for miles; the night sky is unusually clear and the stars surprisingly bright above a national capital city. The whole country appears in satellite images as a dark form between the lights of China and South Korea. Patriotic music plays from loudspeakers in the city each morning, and occasional air-raid drills sound across the city for residents to take cover in response to their government's expressed expectation of a U.S. nuclear attack.

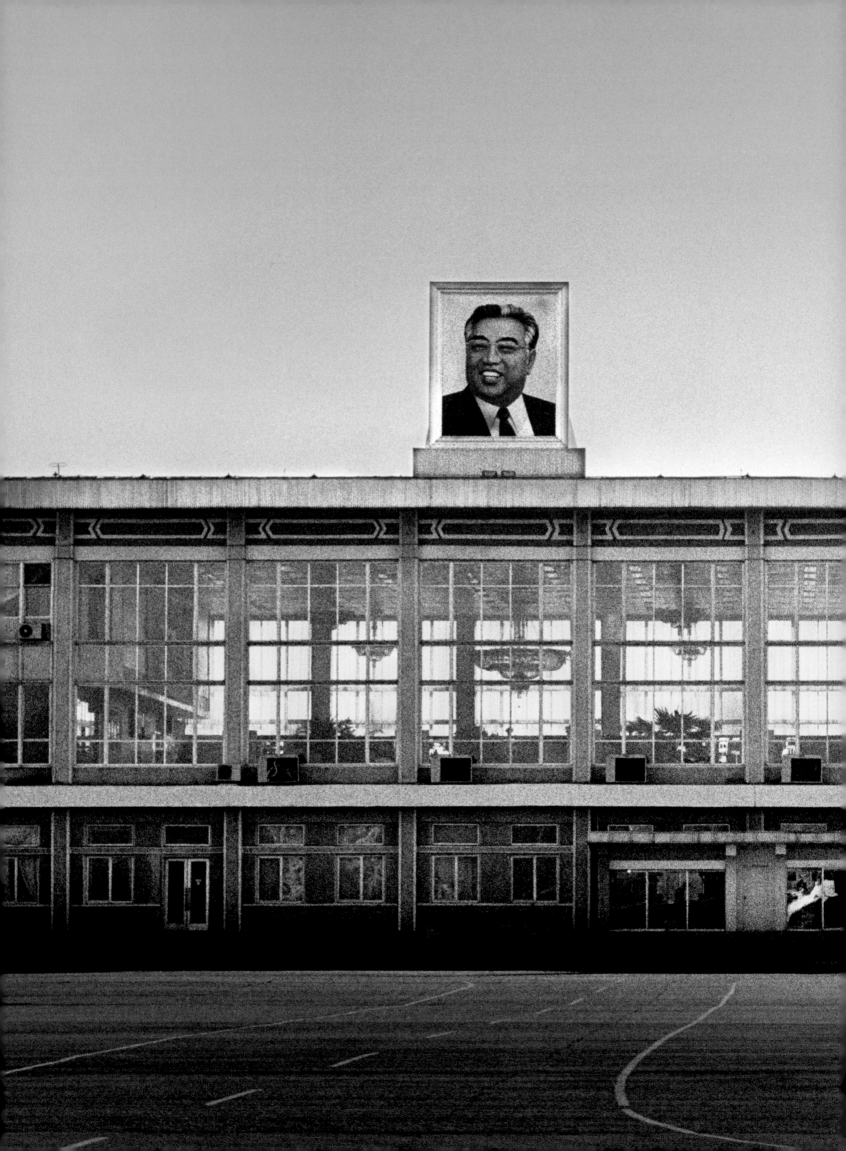

PREVIOUS SPREAD:
At Pyongyang's Sunan Airport, disembarking passengers are welcomed by the smiling portrait of the Great Leader, Kim Il Sung. Four to five flights, on average, depart each week from the airport.

OPPOSITE:
Schoolchildren at the Mansudae Grand Monument pay tribute to Kim Il Sung.

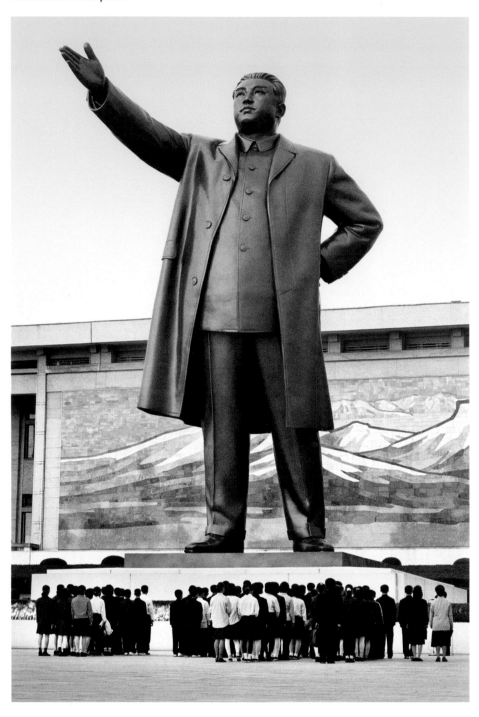

North Koreans bow to a 65-foot bronze statue of Kim Il Sung, erected in 1972 to celebrate his sixtieth birthday, at the top of Mansu Hill. Foreigners are warned that any sign of disrespect will not be tolerated. Offenses include imitating the position of the statue or photographing just the feet.

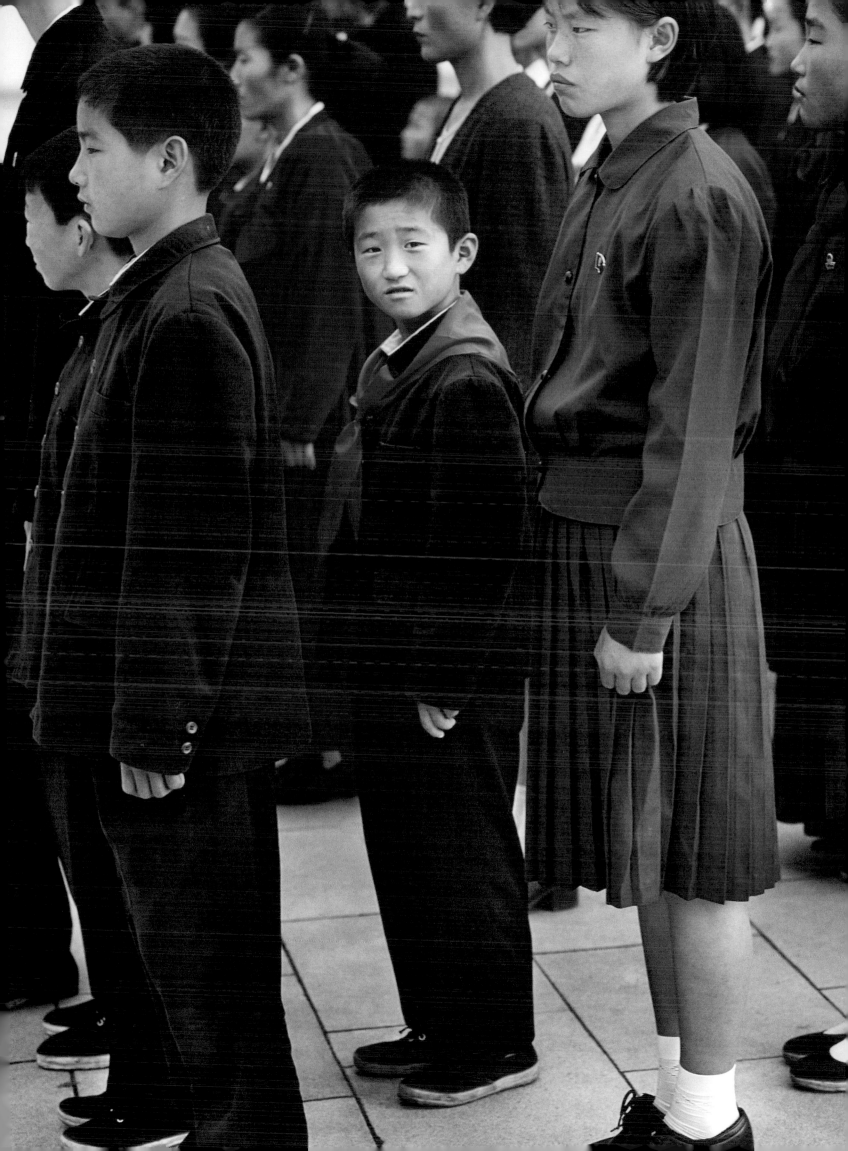

OPPOSITE:
The Monument to the Workers' Party of Korea was erected on the fiftieth anniversary of its founding. Laborers are represented by the hammer, intellectuals by the calligrapher's brush, and farmers by the sickle.

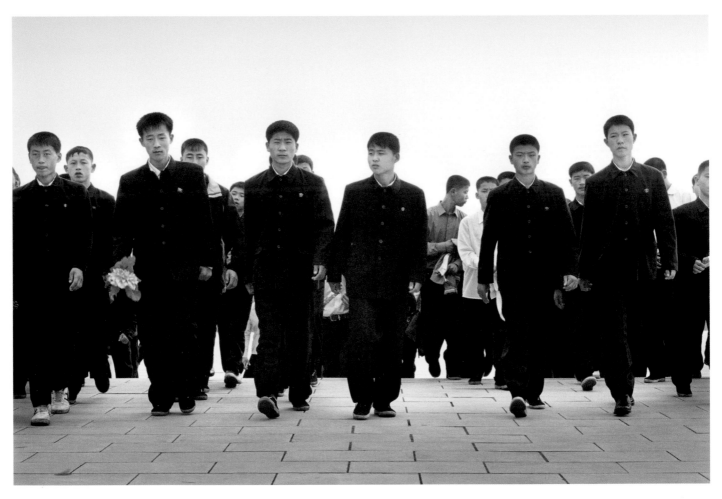

Students at the Mansudae Grand Monument.

FOLLOWING SPREAD:
A park with Mansu Hill and the uncompleted, pyramid-shaped International Ryugyong Hotel in the background. Construction of the hotel began in 1987 but was halted four years later, with no official statement as to why, amid rumors that the 105-story building is structurally unsound. It remains unfinished and unoccupied.

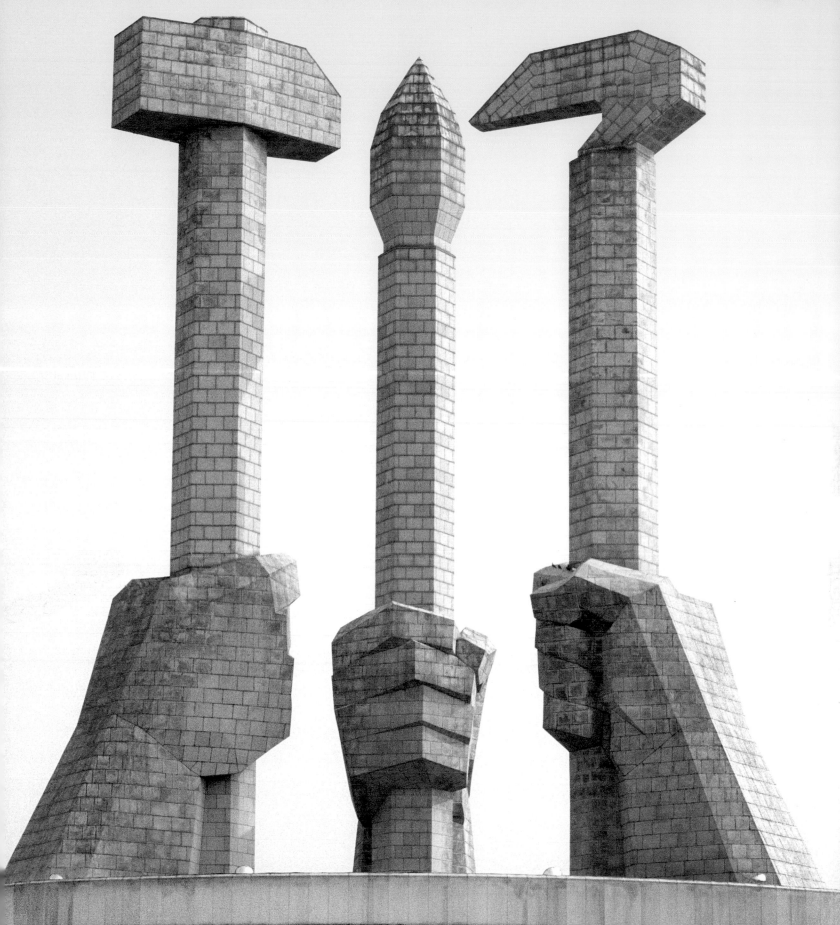

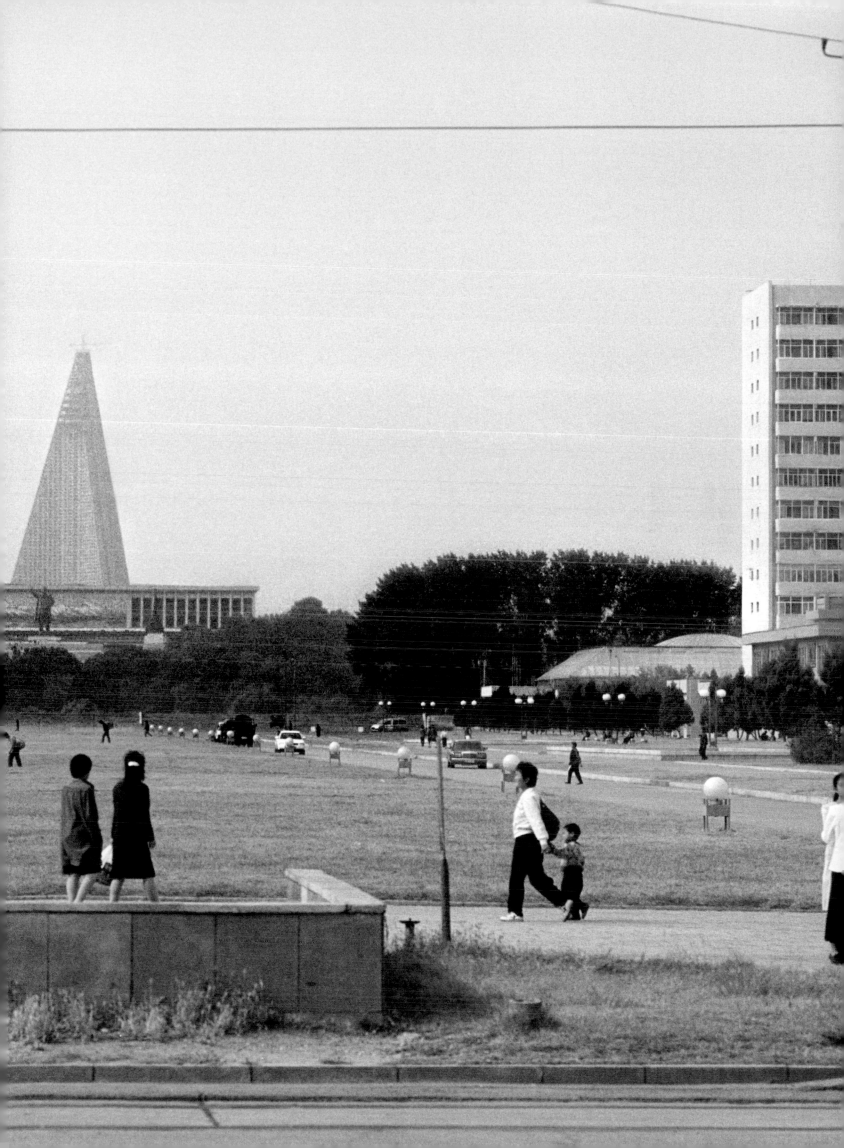

OPPOSITE:
Situated at the edge of the Taedong River, the 557-foot Juche Tower celebrates the philosophy of nationalistic self-reliance put forward by Kim Il Sung (also known as Kimilsungism) that is the guiding philosophy of the DPRK. The tower, based on an architectural style derived from the stone pagodas of premodern Korea, was completed on April 15, 1982, in honor of Kim's seventieth birthday.

A tour guide at the base of Juche Tower wearing a pin depicting Kim Il Sung.

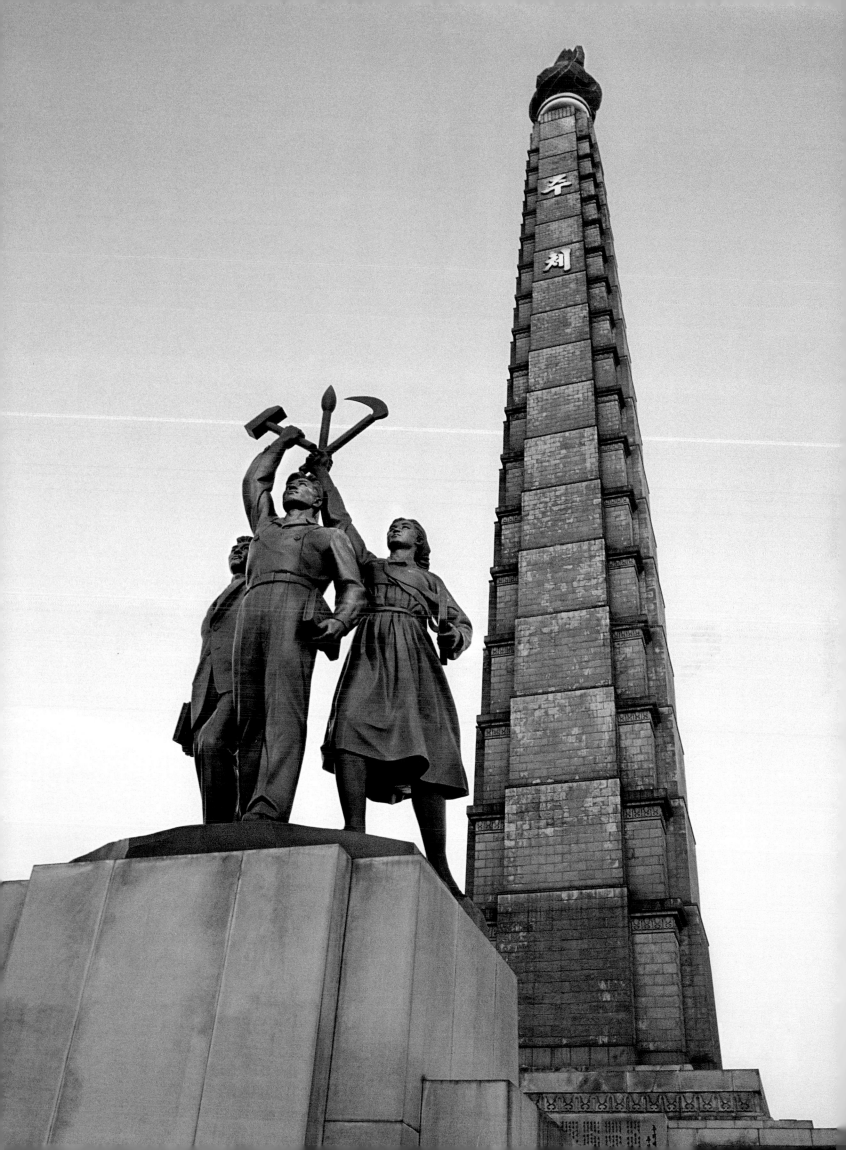

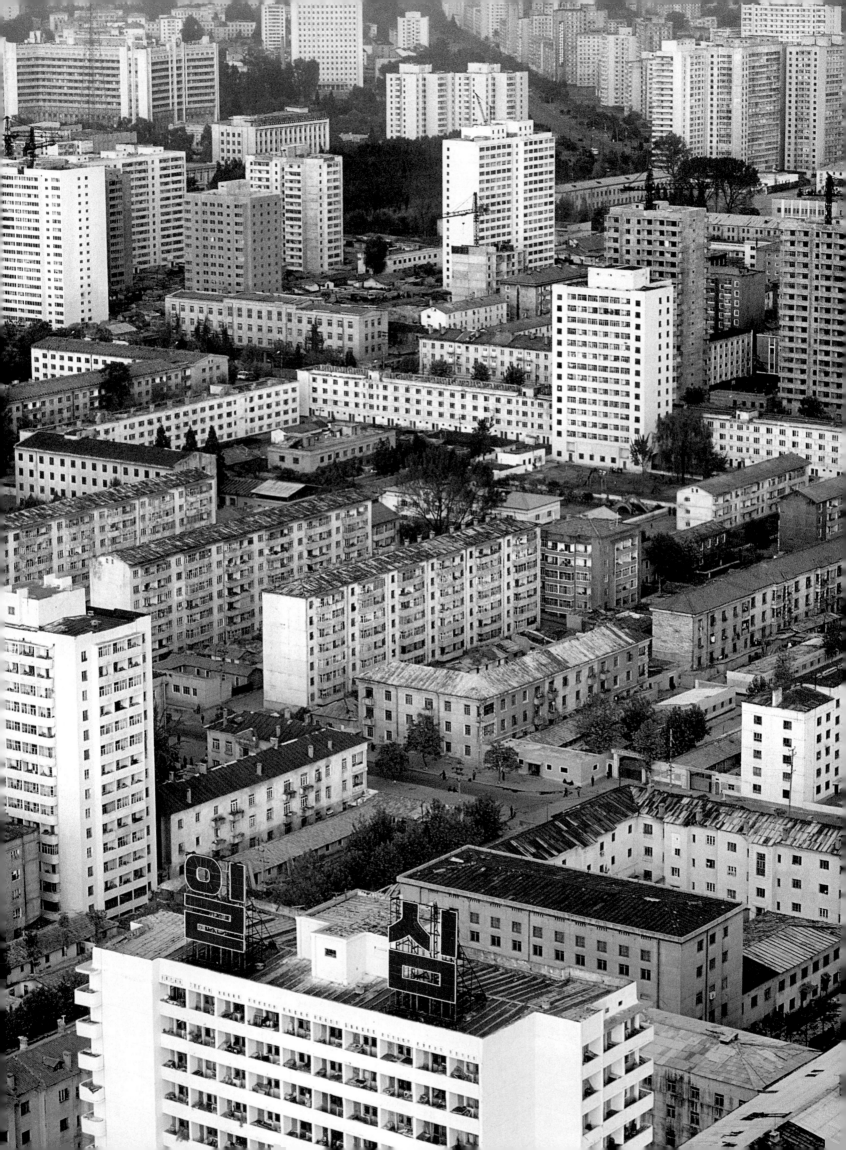

OPPOSITE:
A view of office and apartment
buildings from the top of Juche Tower.
The sign in the foreground translates
as "One heart."

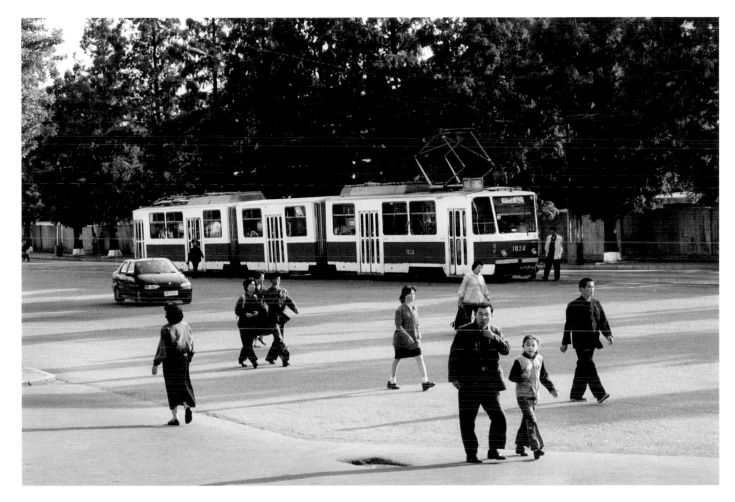

A trolley on the streets of Pyongyang.

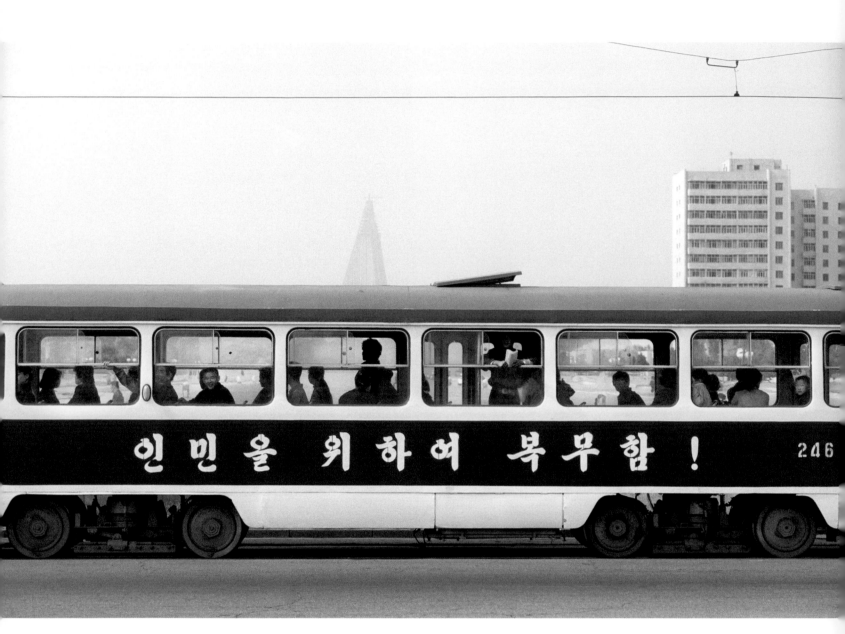

The characters on the side of the trolley
read "We serve the people!"

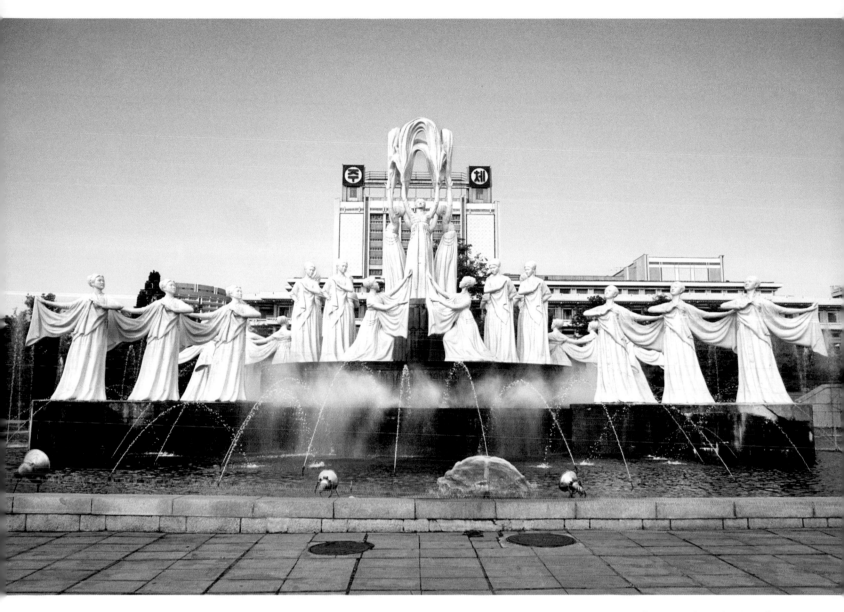

Fountains across the street from the Grand People's Study House, which was built in 1982 to celebrate Kim Il Sung's seventieth birthday, and serves as the city's main library.

OPPOSITE:
A father and son in a park near the
Taedong River.

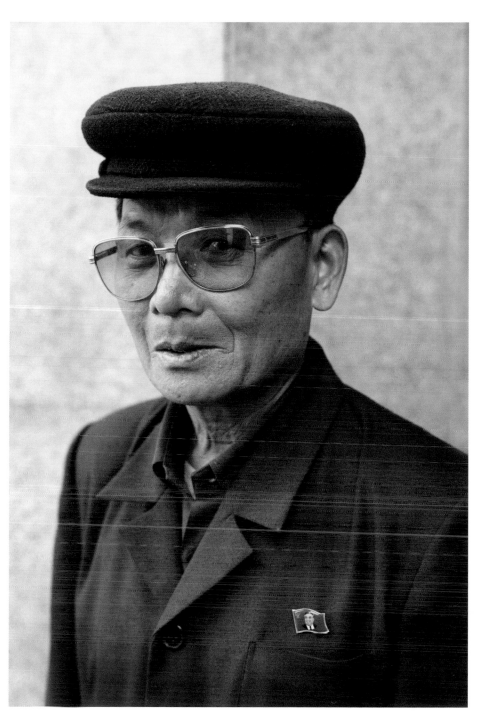

A man on the street.

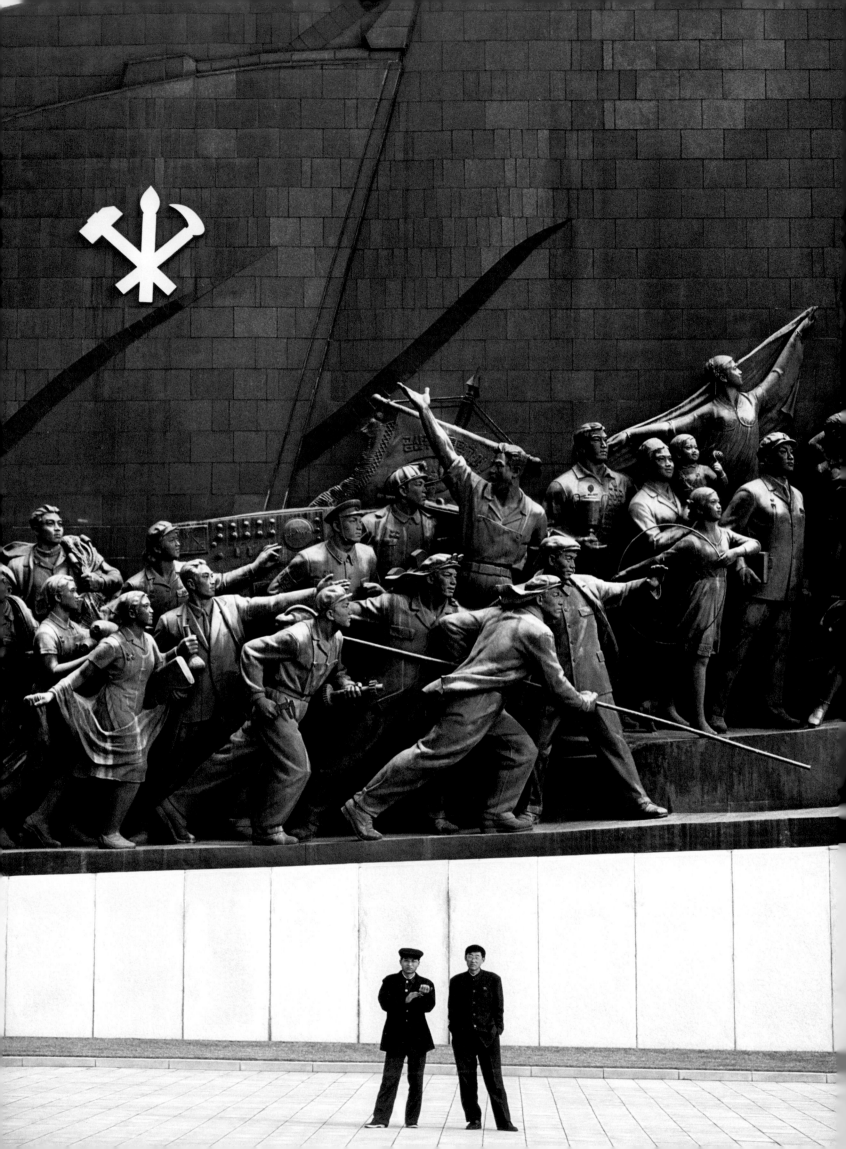

OPPOSITE:
The Mansudae Grand Monument on Mansu Hill celebrates the efforts of workers under a banner of the Korean Workers' Party.

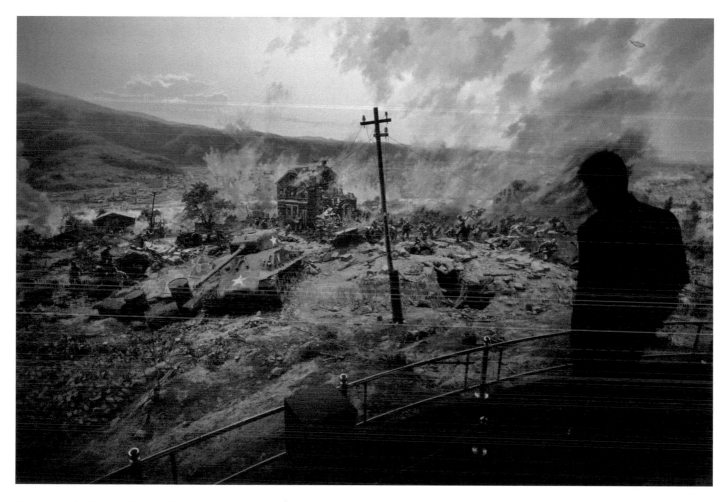

An image of a Korean War battle at the Victorious Fatherland Liberation War Museum. The museum hosts a cyclorama depicting the Battle on Height 1211, fought during the Fatherland Liberation War (the Korean War).

FOLLOWING SPREAD:
A roadside mural depicts the hero's welcome that met the arrival of Kim Il Sung near Pyongyang Municipal Stadium (later renamed Kim Il Sung Stadium) on October 14, 1945, at the end of the Second World War and the country's liberation from Japanese occupation.

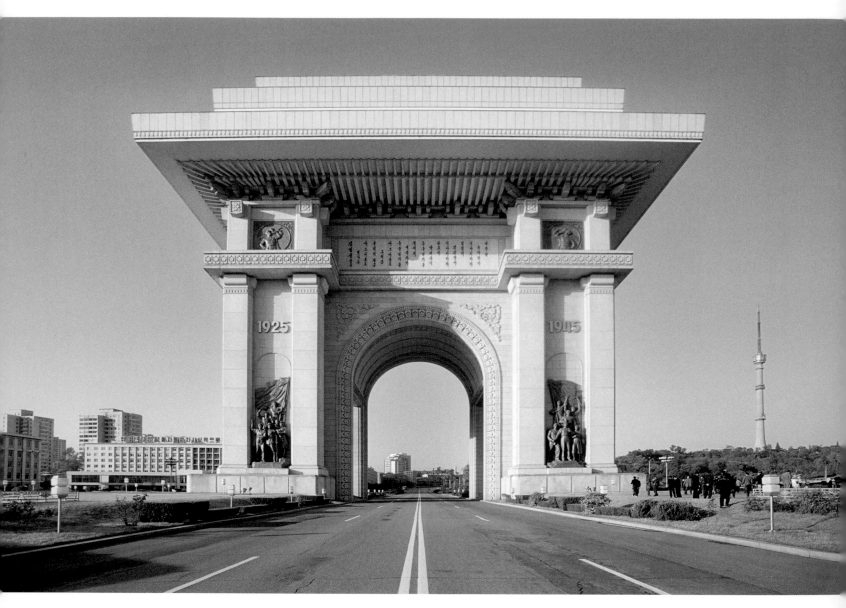

Dedicated on April 14, 1982, Pyongyang's
Arch of Triumph at 197 feet is purposely
several feet higher than Paris's Arc de
Triomphe. The dates 1925 and 1945 on the
white granite structure refer to the period
of Kim Il Sung's struggle against Japanese
occupation. The lyrics above the arch
are from the "Song of General Kim Il Sung."

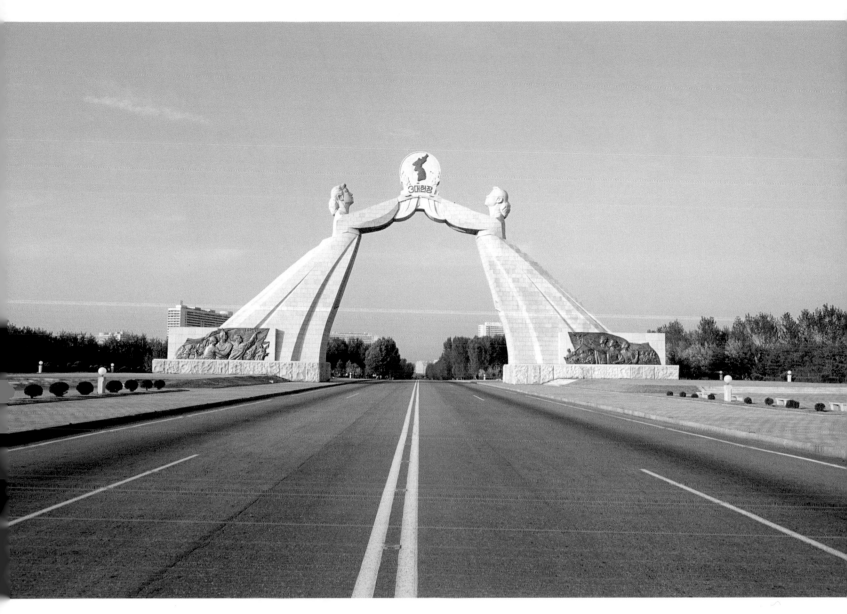

The Reunification Arch spans the Reunification Highway on the road from Kaesong to Pyongyang. Constructed in 2001, the monument commemorates proposals put forward by Kim Il Sung after the country's liberation from Japanese rule, intended to bring the two halves of the country together. The two women bridging the Reunification Highway represent the North and South coming together to support an image of a united Korea.

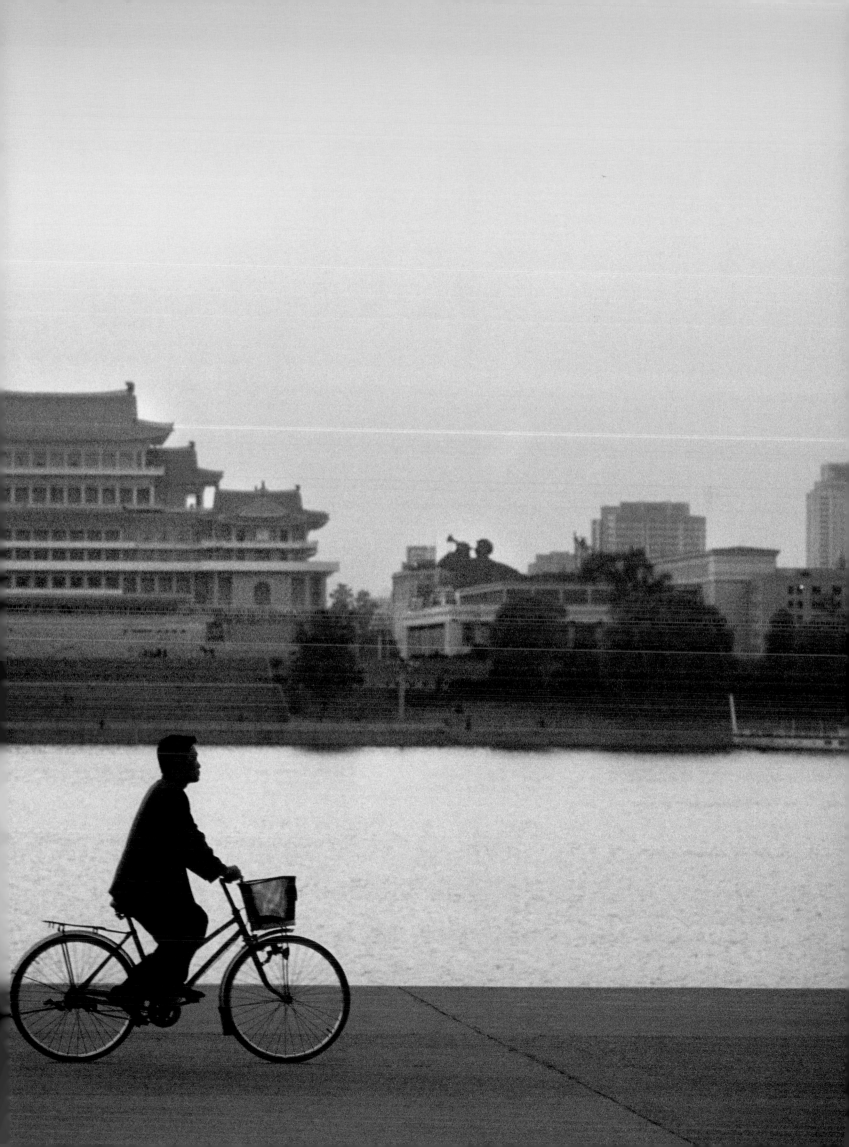

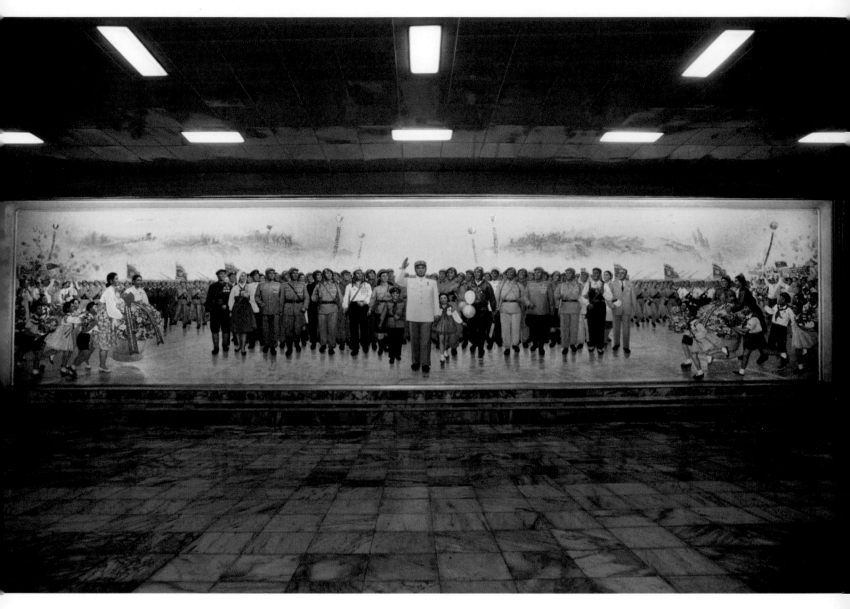

A large mural greets visitors at the entrance
to the Victorious Fatherland Liberation War
Museum. North Koreans are taught that
the United States invaded South Korea under
the pretext of disarming the Japanese at
the end of World War II, establishing a puppet
military and government in South Korea and
instigating the Korean War in 1950. Many
of the exhibits at the museum portray
the United States as imperialist aggressors.

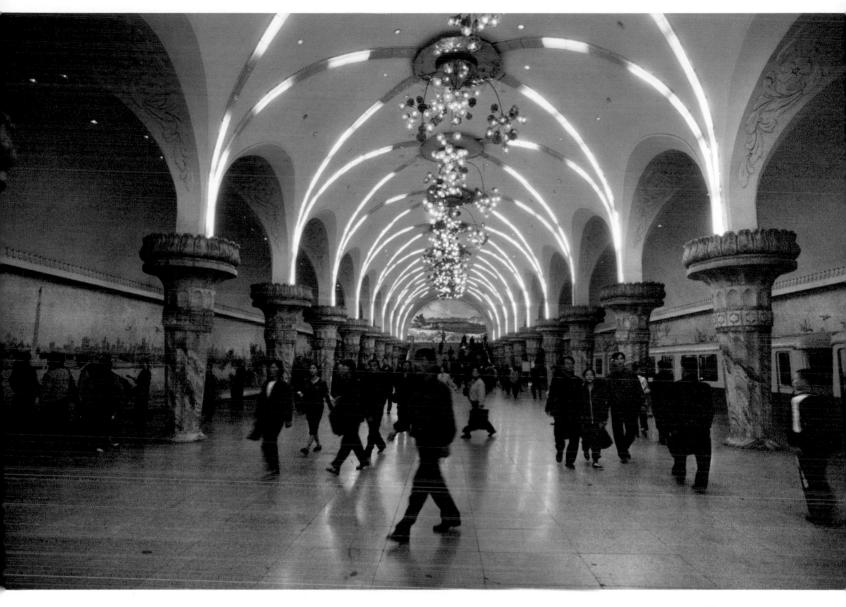

Yonggwang (Glory) Station of the Pyongyang Metro. The city's underground transit system consists of two public lines, which carry an estimated 300,000 commuters through the capital each day. Stations are named for revolutionary concepts. Other stations include Hwanggumbol (Golden Fields), Pulgunbyol (Red Star), and Chonu (Comrade). There is some evidence of additional, secret metro lines solely for government use, similar to the secret metro line built in Moscow during Stalin's rule.

FOLLOWING SPREAD:
Sunset over Pyongyang. The twin-towered forty-five-story Kyoro Hotel with its skybridge is prominent on the skyline.

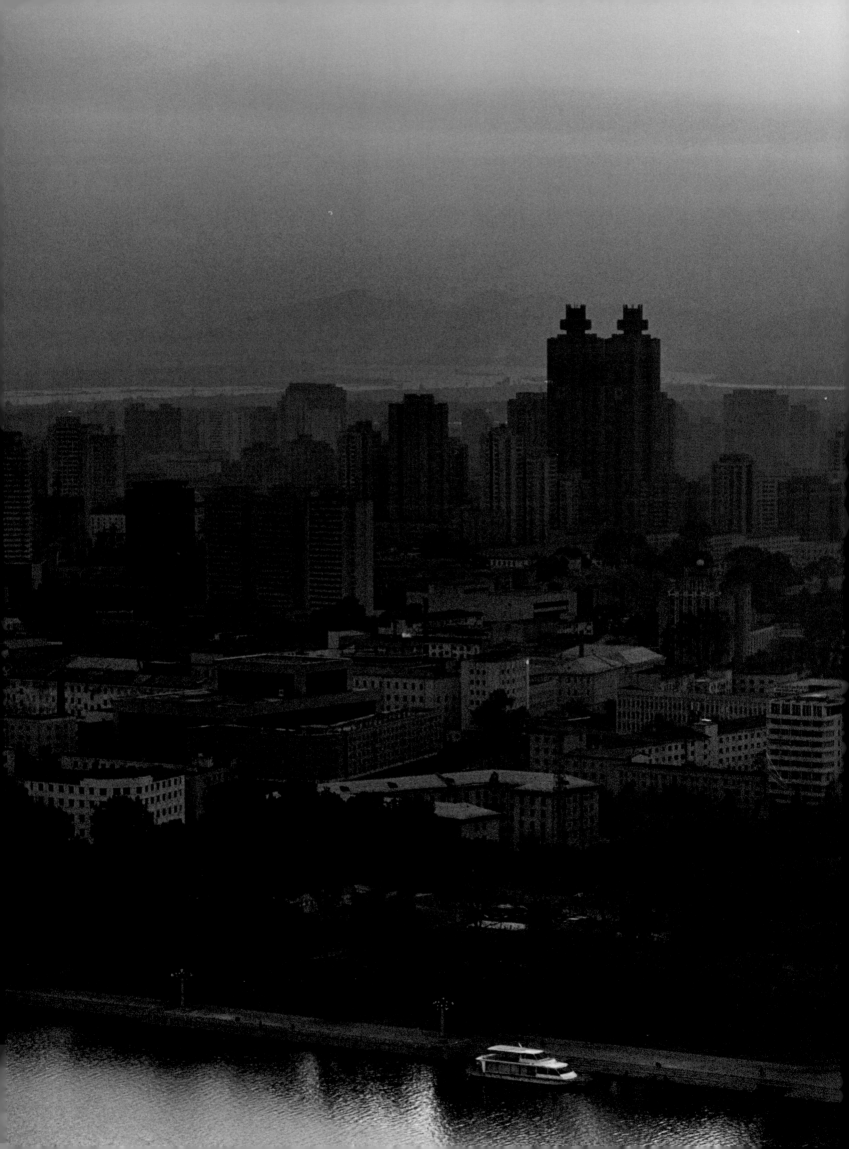

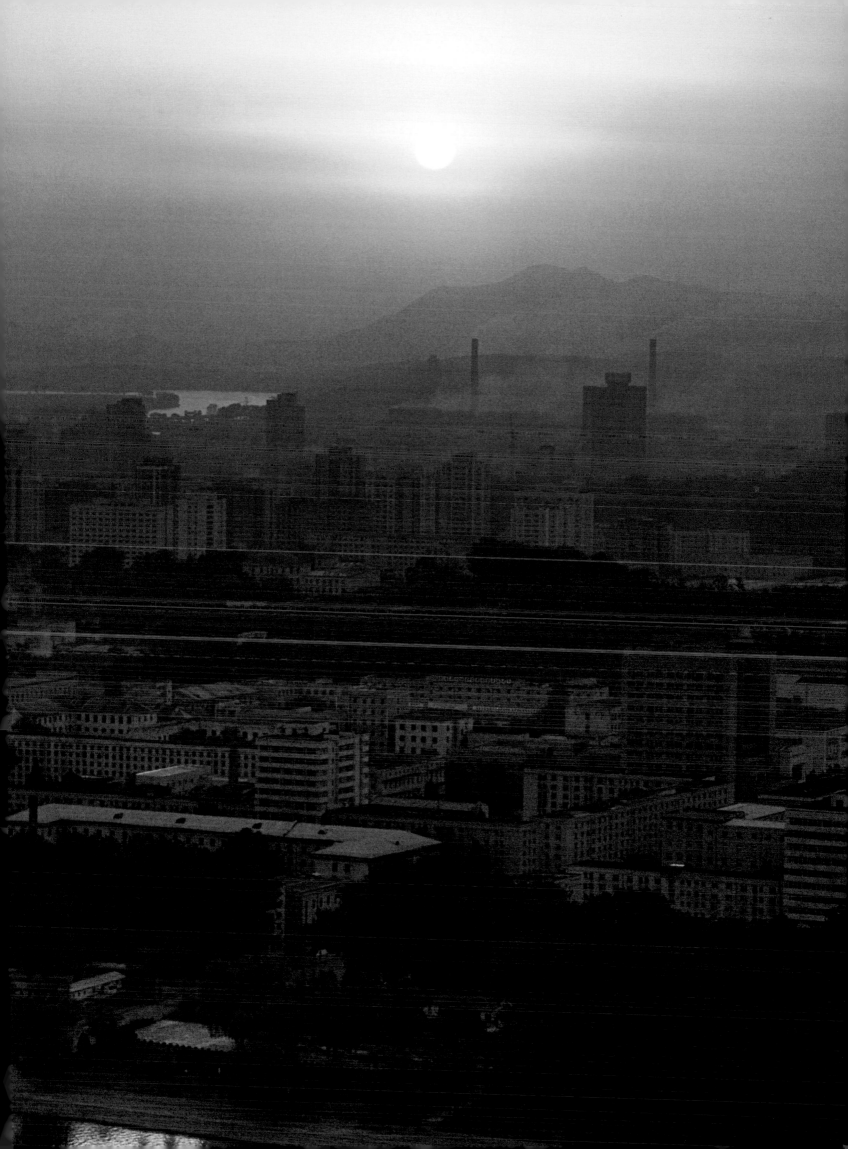

ARIRANG MASS GAMES

North Korea has held mass gymnastic games and performances since 1946. Increasingly lavish, the games have culminated in the national showpiece Arirang Mass Gymnastic and Artistic Performances—premiering in 2002 to coincide with the ninetieth anniversary of Kim Il Sung's birthday and held annually in Pyongyang's 150,000-seat May Day Stadium. The games are astonishing spectacles of precision, athleticism, teamwork, and showmanship, involving 100,000 performers, giant video screens, lasers, fireworks, and an audience section of 20,000 to 40,000 students who hold up colored cards to form mosaic backdrop scenes on cue. The hour-and-a-half performance is divided into chapters celebrating themes of youth, strength, education, farm and industrial production, military might, folktales and historical events, revolutionary struggle, national unity, and the Great and Dear Leaders. It is considered an honor to participate in the games, and training is rigorous— between two and ten hours a day. The results are breathtaking—thousands of teenage girls performing complicated gymnastic routines in perfect unison; battalions of bayonet-wielding soldiers in choreographed precision; thousands of children in egg, livestock, and vegetable costumes trooping across the stadium's field to represent plentiful harvests. The spectacle is seen by more than two million North Koreans each year, but by only a handful of outsiders. The 2005 performance marked the sixtieth anniversary of the Workers' Party.

"Arirang" is one of the few folk songs virtually every Korean on both sides of the DMZ can sing. Hundreds or even thousands of versions of the song (with the refrain "Arirang, Arirang" common to all) share the basic story of a woman hoping that her departing lover will have sore feet

and return to her before he travels too far away. Its theme is all the more resonant in a divided country. In 1985, as part of an exchange in which families separated between South and North Korea were allowed to meet and art troupes exchanged visits between capital cities, a troupe from Seoul performed the song in the North Korean capital. A new version—"Unification Arirang"— was performed at the First Arirang Festival in Seoul in 2002.

The 2006 games were cancelled just two weeks before they were scheduled to begin, after torrential rains caused flooding and damage throughout the country.

OPPOSITE:
Placards held by schoolchildren compose a portrait of Kim Il Sung at the Arirang Mass Gymnastic and Artistic Performance in May Day Stadium.

FOLLOWING SPREAD:
A vision of world peace from the 2005 Arirang Mass Games.

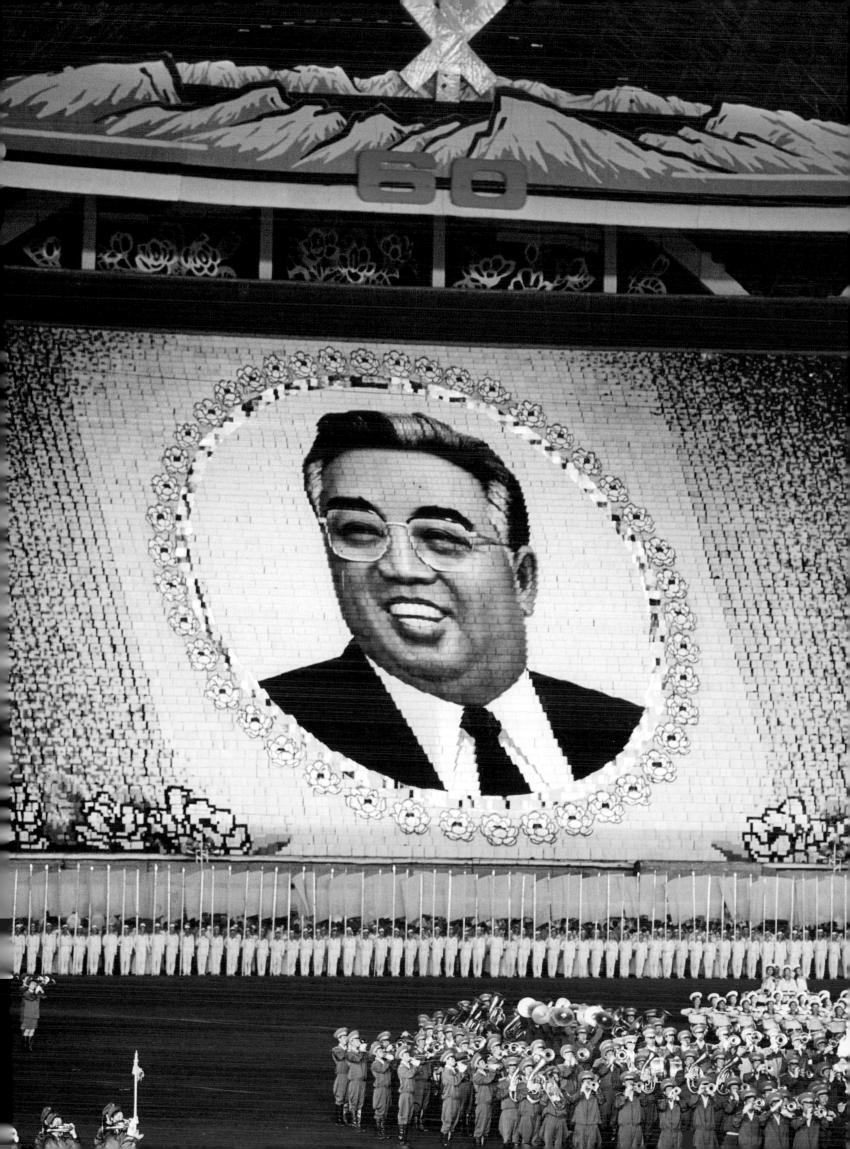

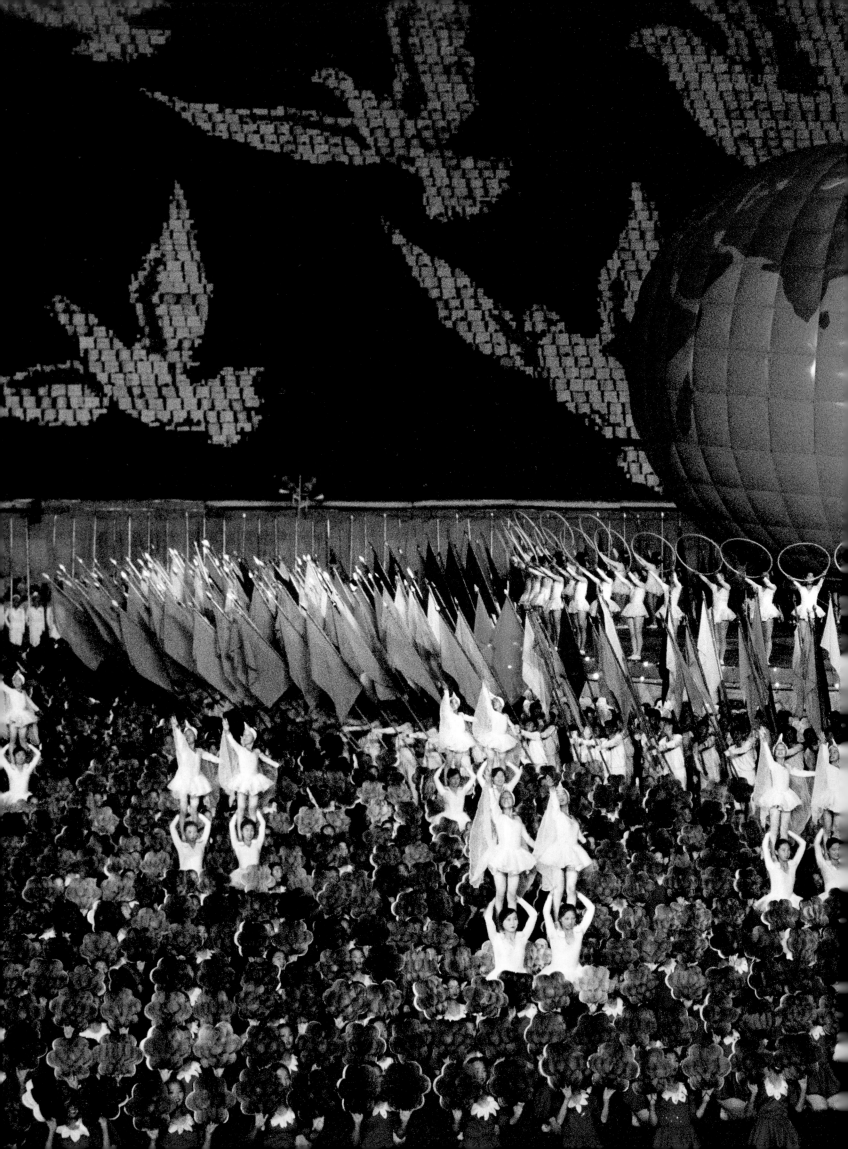

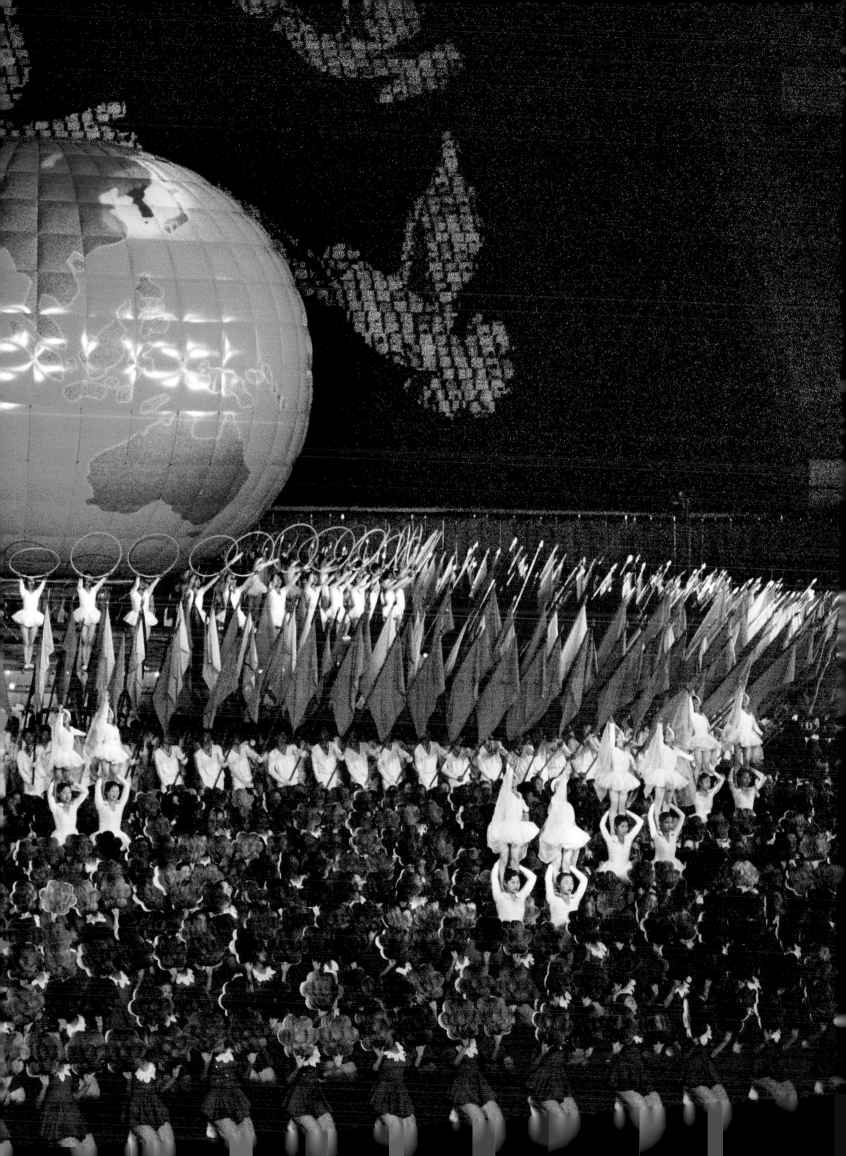

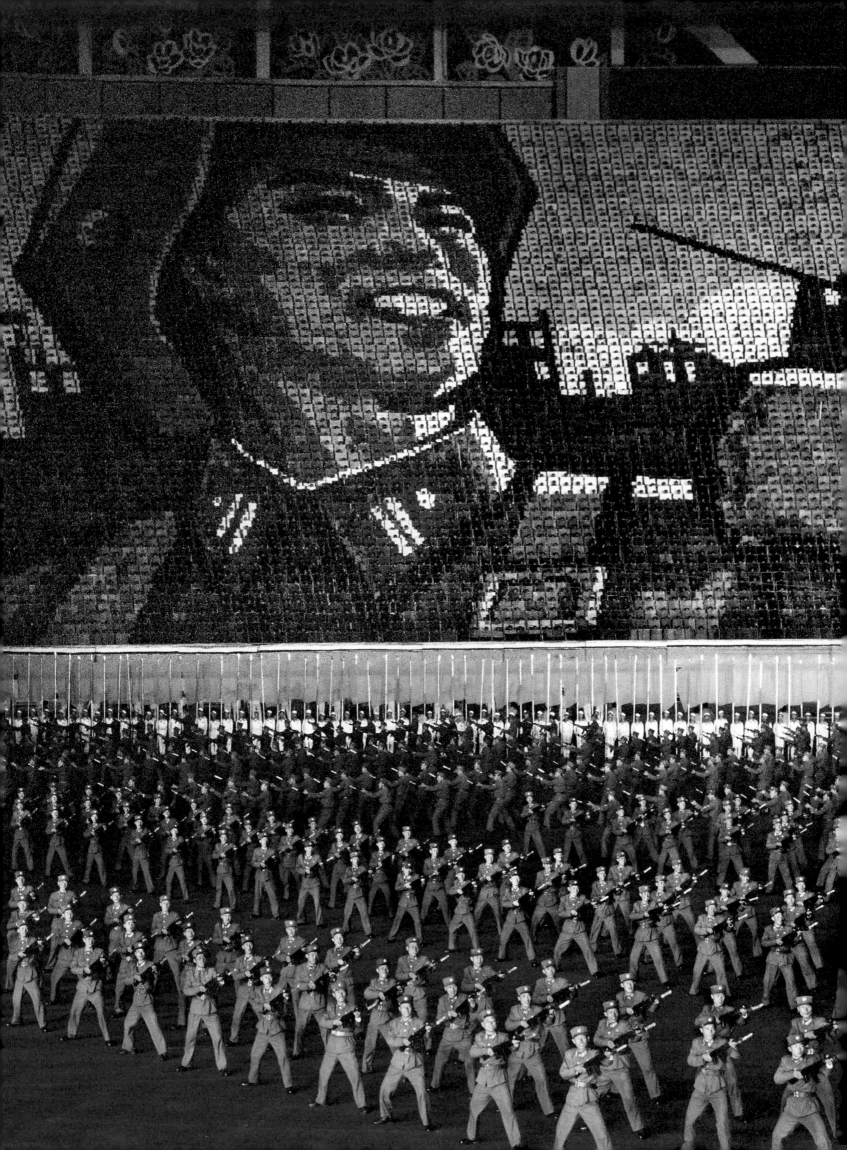

OPPOSITE:
Soldiers perform at the Arirang Mass Gymnastic and Artistic Performance in May Day Stadium.

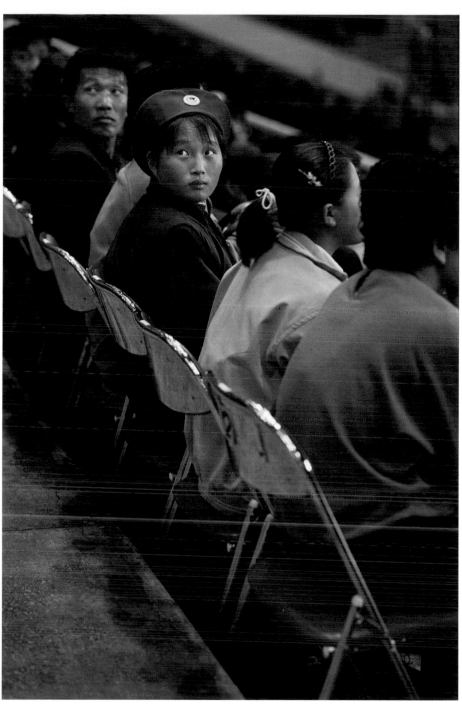

Audience members.

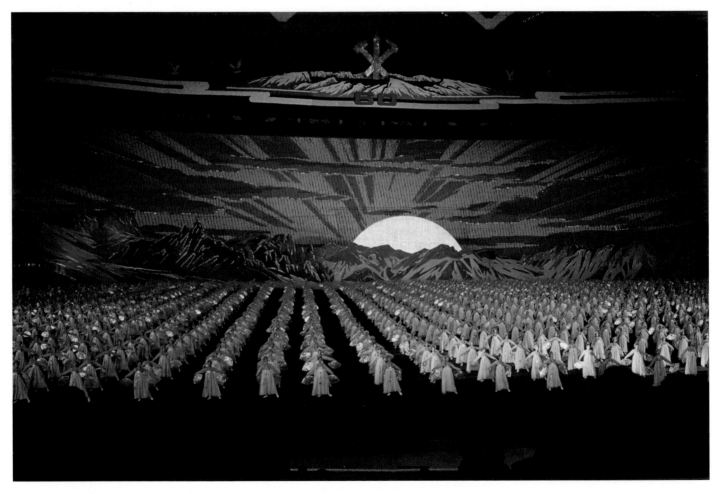

ABOVE AND OPPOSITE:
Scenes from the games.

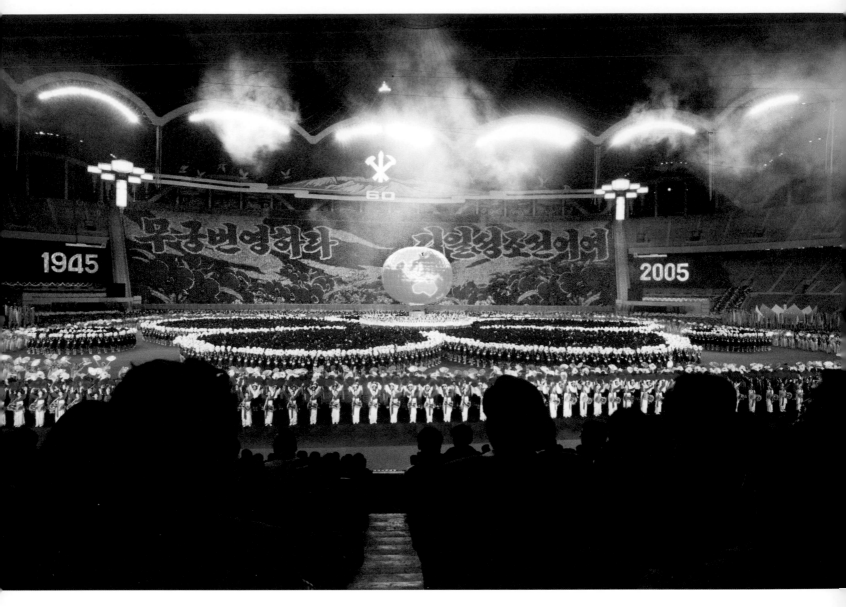

Smoke from fireworks above the stadium.

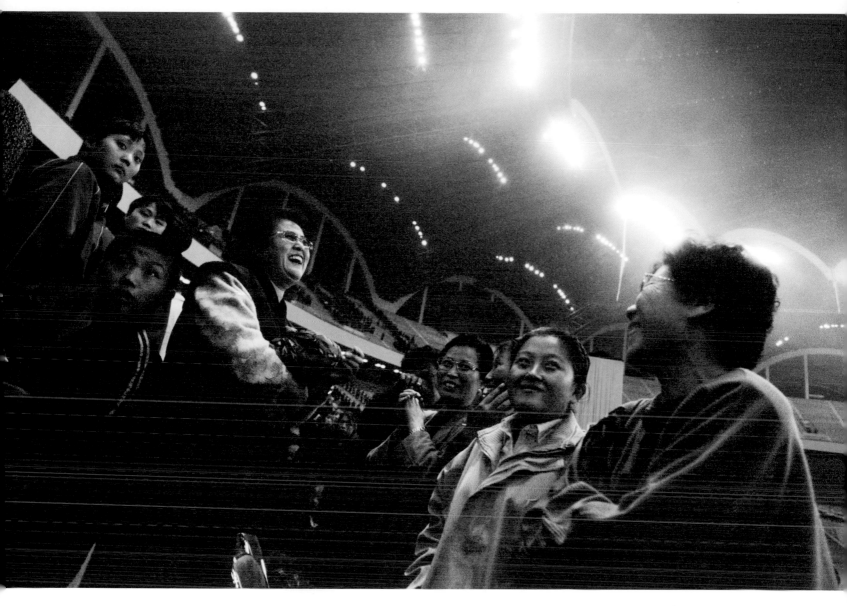

After the performance.

MANGYONGDAE SCHOOLCHILDREN'S PALACE

The Mangyongdae Schoolchildren's Palace, a magnificent 690-room building featuring marble columns and massive chandeliers, opened in 1989 as a school for children who excel in the arts. An estimated 12,000 students a day use the facility, which features an Olympic-size swimming pool, gymnasiums, a library of 100,000 books, and a 2,000-seat theater. Group classes feature instruction in music, dance, calligraphy, embroidery, Taekwondo, and a range of other performing arts, crafts, and sports. The school also serves as a showcase stop for tours and foreign dignitaries such as South Korean President Kim Dae Jung and First Lady Lee Hee-ho, who were treated to an accordion recital and other performances—as well as gifts created by students on the theme of reunification—during their 2000 visit. Much of the music repertoire and art is focused on venerating North Korea's history and leadership.

OPPOSITE:
A dance rehearsal studio at the Mangyongdae Schoolchildren's Palace. The text on the wall, quoting Kim Il Sung, stresses the importance of maintaining good physical and mental health for dance students.

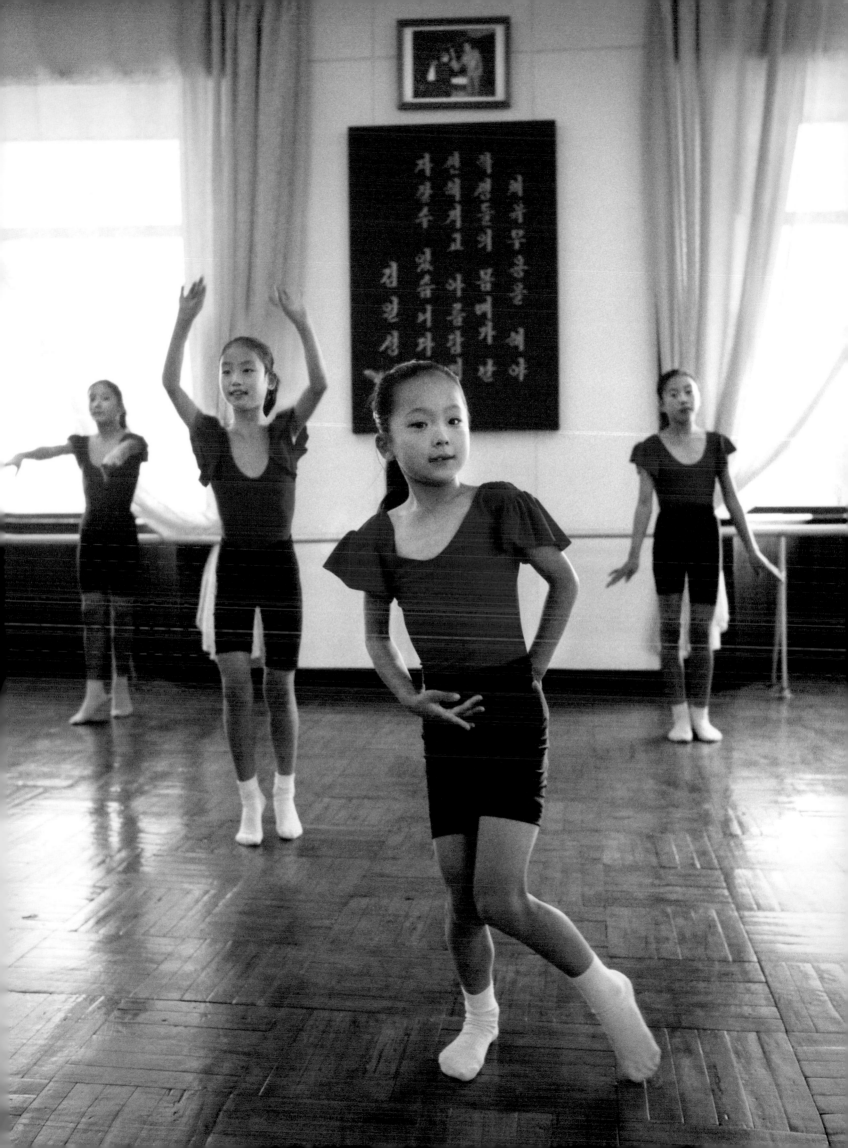

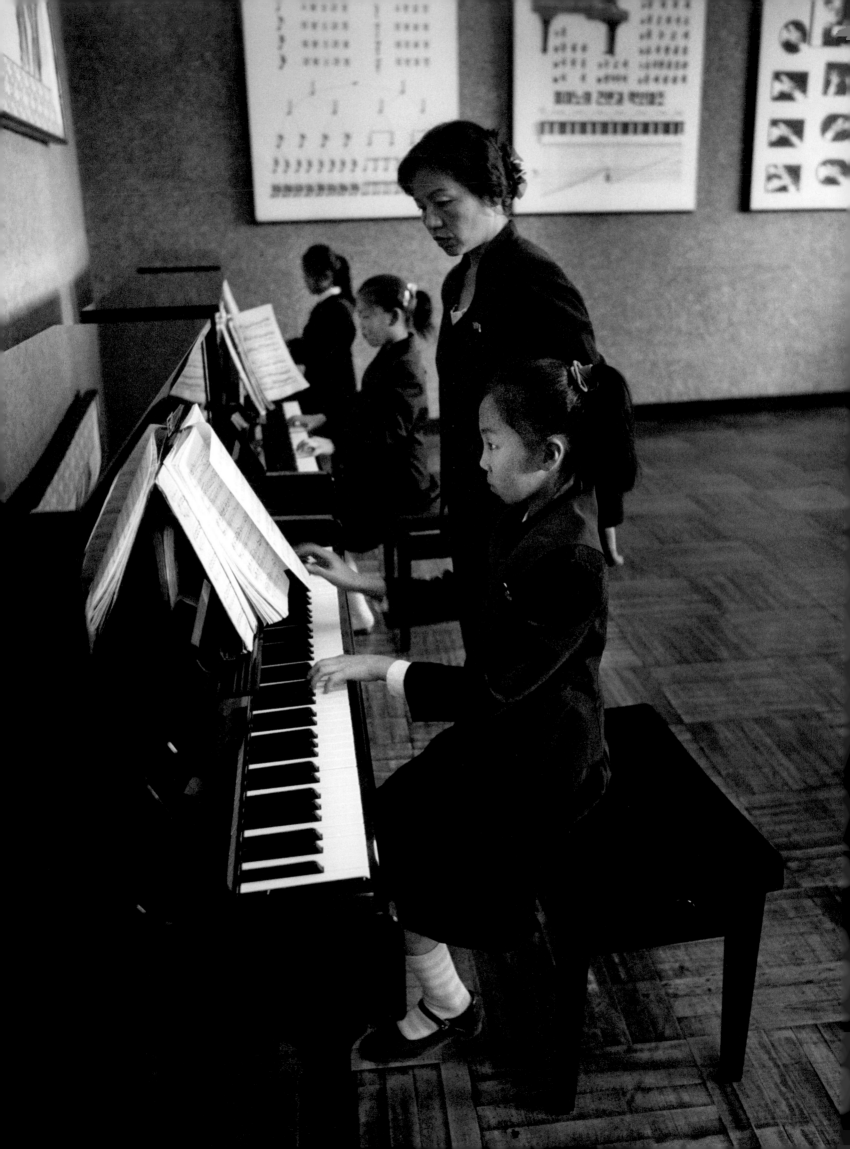

OPPOSITE:
Piano lessons.

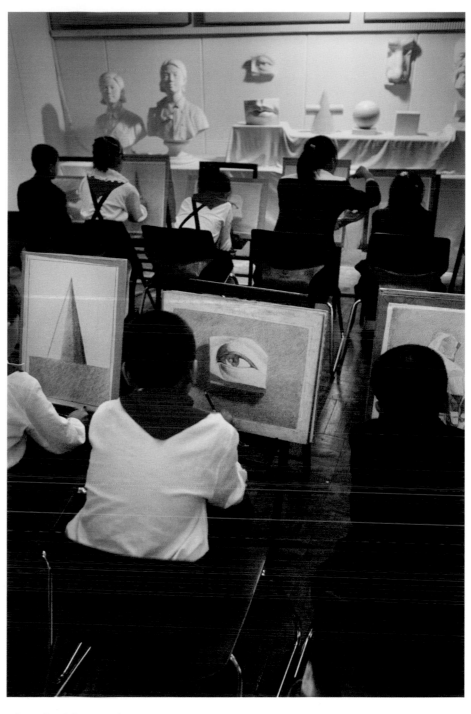

After-school drawing class.

OPPOSITE:
Mangyongdae Schoolchildren's Palace
tour guides.

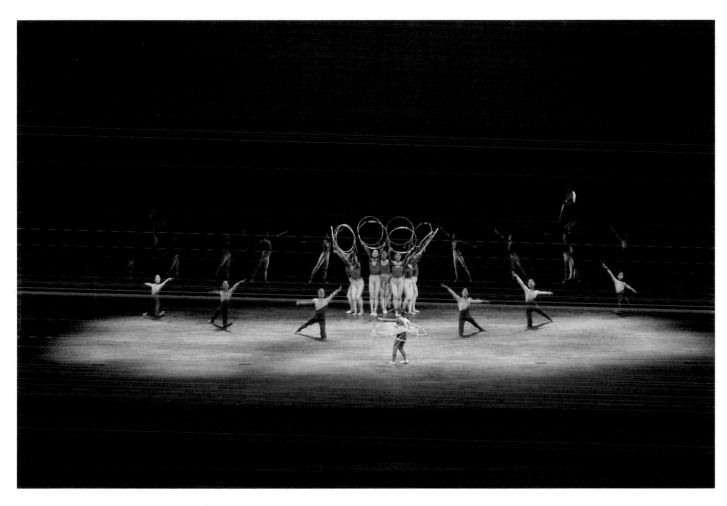

A performance in the school's state-of-
the-art, 2,000-seat theater.

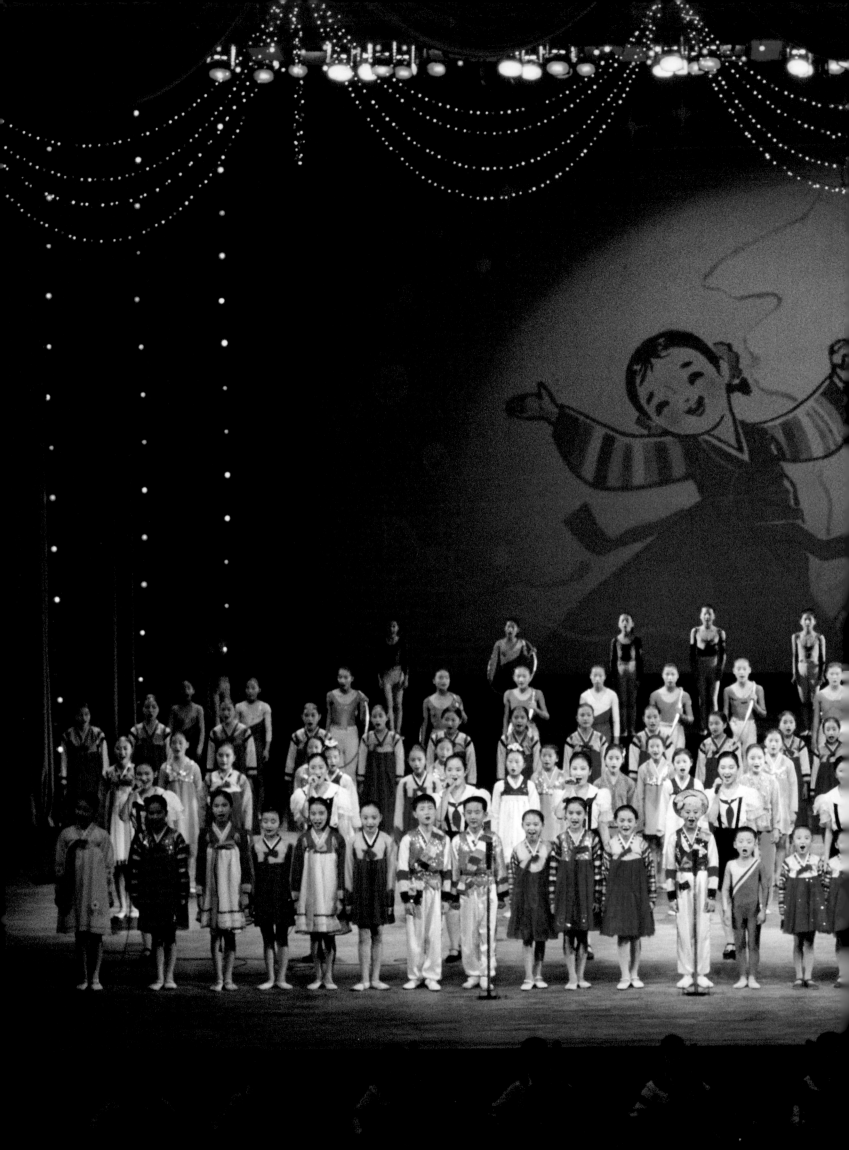

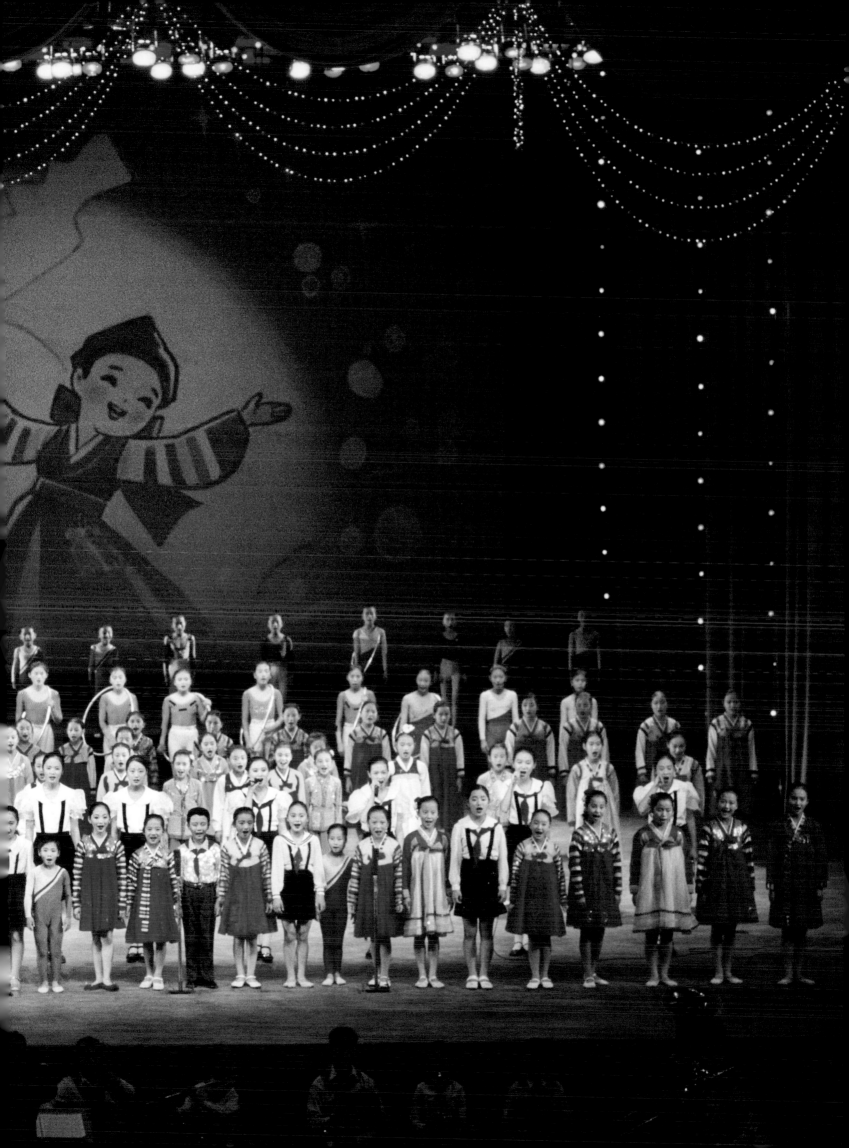

PREVIOUS SPREAD:
Ninety-minute recitals of highly
choreographed singing, dancing,
and acrobatics are held for visiting
guests to the school.

OPPOSITE:
A magnificent chandelier in the
Mangyongdae Schoolchildren's Palace.

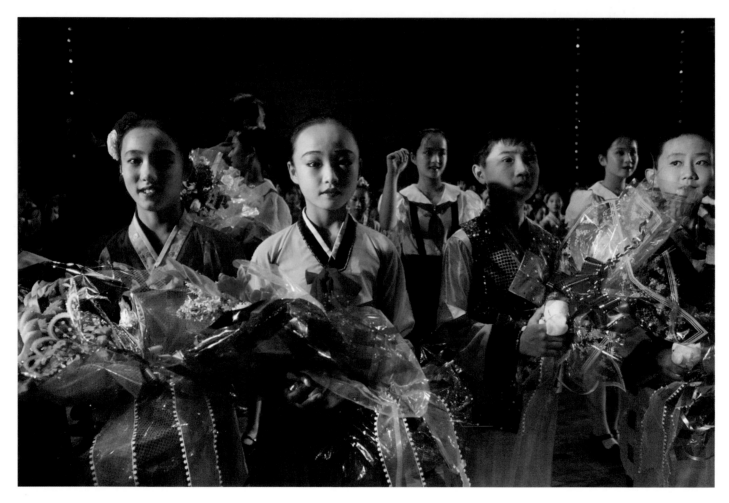

Backstage, children hold flowers
and gifts presented to them after a
spectacular performance.

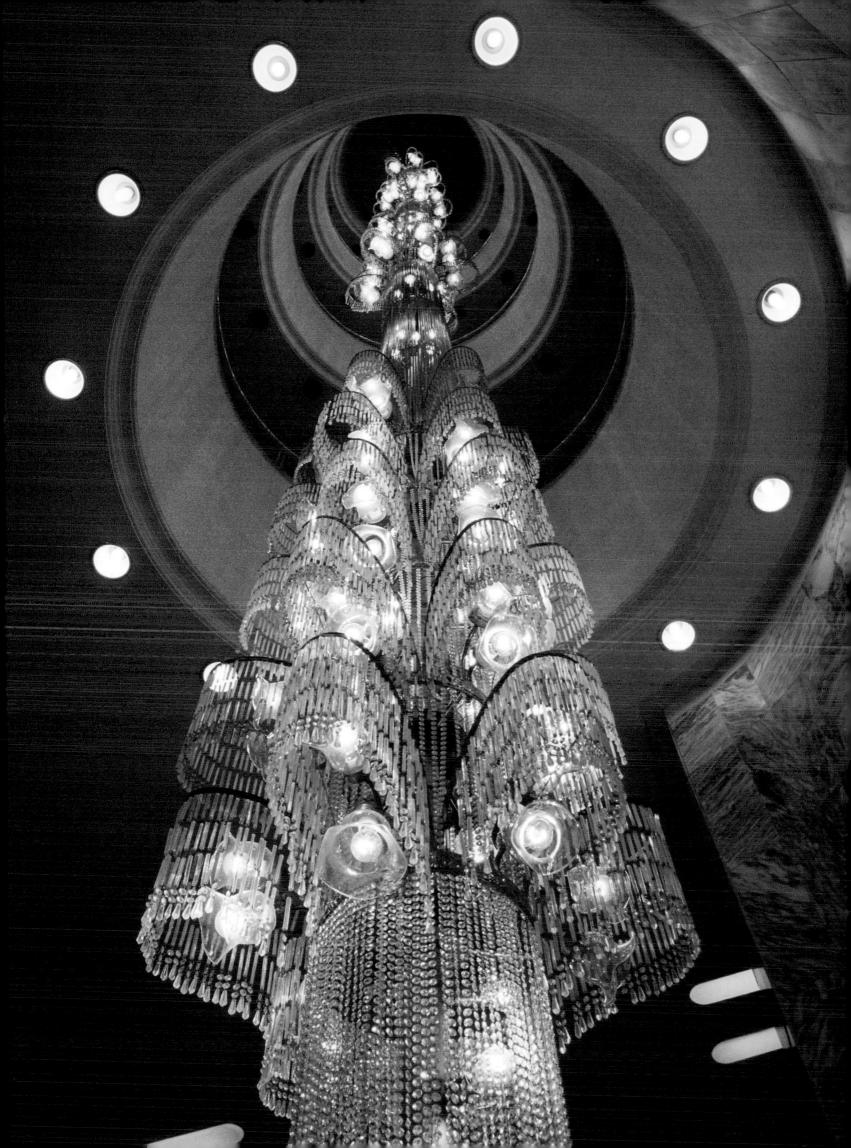

KOREA FEATURE
FILM STUDIO

Established in 1947, the Korea Feature Film Studio in its first twenty years produced films extolling the virtues of Kim Il Sung and the Juche Idea (a philosophy of nationalistic self-reliance that amounts to a state religion), often featuring North Koreans triumphing over the Japanese, the Americans, and the South Koreans. The titles were different (*My Village, The Flower Girl,* and *Sea of Blood*), but the basic themes were essentially the same.

In 1966, Kim Il Sung's son, Kim Jong Il, assumed supervision of the studio. In his book *On the Art of the Cinema* (1973) Kim Jong Il writes: "The task set before the cinema today is one of contributing to people's development into true communists . . . this historic task requires, above all, a revolutionary transformation of the practice of directing." To accomplish this, he sought to bring a fresh stable of North Korean directors and writers to the industry.

Kim Jong Il's love of cinema—it is believed that he has a library of twenty thousand Hollywood films—led to one of the more bizarre incidents that have resulted from the division of the Korean peninsula. In January 1978, South Korean actress Choi Eun Hee was lured to Repulse Bay, Hong Kong, to discuss an acting job when she disappeared. Six months later, her husband, legendary film director Shin Sang Ok, also vanished during a trip to Hong Kong. Considered the father of modern cinema in postwar Korea, Shin was subdued and kidnapped after a sack filled with a chloroform-like substance was pulled over his head.

Both had been abducted by North Korean agents. This type of "recruitment" was not new to the North. Eleven Japanese citizens had been kidnapped in the late 1970s and 1980s to act as cultural advisers and language teachers. Several died in captivity.

In his memoirs of his time in the DPRK, Shin wrote of spending four years in an all-male prison camp after an early escape attempt, "living on a diet of grass, salt, rice, and party indoctrination," not knowing if his wife was dead or alive.

In 1983, Shin and Choi were released and reunited at a reception hosted by Kim Jong Il, who blamed their unfriendly welcome on misunderstandings by thoughtless officials. He then explained why they were there: "The North's filmmakers are just doing perfunctory work. They don't have any new ideas. Their works have the same expressions, redundancies, and the same old plots. All our movies are filled with crying and sobbing. I didn't order them to portray that kind of thing." It was explained that Shin and Choi had been brought to the DPRK to revitalize its film industry.

When it came to choosing subject matter, Shin later told the *Seoul Times* that there were "fewer restrictions than is commonly believed." Still, all ideas were approved and developed in story conferences with Kim Jong Il.

Ironically, Shin considers his 1984 North Korean film *Runaway*, the story of a Korean family in 1920s Manchuria dealing with Japanese oppression and the dishonesty of their neighbors, to be the best film of his career. For his next film, Shin created a North Korean version of Godzilla, *Pulgasari* (1985), at Kim's request, enlisting the assistance of several monster-movie veterans from Japan to come to his North Korean studio, including Kenpachiro Satsuma, the second actor to wear the Godzilla suit, in the title role as Pulgasari. The creature, a tiny figure created by an imprisoned fourteenth-century blacksmith, comes to life and grows to enormous size through its insatiable appetite for iron, leading a group of starving farmers in an assault on an oppressive king's fortress

and army. Thousands of North Korean soldiers served as extras for the film.

Shin's next film was to be an Asian version of *The Conqueror*, a Hollywood film in which John Wayne portrays Genghis Khan. (Shin said he was "sickened" at the sight of American actors portraying Asians.) Pleased with the results of *Pulgasari*, Kim immediately green-lighted the project, and arrangements were made for a joint venture production with international distribution by an Austrian company. Shin and Choi were allowed to travel to Vienna for a business meeting in 1986; seizing the opportunity for escape, they enlisted the help of a friend who was a Japanese film critic. Ostensibly meeting for lunch, Shin and Choi fled by taxi to the American embassy, shaking off their North Korean escort, who pursued them in another taxi. They were granted asylum and returned home, where Shin continued to make films until he died in 2006.

Despite the loss of Shin, the Korea Feature Film Studio soldiers on, producing about forty films annually, with six other facilities wrapping another forty features every year. North Korean films are seldom seen outside the country, except for screenings at socialist film festivals, but they are widely seen within the North, either in the state-run cinemas or on the nation's two television channels. No outside television programming is allowed in North Korea, and all radios are sold with dials fixed to state stations.

On the Art of the Cinema is required reading for North Korean film directors. In the opening paragraph Kim Jong Il writes: "The freer man is from the fetters of nature and society and from worries over food, clothing, and housing, the greater his need for art and literature. Life without art and literature is unimaginable."

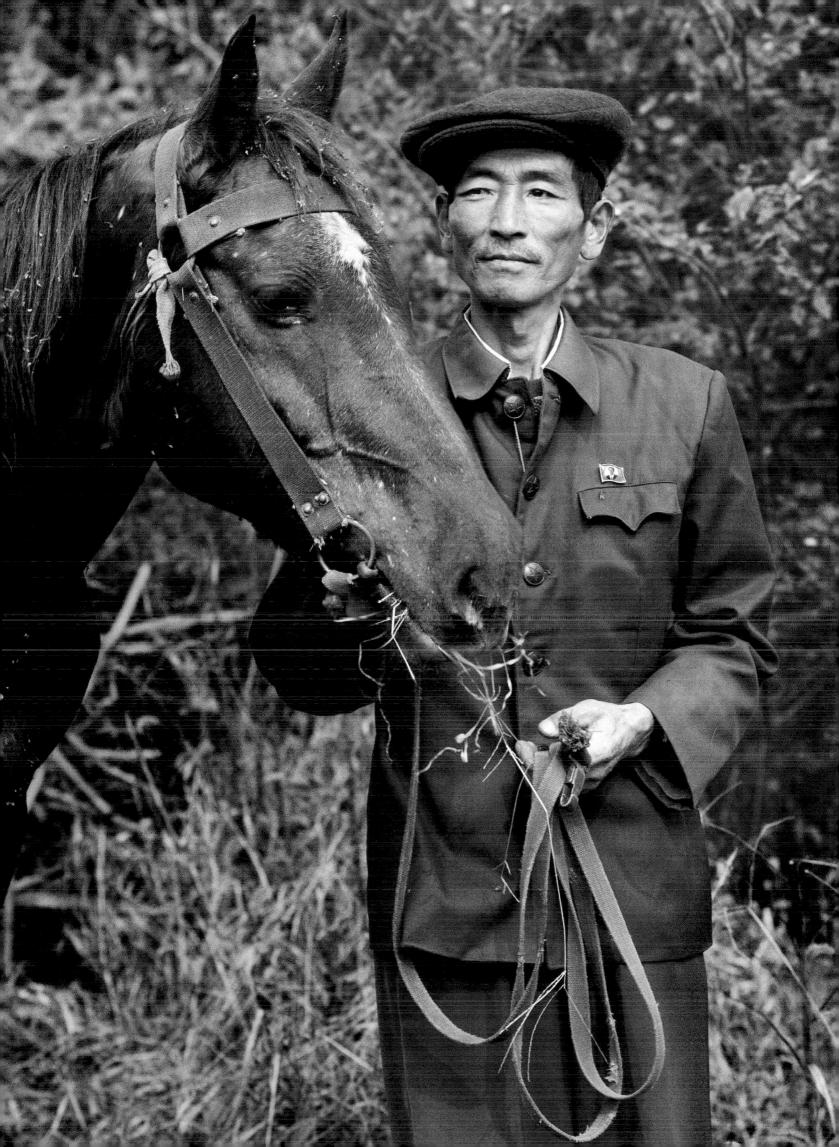

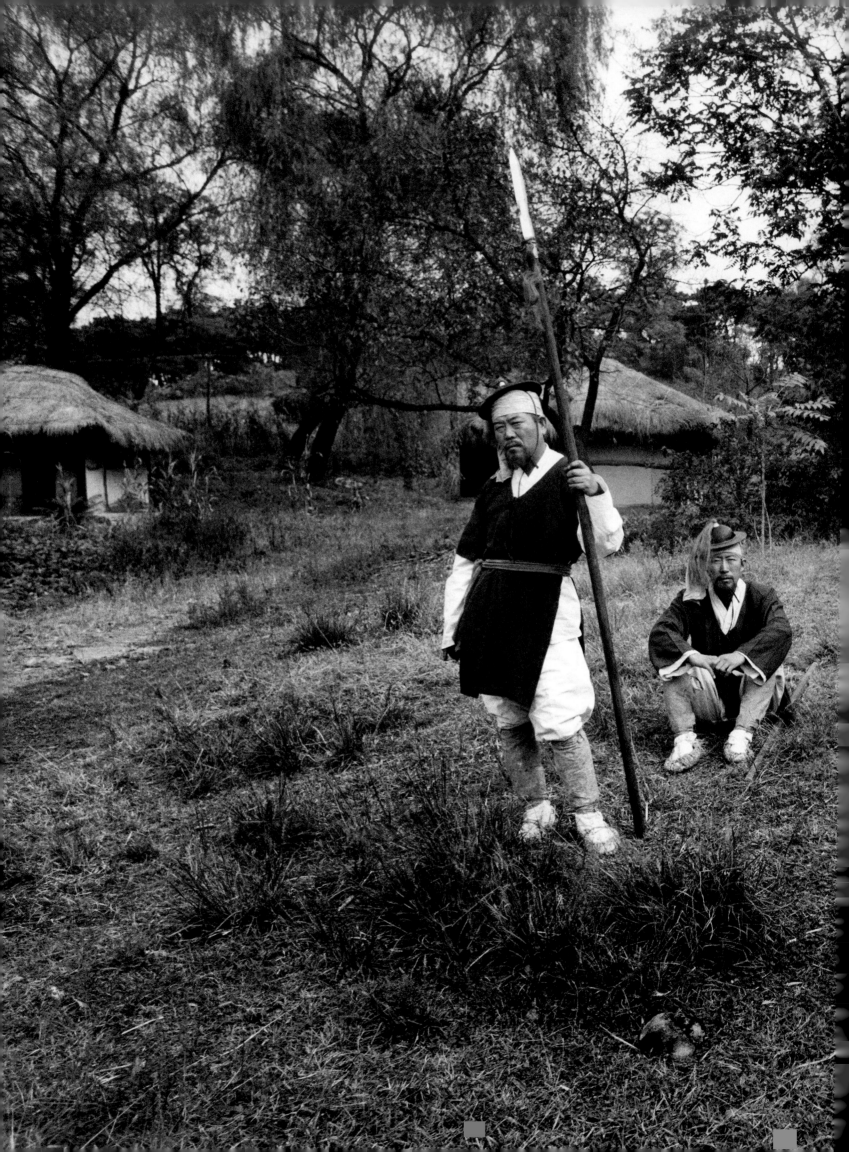

OPPOSITE:
An actor in period costume between scenes
on the Korea Feature Film Studio backlot.

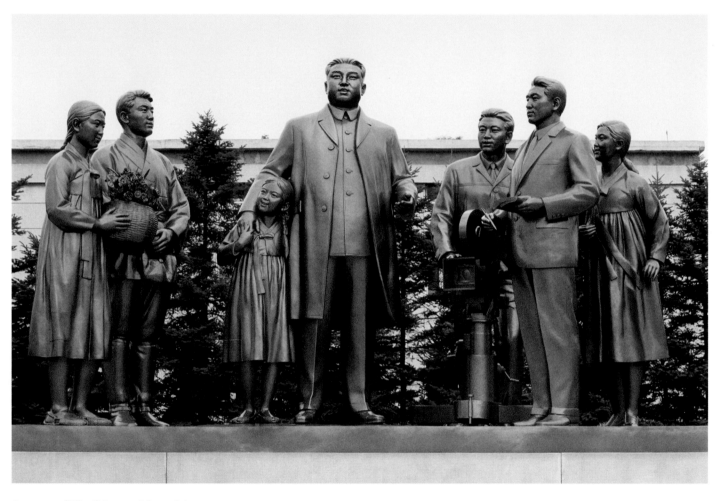

A statue of Kim Il Sung, giving advice
on a movie set, in the central courtyard of
the Korea Feature Film Studio.

USS *PUEBLO*

Harbored at a quiet bank on the Taedong River in Pyongyang is one of North Korea's proudest accomplishments in its war of the wills with the United States.

The 850-ton USS *Pueblo* was built at Kewaunee, Wisconsin, in 1944 as U.S. Army cargo ship FP-344, and transferred to the Navy and renamed *Pueblo* in April 1966. Initially designated a light cargo ship (AKL-44), the *Pueblo* was converted to a research vessel and redesignated AGER-2 shortly before commissioning in May 1967. Following training operations off the U.S. West Coast, the *Pueblo* departed for the Far East in November 1967 to undertake electronic intelligence collection and other duties.

Sailing out of Yokosuka, Japan, on January 5, 1968, with a brief stop at Sasebo Naval Base, Japan, the ship crossed frigid and stormy seas in the Sea of Japan to a position in international waters about fifteen miles off the coast of North Korea. As part of Operation Clickbeetle—the codename for electronic and radio intelligence gathering by small noncombatant naval ships that operated close to potential enemies—the USS *Pueblo* had been tasked to collect intelligence signals in the Sea of Japan using the cover of conducting hydrographic research.

On January 23, 1968, off Wonsan, North Korea, four North Korean torpedo boats circled the *Pueblo* and ordered it to follow them into port. Captain Lloyd "Pete" Bucher, the *Pueblo*'s commanding officer, ordered the ship farther out to sea, but the North Koreans opened fire, killing one crew member and injuring seventeen.

A slow vessel, armed only with a few .50-caliber machine guns, the *Pueblo* was not prepared for combat. Bucher surrendered the ship after stalling his pursuers for sixty-five minutes, inadequate time to destroy the vessel's surveillance equipment and classified material on board.

The defensive cover that was to have been provided by the Navy and the Air Force in response to calls from the *Pueblo* never came. The surviving eighty-two men on board were taken prisoner and charged with intruding into North Korean territorial waters, a claim vigorously denied by the United States. After several months, with no help in sight, Captain Bucher and other crew members reluctantly signed documents confessing that the ship was spying on North Korea. Both captain and crew later recounted torture at the hands of the North Koreans. To signal that the confessions were forced, the sailors listed fictional accomplices, including the television spy character Maxwell Smart. When forced to pose for a photo, some crew members extended their middle fingers to the camera, explaining to the North Korean photographer that this was a Hawaiian good-luck sign. The sailors later recounted suffering a week of particularly brutal torture after the photo was published and the North Korean guards realized they'd been had.

Just a week after the ship was taken by North Korea, the Tet Offensive in Vietnam exploded on the front pages and televisions of America, consuming the administration's attention. The chairman of the U.S. House Armed Services Committee urged retaliation for the seizure by dropping a nuclear bomb on a North Korean city—thankfully a proposal not heeded. Instead, the United States urged the U.N. Security Council to condemn the capture and pressured the Soviet Union to negotiate with the North Koreans for the ship's release.

The ship's capture was a special propaganda coup for North Korea. Point made, the North Koreans released the prisoners after eleven months and returned the body of one crewman who died in captivity. The *Pueblo*'s crew were repatriated through Panmunjeom on December 23, 1968.

The ship was retained by North Korea as a trophy, though it is still technically the property of the U.S. Navy. The *Pueblo* was exhibited at Wonsan and Hungham on the country's east coast for three decades. Judging that the symbolism might be better if the ship were moved to the capital, Kim Jong Il ordered the North Korean navy to sail the vessel, in disguise as a freighter under a North Korean flag, through international waters around South Korea to the west coast of North Korea and then upriver, arriving in Pyongyang in 1999. The ship is now a floating museum on the Taedong River. It is docked at the approximate site where, in 1866, the American trading ship *General Sherman* was set afire and its crew killed by soldiers after they failed to heed warnings that trade with Korea, and the proselytizing by a Protestant missionary on board, were illegal, and the *Sherman*'s crew seized a Korean deputy commander as a hostage. The incident symbolized and justified the idea that Western intrusion should be met with suspicion and, perhaps, with force.

OPPOSITE:
Bullet holes are highlighted in red by the North Koreans.

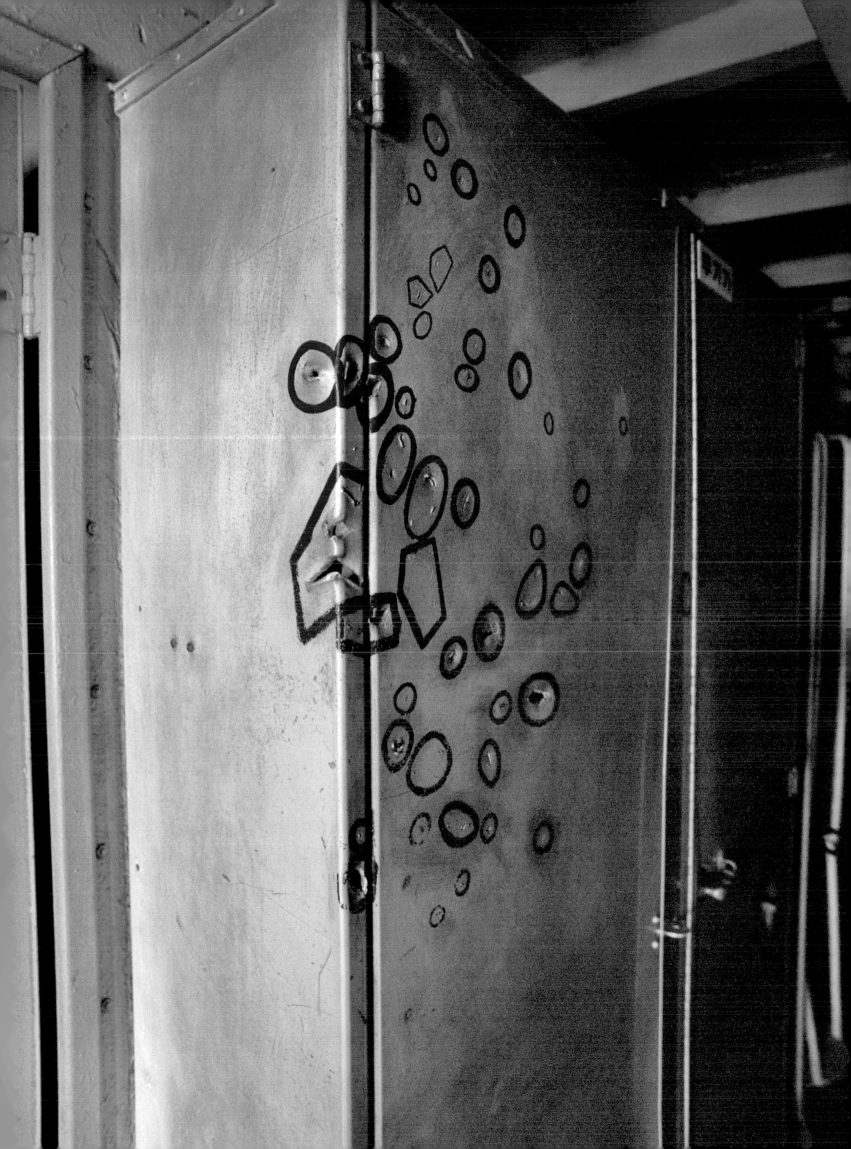

OPPOSITE:
A North Korean sailor aboard the
USS *Pueblo*.

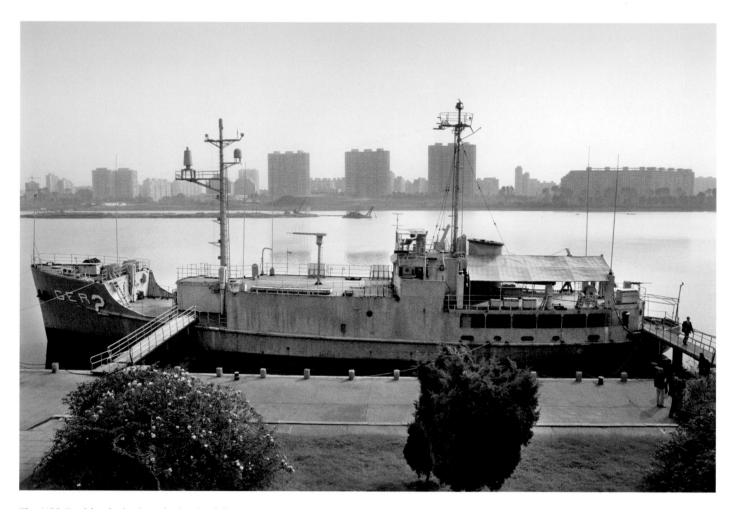

The USS *Pueblo*, docked on the bank of the
Taedong River and open for tourism.

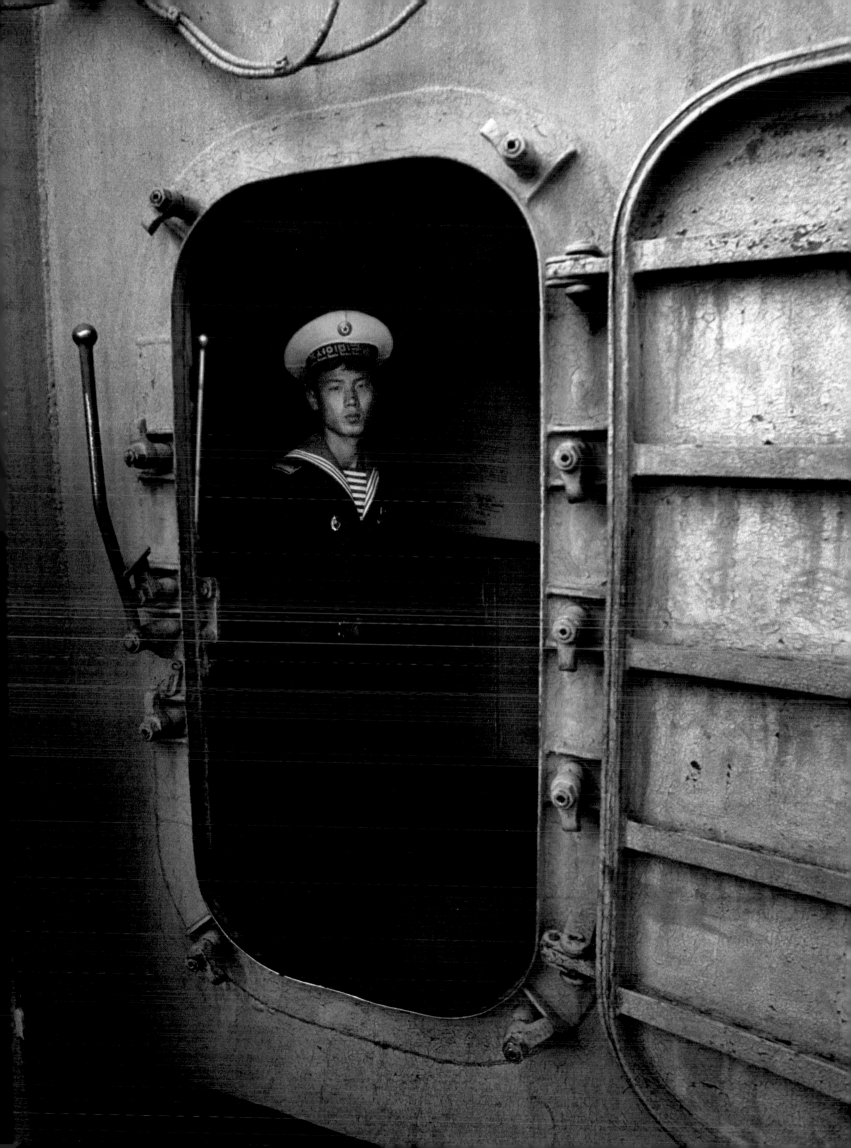

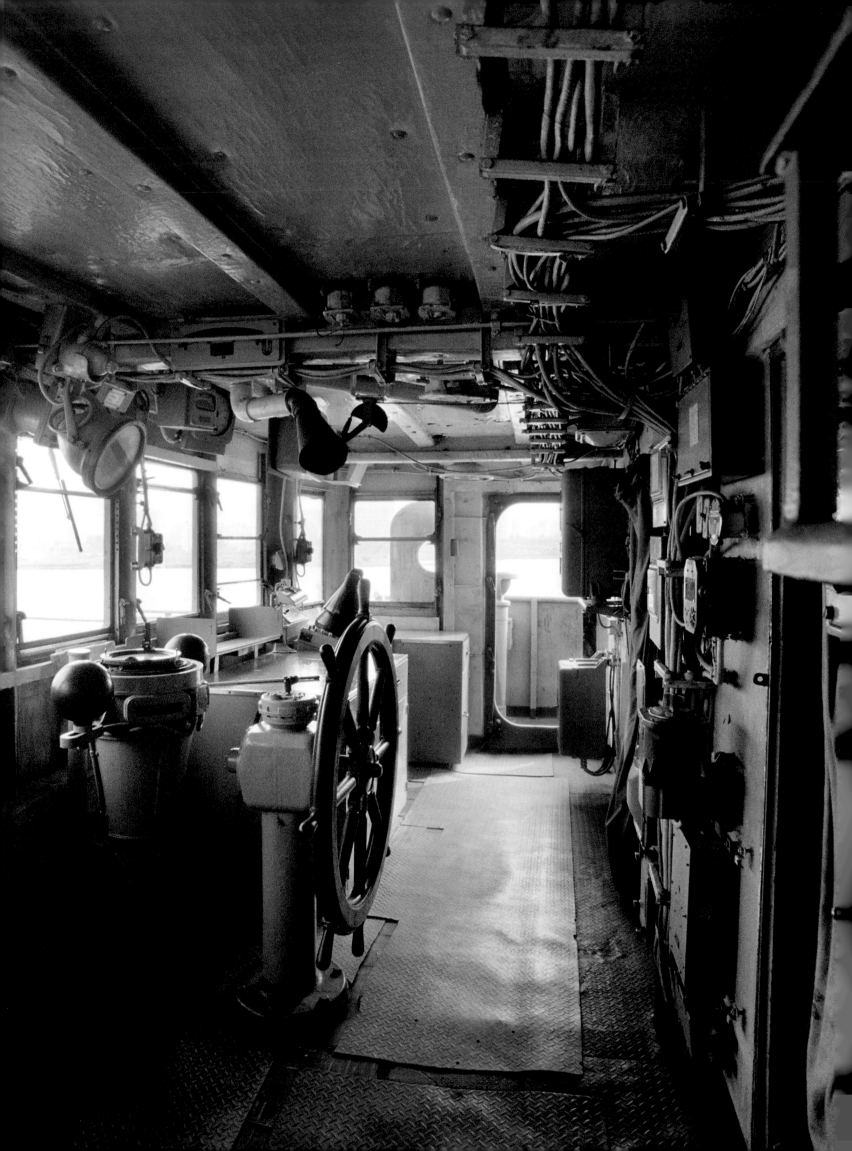

OPPOSITE:
The bridge of the USS *Pueblo*.

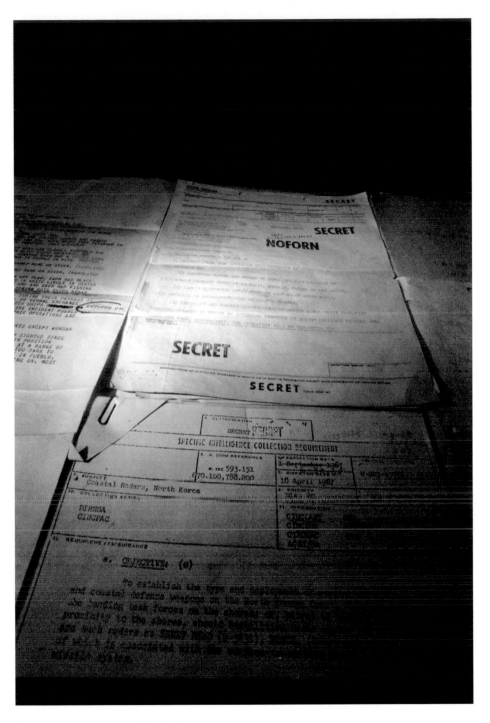

Secret documents seized during the
vessel's capture.

KAESONG

KAESONG WAS ESTABLISHED BY KING
Wan Kong in 932 as the capital of Korea
during the Koryo Dynasty (918–1392), until Ri
Taejo moved the capital to Hanyang, renaming
it Seoul, at the beginning of the Ri Dynasty
(also known as Chosen or Yi, 1392–1910).
In its time as the capital, with Buddhism as its
official religion, Kaesong thrived as a trade
and business hub and evolved into a wealthy
and sophisticated metropolis. Once a walled
city (little of the walls now remain), its name
means "castle gate opening."

Though the city was designated by the
United States as off-limits to bombing during
the Korean War because of its historical
significance, the area was severely damaged
in military ground operations because of its
central location between North and South.

A city of approximately 335,000, Kaesong
currently hosts the Kaesong Industrial Complex,
a joint North-South economic zone in which
South Korean companies operate factories
and employ North Korean workers to produce
a range of goods for the South Korean market.
An hour's drive from Seoul, Kaesong is linked
to the South Korean capital by a four-lane
highway lined with barbed wire that cuts
across the DMZ, ending on the North Korean
side at a checkpoint manned by soldiers.
Opened in 2003, the complex is part of
the South Korean government's strategy of
engagement with the North. South Korean
supervisors live within the complex, returning
home about once a month, but are strictly
prohibited from interaction with North
Koreans beyond the course of business
activities. The two countries share high hopes
for development, announcing ambitions to
increase the number of workers employed
in the zone from several thousand to as many
as several hundred thousand by 2012,
and to take advantage of the city's cultural
importance by creating a tourist infrastructure
for South Korean visitors.

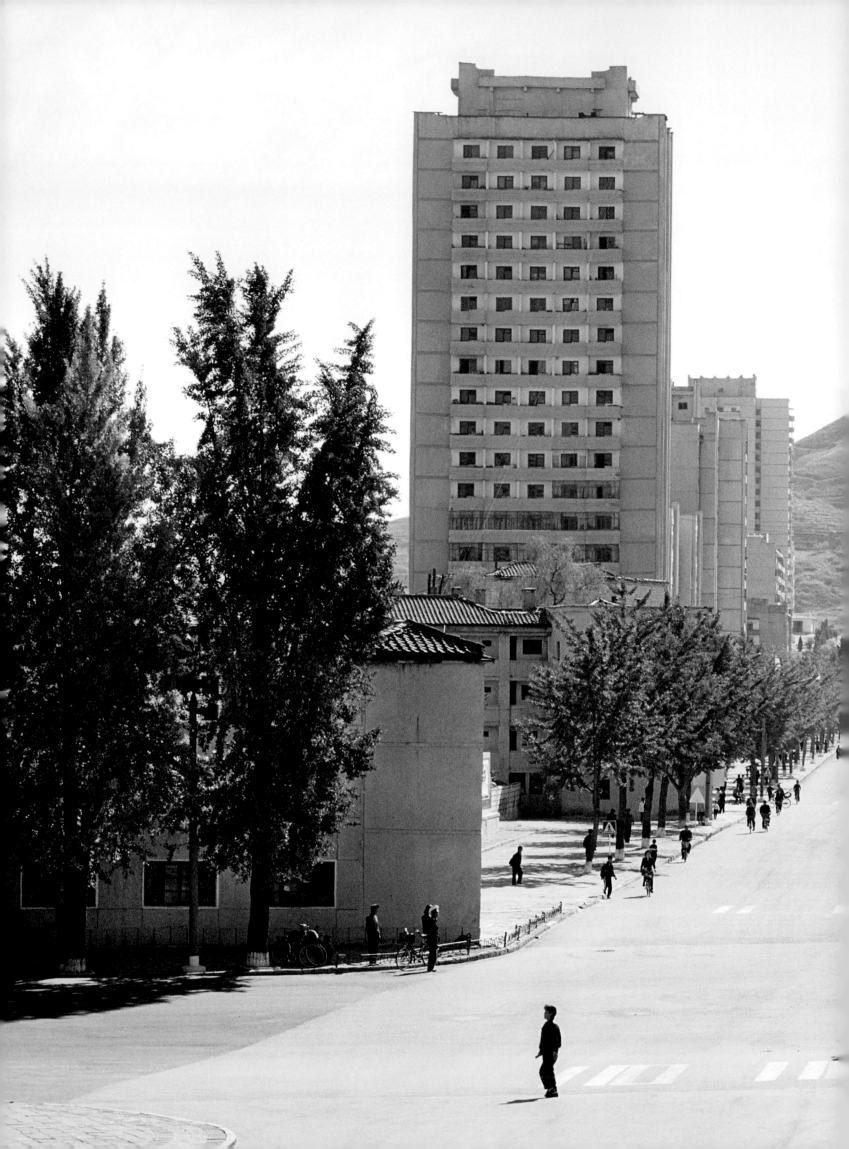

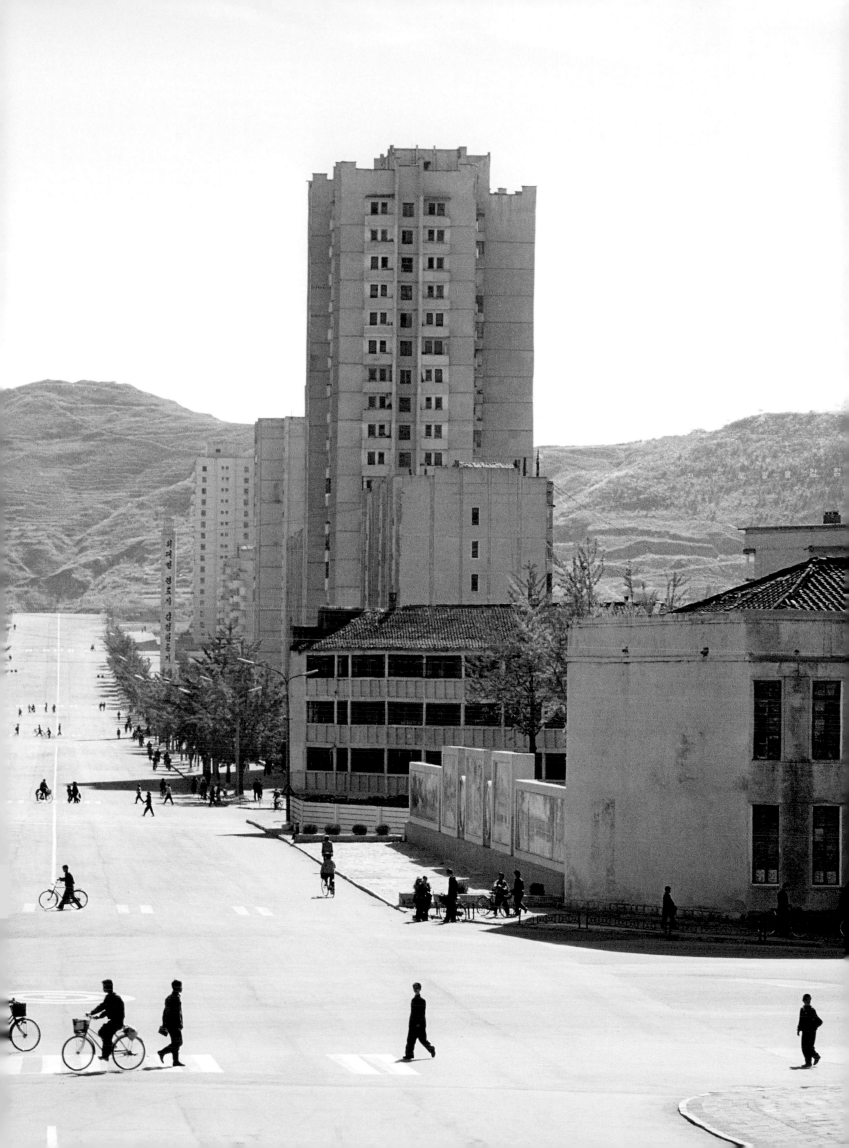

PREVIOUS SPREAD:
A view down Thongil Street, Kaesong's main thoroughfare. While Pyongyang has light vehicular traffic, Kaesong has virtually none.

OPPOSITE:
The Thongil Restaurant at the foot of Mt. Janam serves a variety of Korean dishes with local accents, such as *Kaesong posam kimchi* and *Kaesong yakbap*.

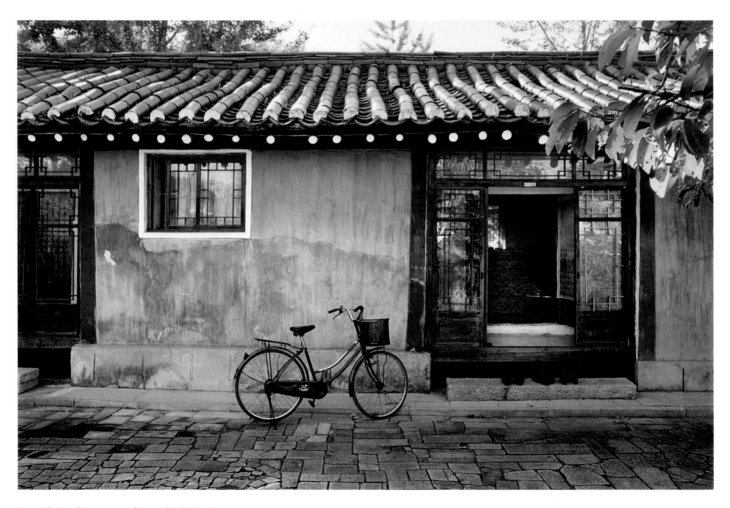

A traditional one-story house built during the Ri Dynasty, now part of the Kaesong Folk Hotel.

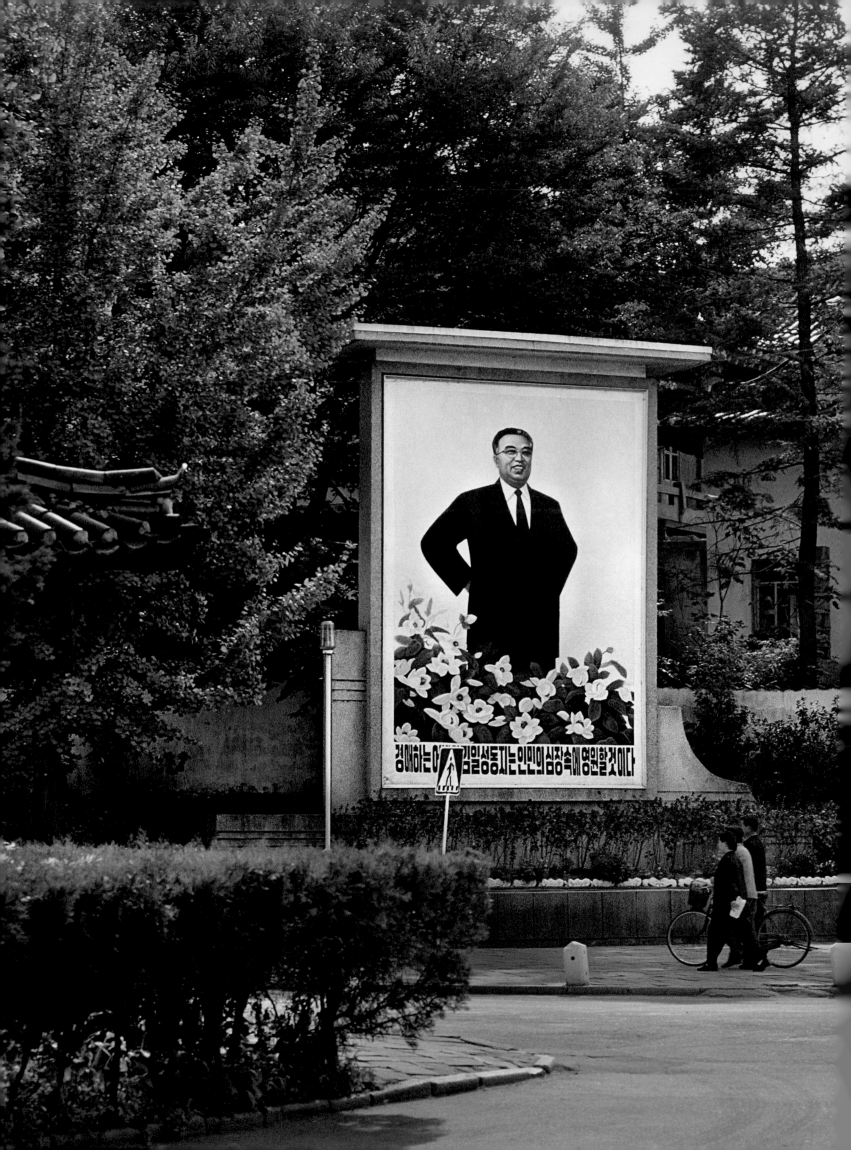

OPPOSITE:
Kim Il Sung overlooks a tree-lined
Kaesong street.

Young woman who works at a
souvenir and snack kiosk on the
highway near Kaesong.

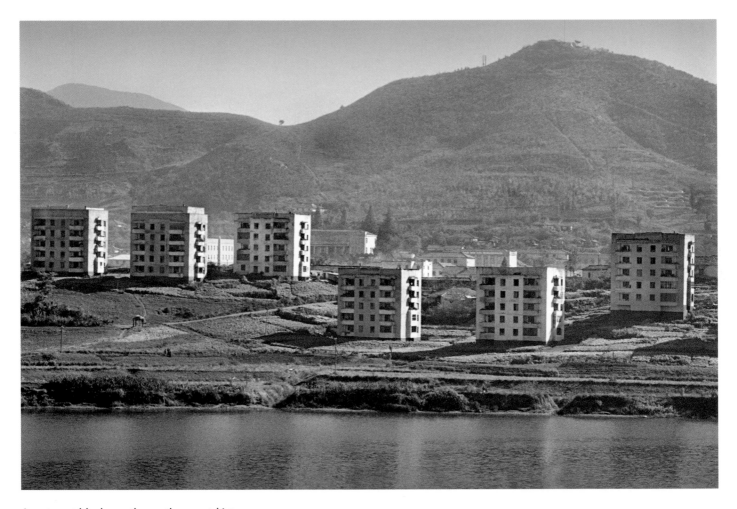

Apartment blocks on the northern outskirts
of Kaesong.

GEUMGANGSAN

"If I were to die the day after seeing Goryeo (Korea) Geumgangsan, I would have no regrets," said the Chinese Song Dynasty poet Su Shi (also known as Su Dong-Po, 1037–1101). This mountainous area, part of the Taebaek mountain range along the country's east coast, was considered sacred by Korean Buddhists for thousands of years (though religious practice in the DPRK has almost totally fallen away since the 1950s). Composed of thousands of rugged, glittering granite and diorite peaks, cliffs, steep ravines, waterfalls, and ancient Buddhist temples, Geumgangsan (which means "Diamond Mountains") is a region of breathtaking beauty that, until recently, had been off-limits to South Koreans and most foreigners for more than fifty years.

Opened on November 18, 1998, the Geumgang Mountain Tourist Project created a zone open to South Korean tourists. Reachable at first only by cruise ship and later also by an overland bus route across the DMZ, the fenced zone offers another opportunity for the South to visit the North (though as elsewhere, interaction with the North Koreans who work in the area is tightly restricted: a South Korean woman was arrested at the resort after suggesting that the South enjoyed a higher standard of living than the North). The project is the result of the passion of Hyundai Asan Corporation founder Chung Ju Yung, who was born in a small village in what later became North Korea, to try to find ways to bridge the gap between the countries. After Hyundai Asan spent more than $400 million to fund the project, nearly driving the company bankrupt, the South Korean government stepped in to continue subsidizing what has become a troubled but important symbolic enterprise.

Patrolled fences make clear where visitors are and are not allowed to go. A small village where many of the North Koreans who work at Geumgangsan live is visible in the distance beyond the fencing. Within the resort's boundaries are a hot spring, shopping areas, restaurants, hotels, and a new eighteen-hole golf course, offering incentive for South Koreans to visit and spend hard currency. Hiking trails, traveled with an escort, lead through the most spectacular scenery on the peninsula.

Closely monitored reunions of families separated between South and North have been held at Geumgangsan, organized by South and North Korean Red Cross officials and made possible by an inter-Korean summit in 2000. Since then, several group trips have reunited nearly 600 South and 300 North Korean family members—at least for a few days—and talks to build a dedicated reunion center on the site began in 2004.

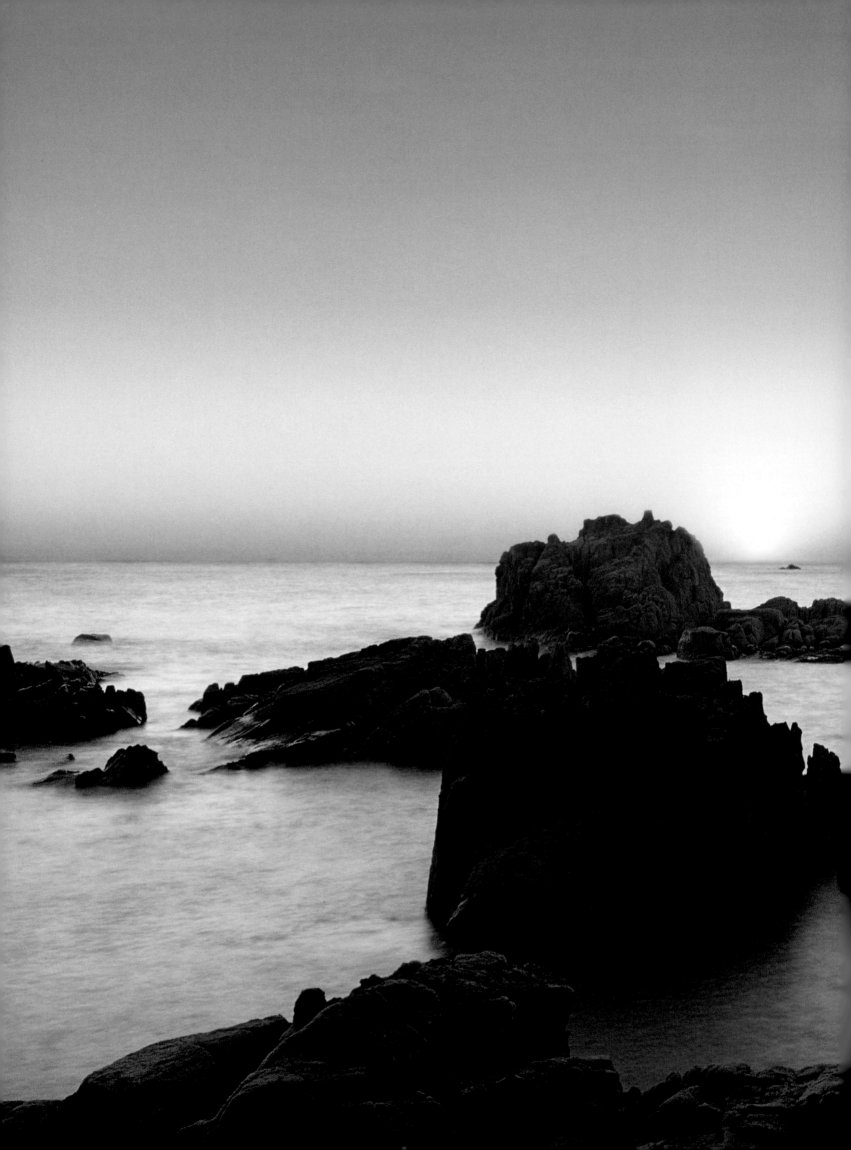

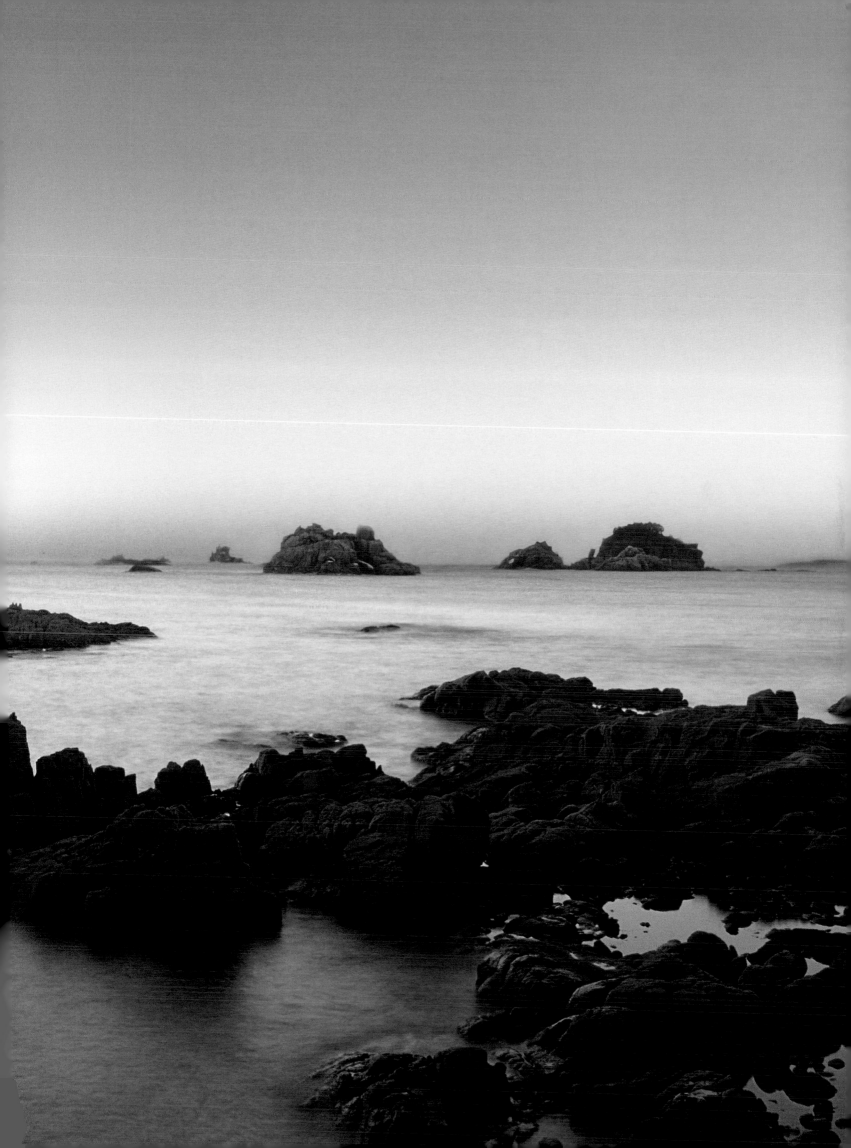

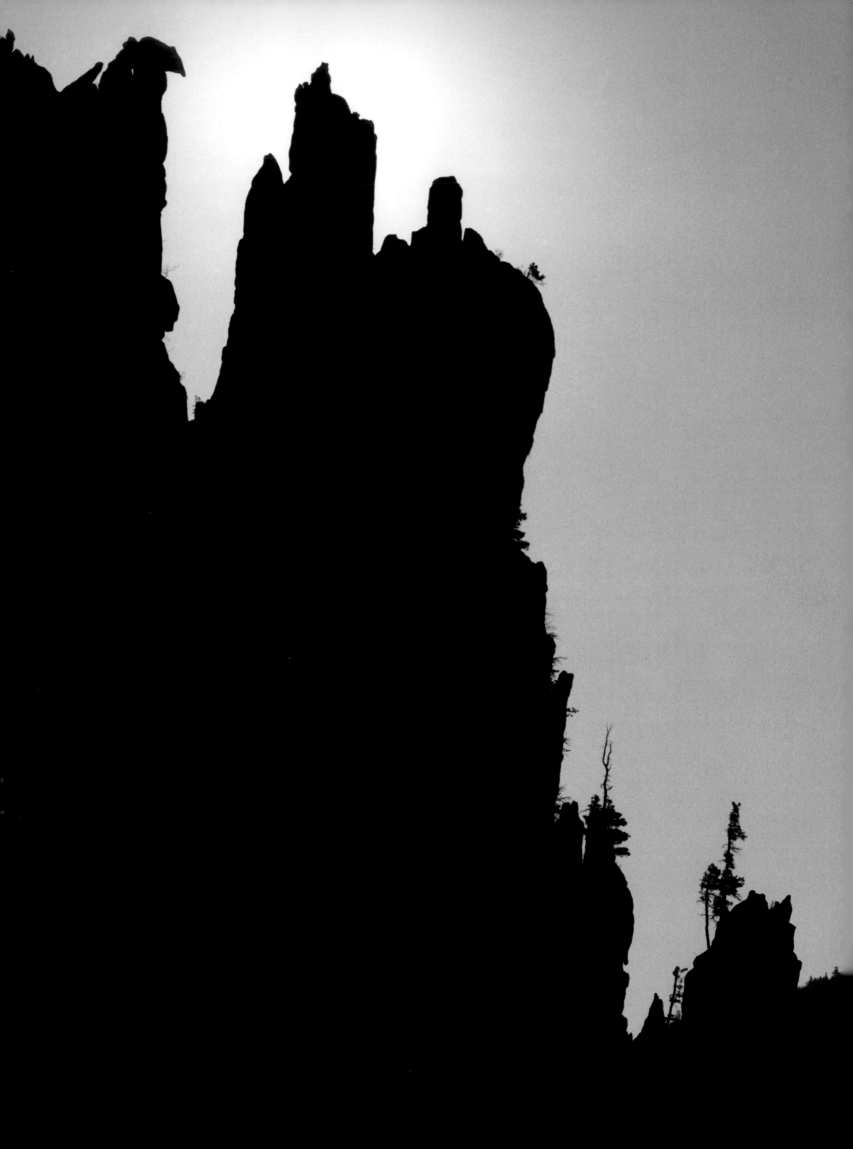

Silhouettes of the Manmulsang (Stone Images of Ten Thousand Things) area of the Geumgang Mountains. The name derives from the incredible assortment of natural stone images to be found here, with names such as Gwimyeonam (Demon-Faced Rock) and Samseonam (Rocks of Three Immortal Hermits).

Sunrise on the DPRK's east coast.

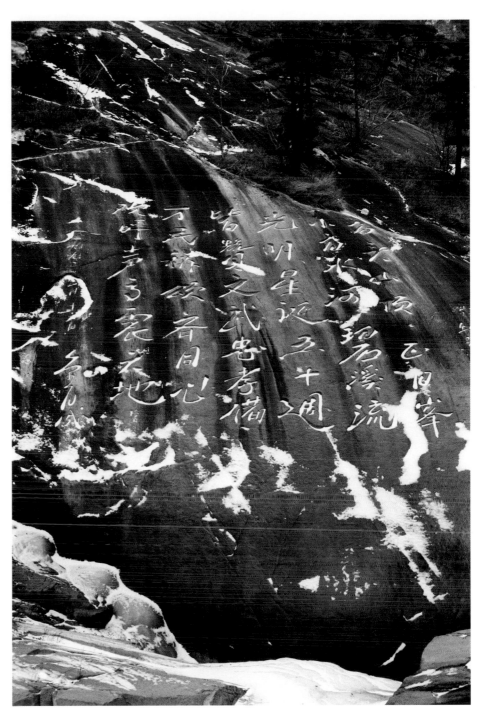

On massive boulders bracketing the Manpokdong and Ongnyudong valleys, short verses mixed with communist writings have become a part of the landscape, including this poem by Kim Il Sung praising the greatness of nature in Geumgangsan.

A restaurant at a trailhead in the Geumgang Mountains.

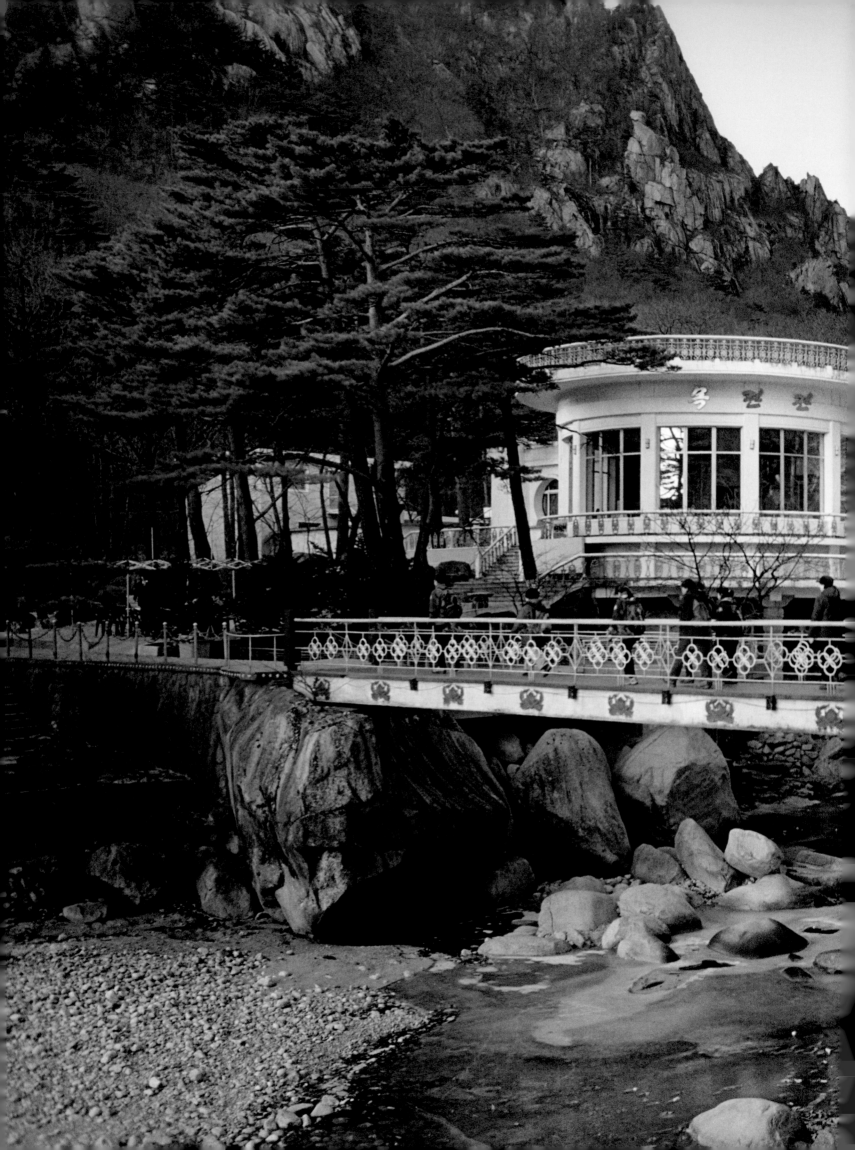

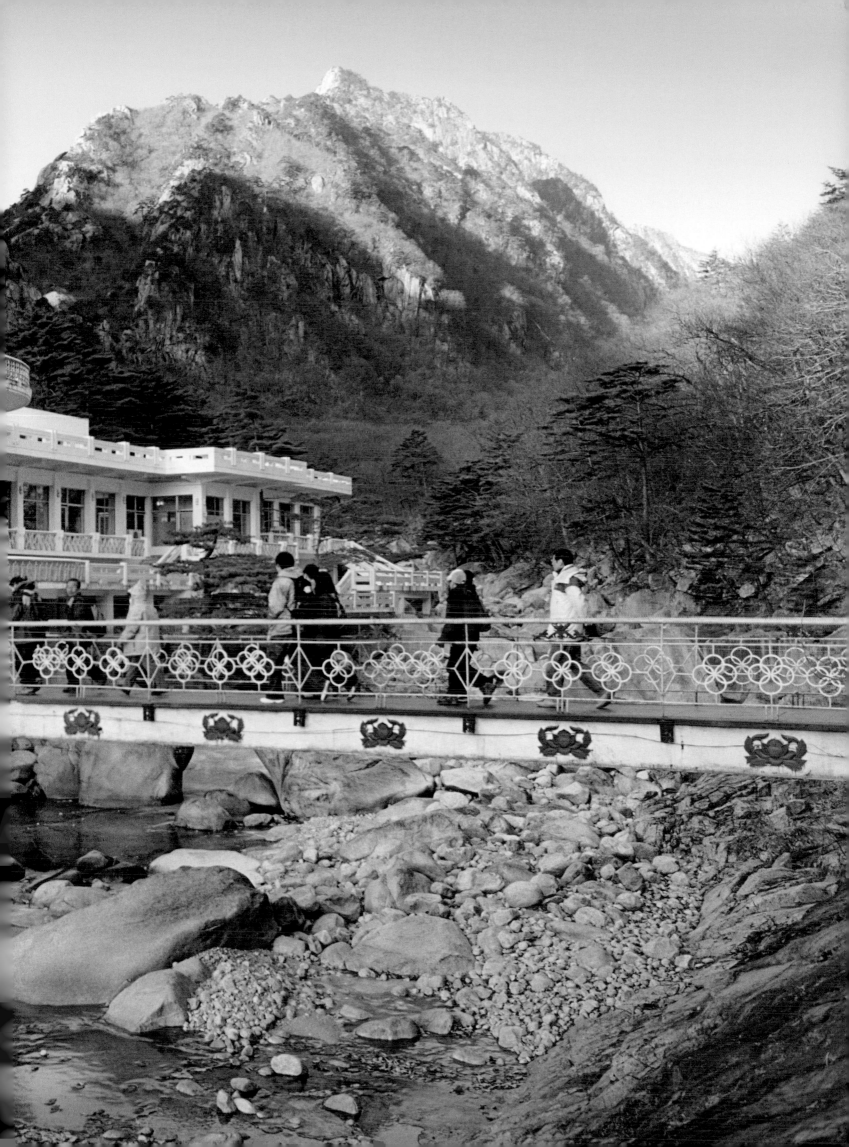

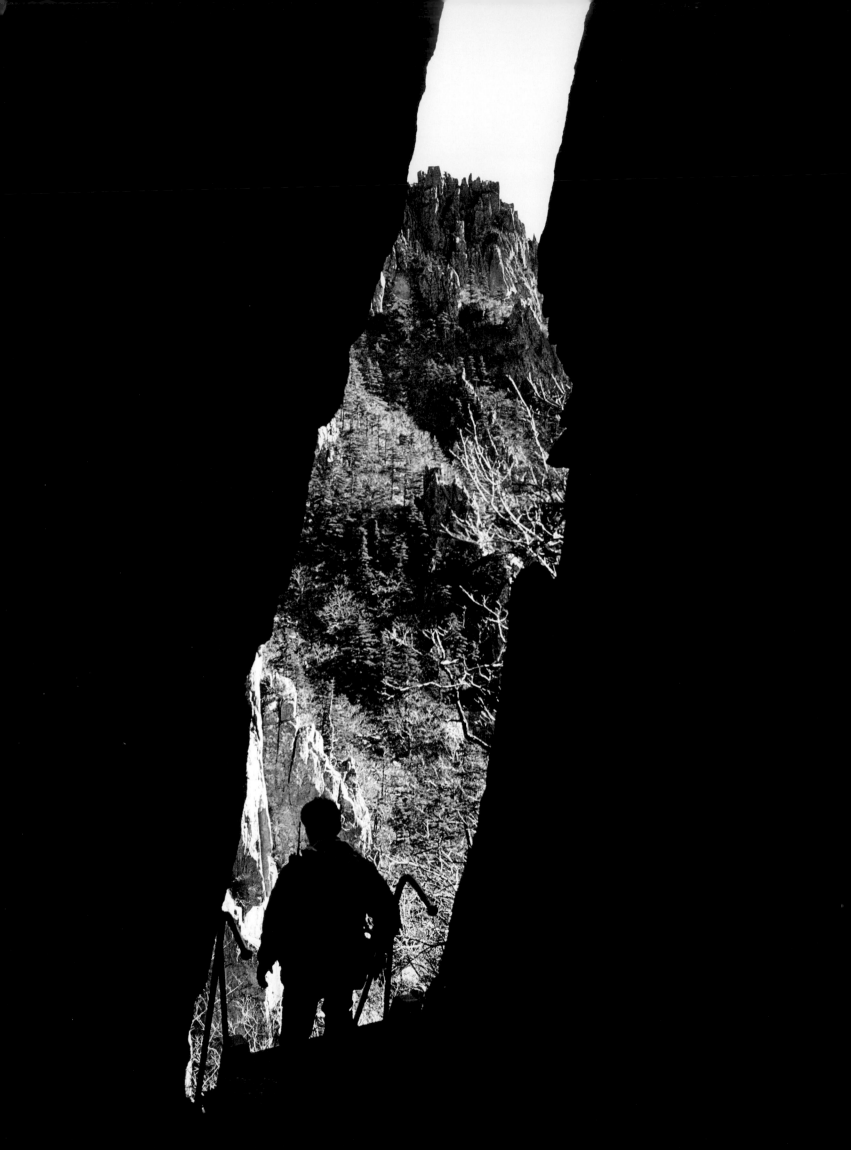

OPPOSITE:
A hiking trail leads between boulders.

Colorful characters mark a trailhead
in the mountains.

FOLLOWING SPREAD:
Employees in the Geumgangsan Hotel
lobby stand in front of a sightseeing map
of the area.

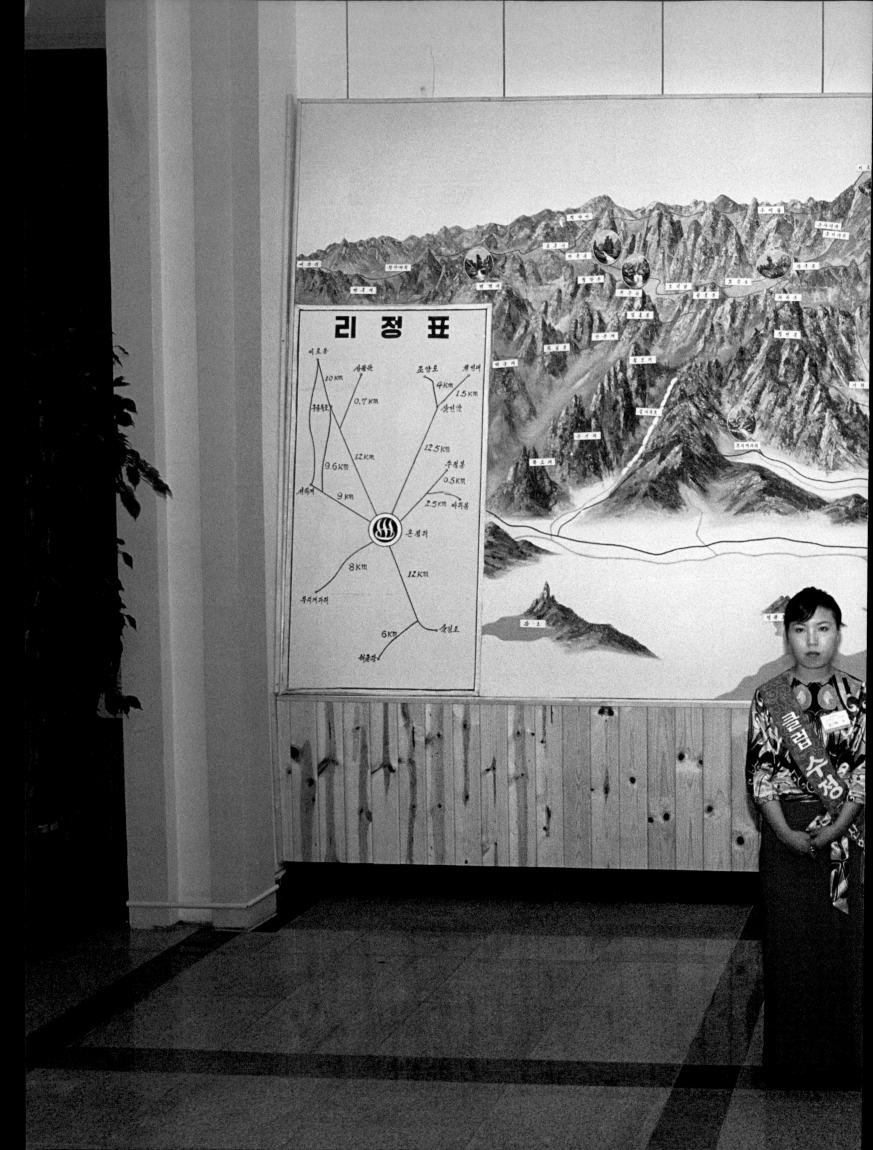

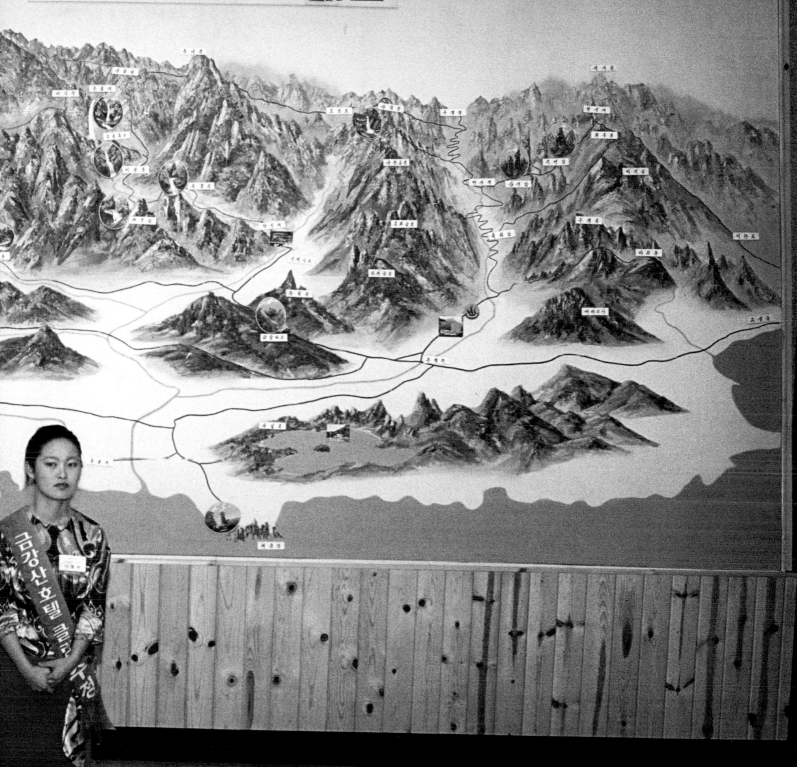

OPPOSITE:
"Contestants of Miss Korea 2000 Tour at
Mt. Geumgang (May 8–11)," South Korean
contestants visiting through special
arrangement, Geumgang Hot Spa.

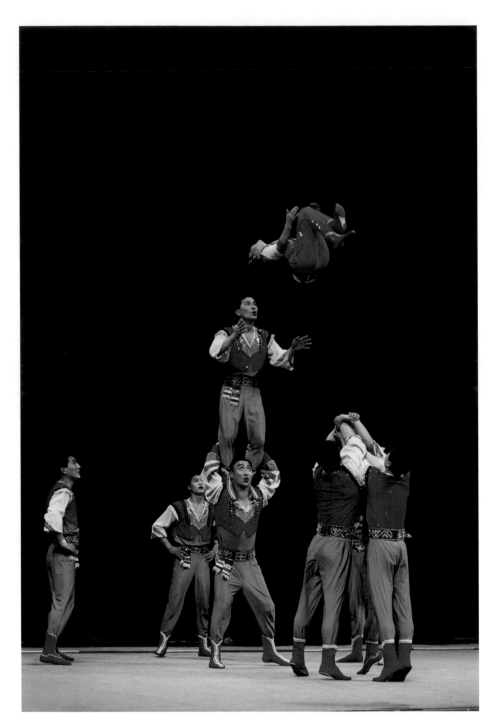

The Pyongyang Moranbong Circus
performs for visitors at Geumgangsan
Culture Hall.

FOLLOWING SPREAD:
The Geumgangsan Hot Spa features baths
in warm, mineral-rich hot spring water.

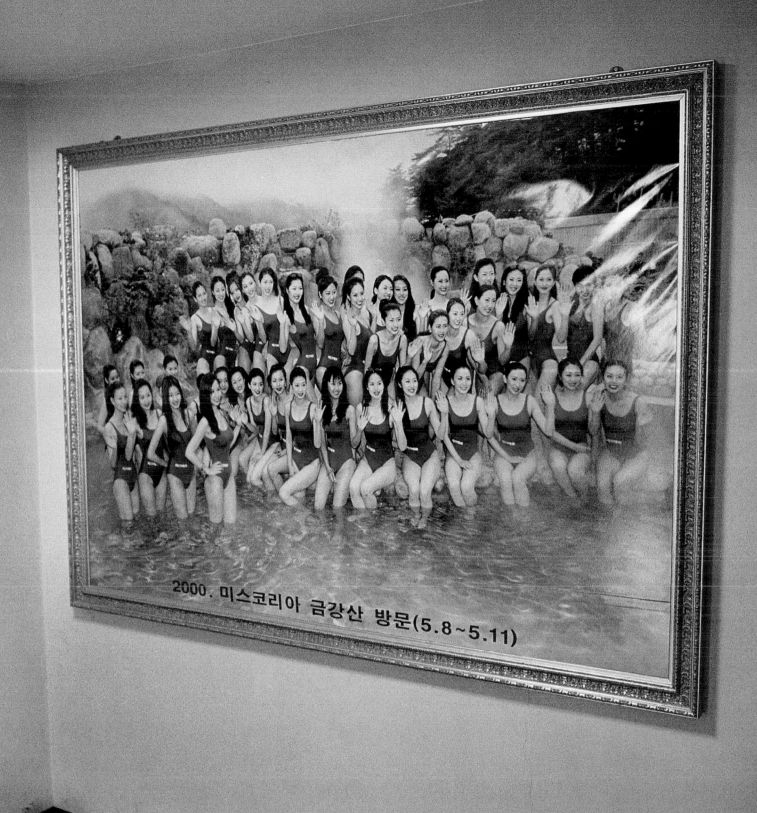

2000. 미스코리아 금강산 방문(5.8~5.11)

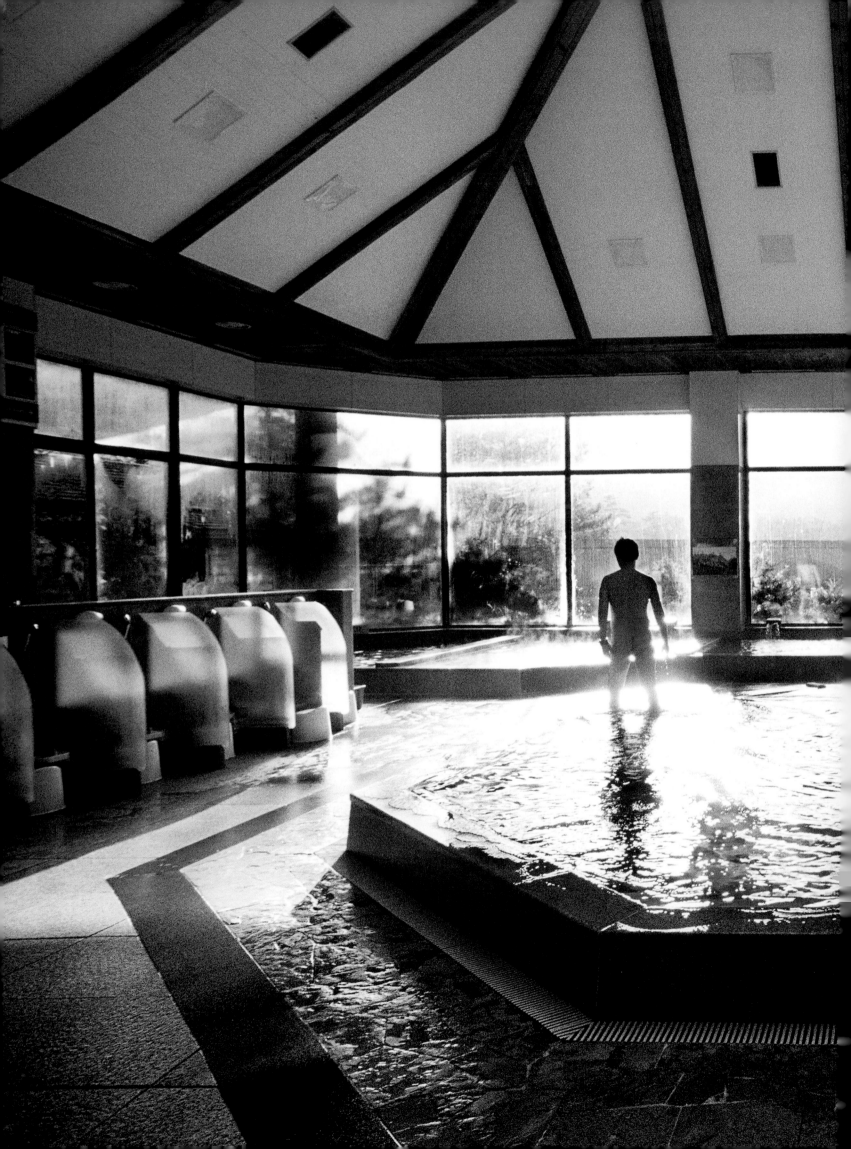

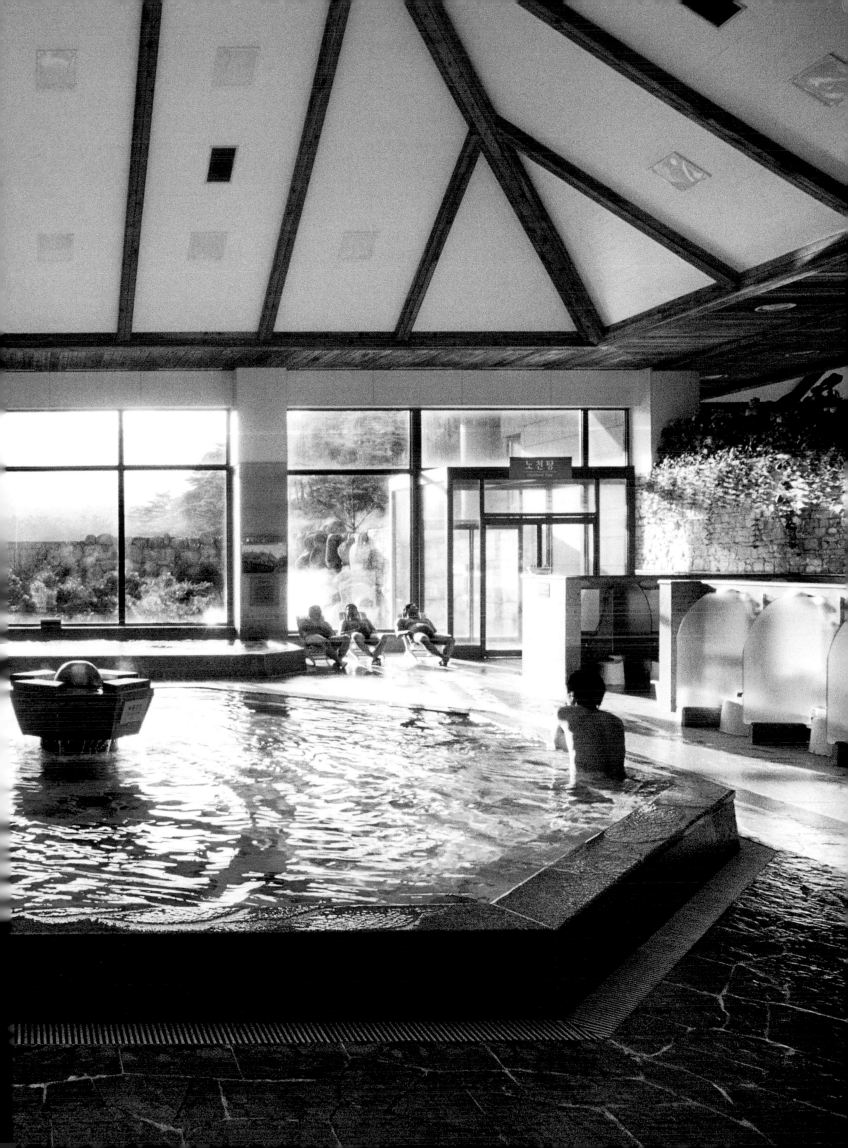

OPPOSITE:
A billboard of Kim Il Sung, surrounded
by adoring children, in front of the
Geumgangsan Hotel.

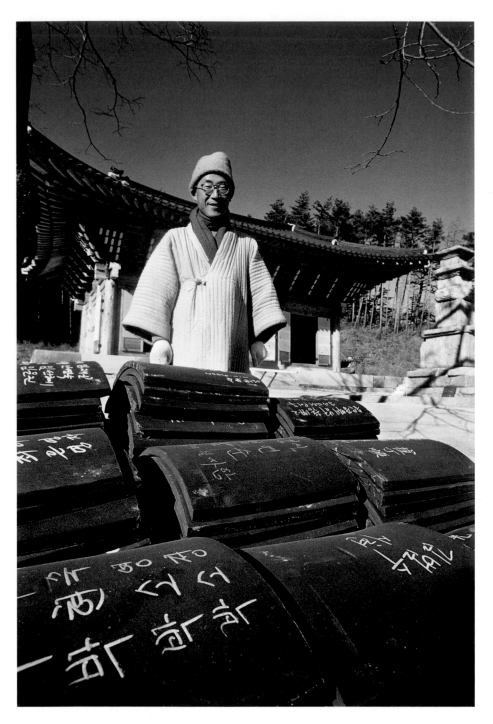

A Buddhist monk with tiles that visitors
can inscribe for $20 U.S. before they
are placed on the temple roof. At one
time, tourists were required to use special
tourist-issued currency when visiting
North Korea (it is illegal for them to
possess North Korean currency), but the
government has recently shifted its policy
to require payment in euros or U.S. dollars.

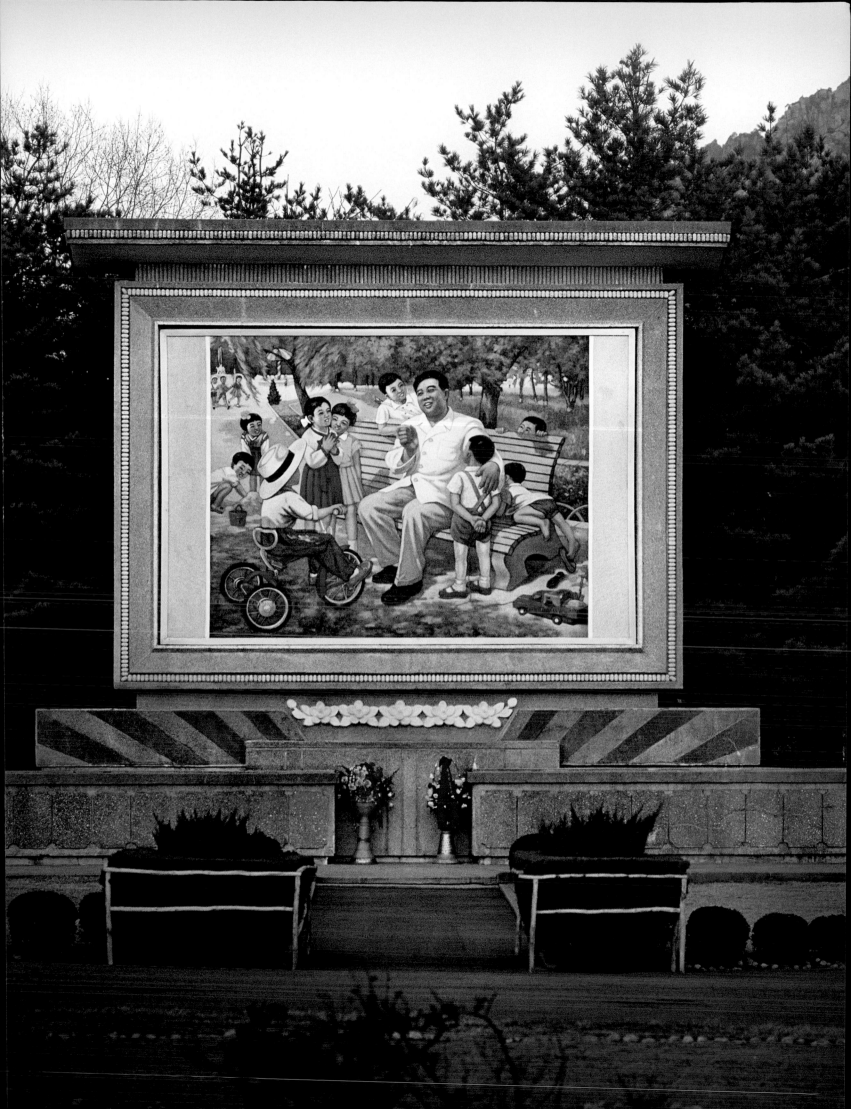

SINUIJU AND THE AMNOK RIVER

WEST OF MT. PAEKTU, THE AMNOK River (Yalu River in Chinese) marks the border between China and North Korea. On the Korean side of the river, twenty-five miles upriver from where the Amnok meets the Yellow Sea, is the city of Sinuiju, which originally developed from a logging center into a port and rail terminus. A bridge built over the Amnok in 1910 connected it with Dandong, China.

Because of its strategic location between China and Korea, the river was the site of battles during the Sino-Japanese War (1894–1895) and the Russo-Japanese War (1904–1905). The Korean side of the river was heavily industrialized—manufacturing chemicals, aluminum, and textiles—during the Japanese colonial period (1910–1945), and by 1945 almost 20 percent of Japan's total industrial output originated in Korea. During the Korean War, the movement of UN troops approaching the river provoked massive Chinese intervention from around Dandong. In the course of the conflict every bridge across the river was destroyed except the 3,097-foot Sino-Korean Friendship Bridge connecting Sinuiju and Dandong.

During the Korean War, U.S. General Douglas MacArthur ordered B-29 bombers along the Amnok River to focus on the area surrounding the Sinuiju Bridge in order to disrupt the flow of troops and material from Manchuria into North Korea, and here Chinese MiGs and U.S. jets escorting the bombers engaged in history's first jet-to-jet combat. MacArthur wanted to allow pursuit of the Chinese planes to their bases in Manchuria, but the Truman administration refused, fearing the action would trigger an even larger Chinese, and potentially Soviet, response.

These days, Chinese, as well as a handful of Korean, Japanese, and other nationalities, venture across the Chinese half of the river from Dandong for a ten-minute cruise paralleling Sinuiju for a close-up glimpse into North Korea.

It was on one of these cruises that a Japanese tourist named Kazumi Kitagawa jumped from a ferry and swam across the Amnok River into North Korea to seek asylum in August 2003. A member of the Aum Shinrikyo cult in Japan (as well as an informant on the cult to Japanese authorities), she left a note saying she wanted to go to North Korea for "personal reasons." North Korean authorities cited her reasons for defecting as "persecution" and "abuse" by the Japanese government. Upon entering North Korea, she initially expressed excitement, saying she wanted to study the Korean language to work as a translator. However, she was allowed to repatriate to Japan two years later by the North Korean government, after her complaints concerning the chill of her hotel room, constant surveillance, and lack of Japanese cosmetics and other amenities. Her defection to the North was the first by a Japanese since the hijacking to Pyongyang of a Japan Airlines jetliner by nine left-wing radicals in 1970.

In September 2002, the North Korean government announced plans to develop Sinuiju as an "international financial, trade, commercial, and industrial" zone along the lines of China's Special Economic Zones. The plans call for the city's current estimated two hundred thousand residents to be relocated to make room for hundreds of thousands of new skilled technical workers from China and North Korea, allowing for private ownership of property and a semi-autonomous government with its own legislature. Yang Bin, a Chinese business tycoon named by *Forbes* magazine in 2001 as the second-richest man in China, was appointed to govern the region by close friend Kim Jong Il. Yang was placed under house arrest shortly thereafter by the Chinese government, under investigation for fraud relating to his property and horticulture business, and removed from oversight of the Sinuiju project, the future of which is now uncertain. Yang was convicted of fraud in 2003 and sentenced to 18 years in prison and a nearly $300,000 fine. An earlier effort at developing such an economic zone, the Rajin-Sonbong Economic and Trade Zone, located in North Korea's northeast, had begun in 1996 but failed due to lack of infrastructure and foreign investment.

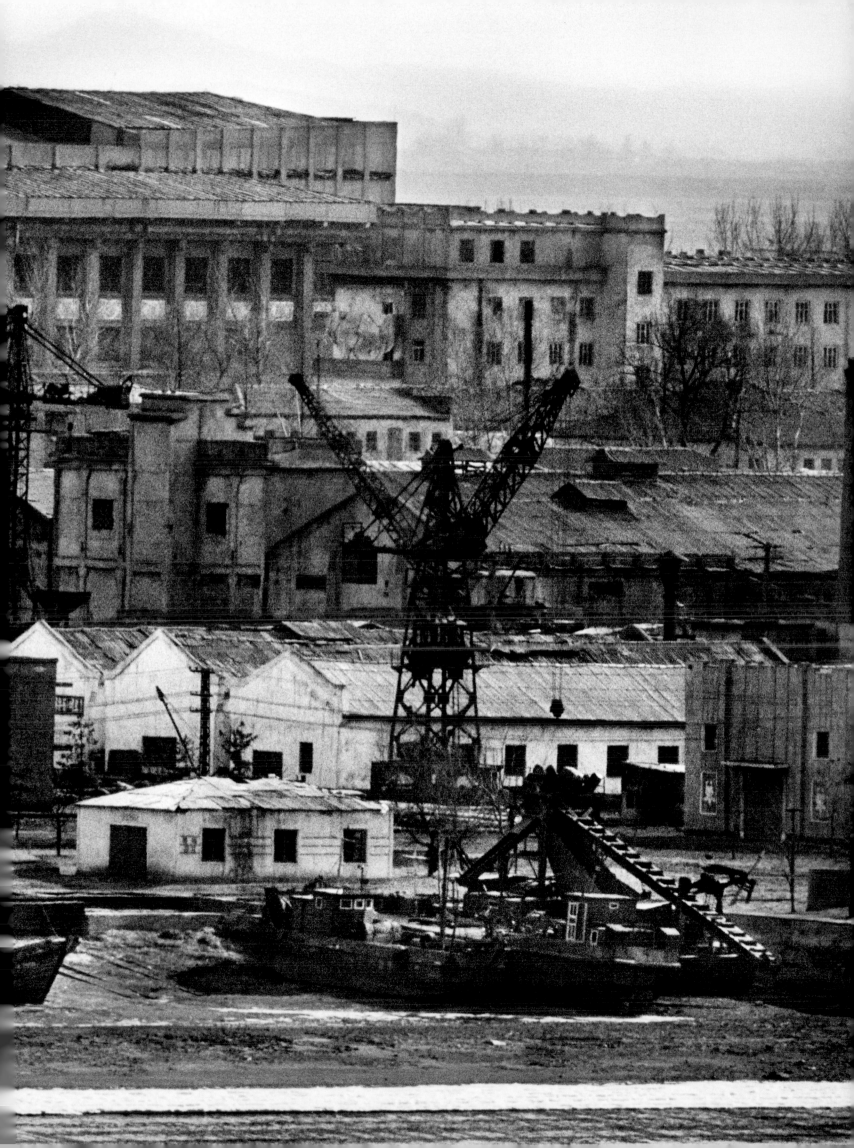

PREVIOUS SPREAD:
Sinuiju's light industrial area includes manufacturing plants and mills. On the roof of the building at top left is the word *juche*, meaning the North Korean ideal of self-reliance.

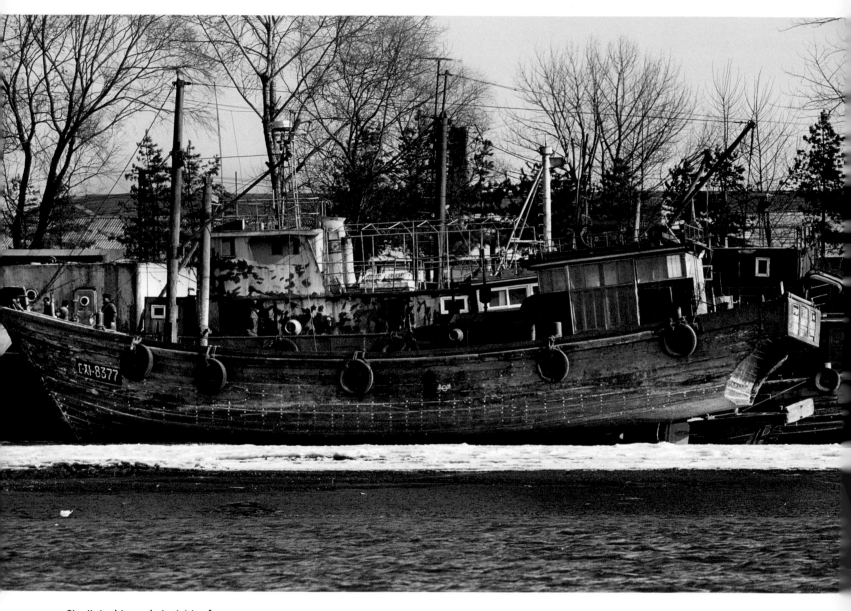

Sinuiju's shipyard. Activities focus more on scuttling vessels for scrap metal than for shipbuilding or maintenance.

An idle factory on the North Korean side
of the river.

The city visible beyond the treeline.

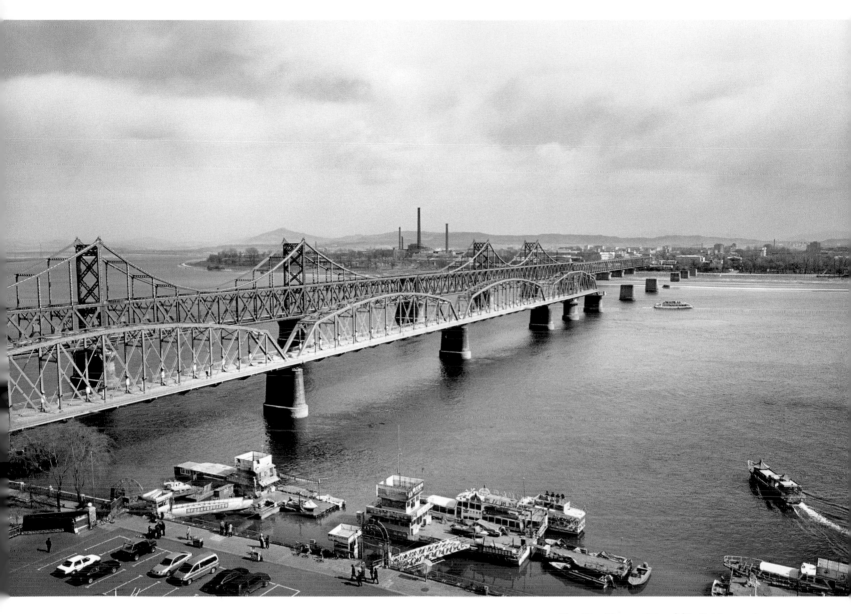

The Sino-Korean Friendship Bridge and
the half-destroyed Yalu River Bridge sit
side by side on the Amnok River. In the
foreground a tourist boat leaves the dock
at Dandong to sail along the North Korean
city of Sinuiju on the far bank. Three
border bridges once crossed the lower
reaches of the river. Two were destroyed
by American forces during the Korean
War. The Friendship Bridge, built in 1943,
survived the bombing and today is used
as one of the very few points of entry
into North Korea from China for rail, road,
and pedestrian traffic.

FOLLOWING SPREAD:
Ruined bridge supports on the Amnok
River. According to Chinese residents of the
area, the Ferris wheel constructed on the
North Korean side has never been in use.

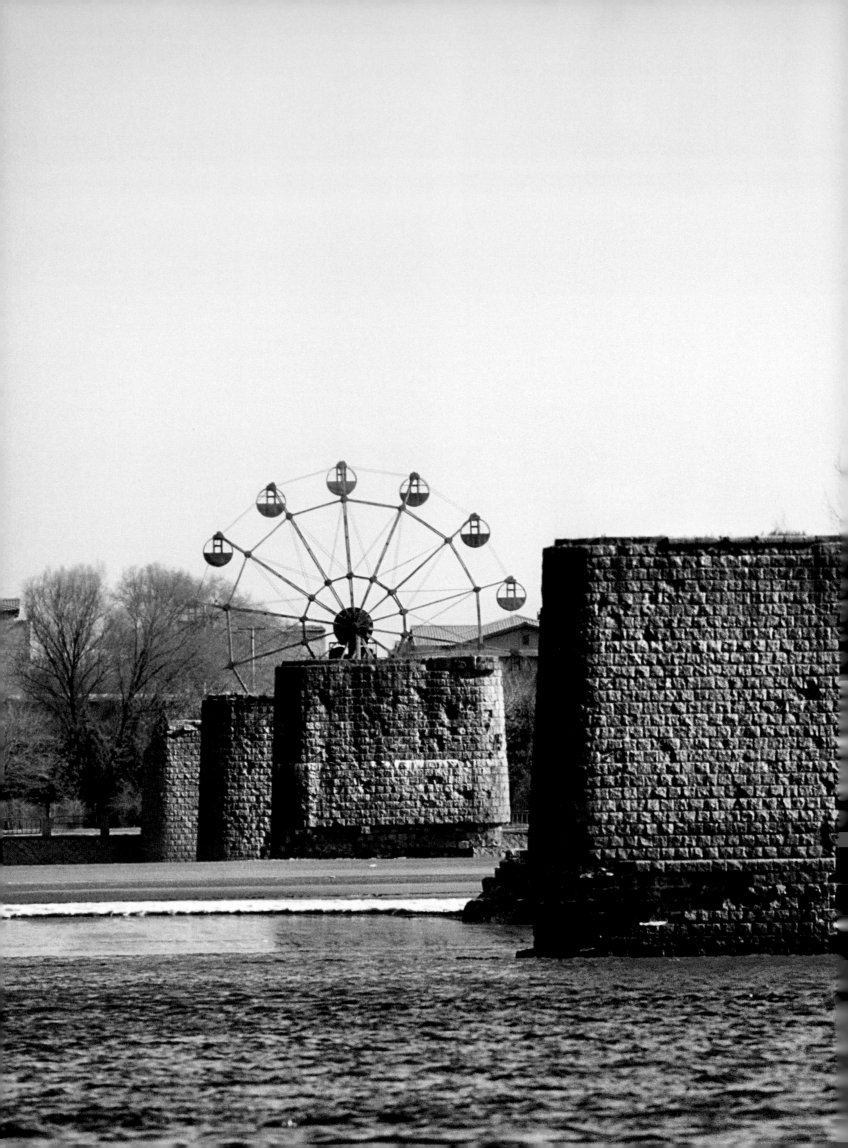

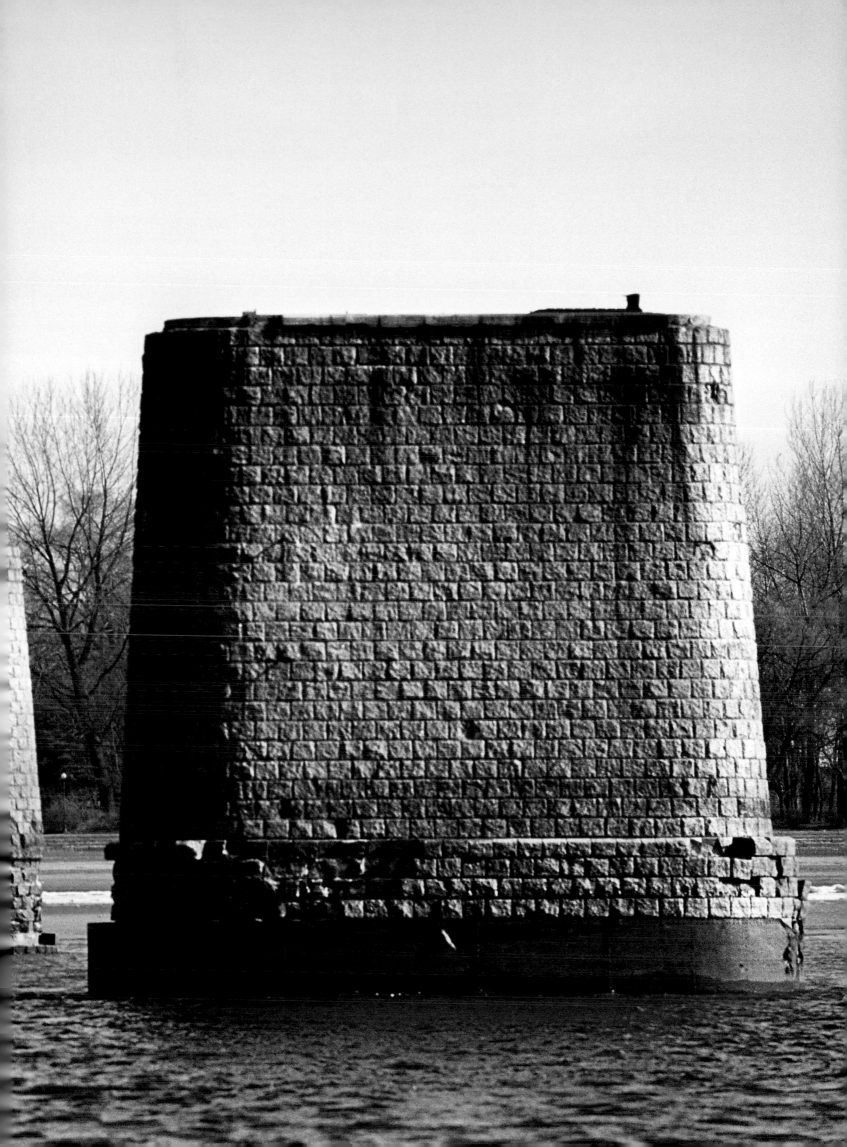

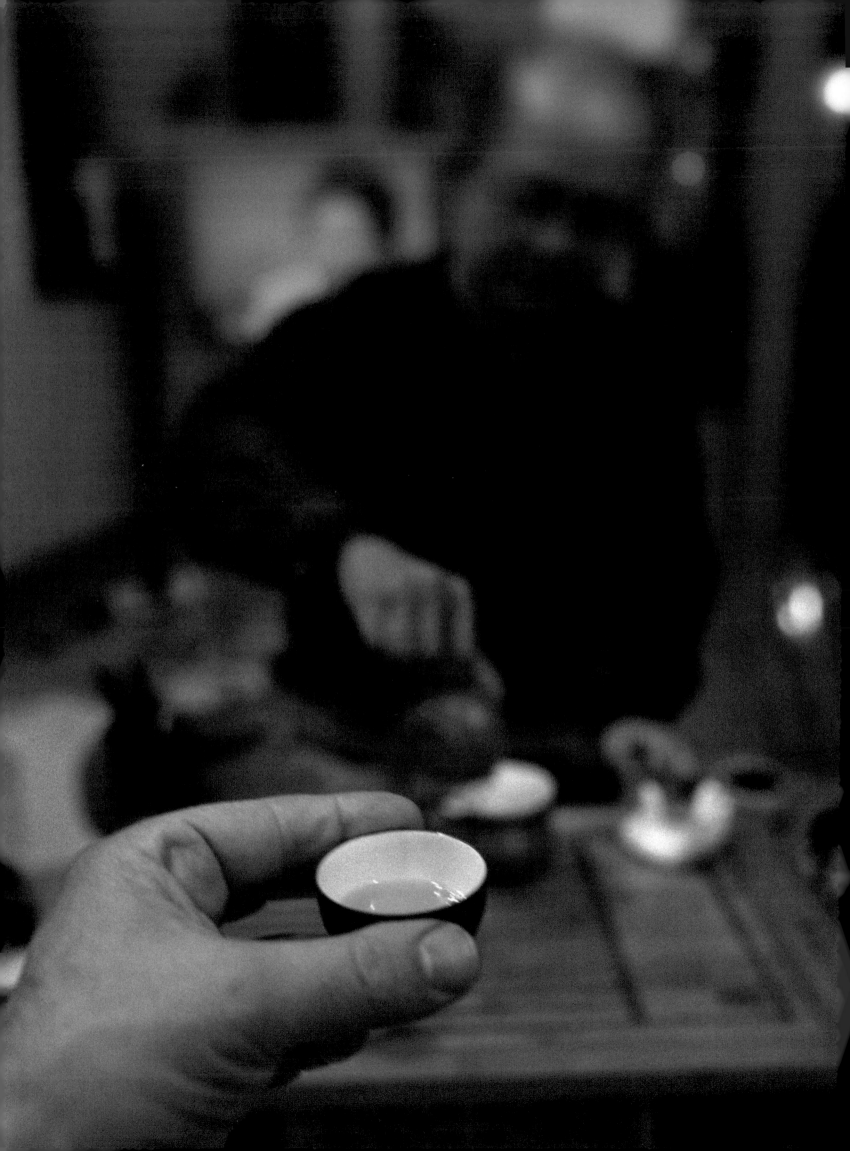

OPPOSITE:
A South Korean minister who works with
North Korean refugees serves tea in China.
It is against Chinese law to assist illegal
immigrants in the country.

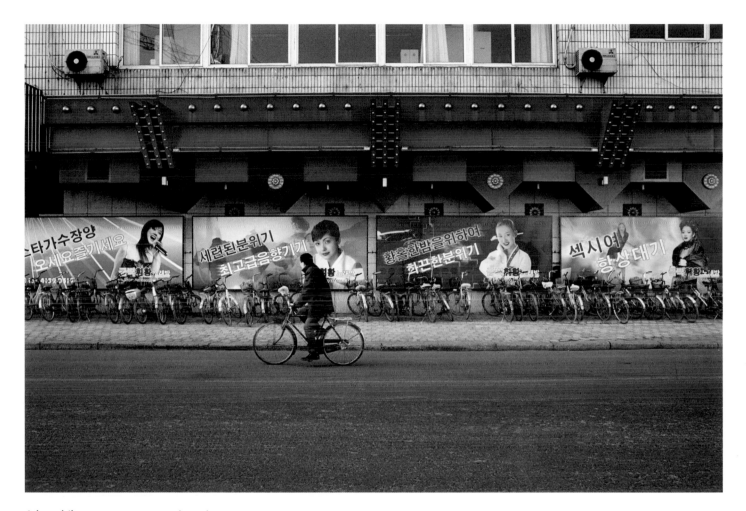

A lone biker passes posters written in
Korean in Dandong, China, inviting
potential customers to "Come and enjoy
Korean karaoke rooms," promising
"hot nights" and "sexy girls always
waiting for you." A South Korean visitor
who translated the sign commented,
"Capitalism is alive and well in Dandong."

PAEKTUSAN

MT. PAEKTU IS LOCATED AT THE KOREAN-Chinese border, 217 miles northeast of Pyongyang. At 9,003 feet, the dormant volcano that last erupted in 1702 is the highest mountain on the Korean peninsula. The main peak is covered year-round by a whitish pumice and snow, giving it the name Paektusan ("White Head Mountain"). Craggy peaks surround the crater lake called Chonji ("Heavenly Lake"). Fed by two hot springs, Chonji is one of the deepest alpine lakes in the world, with an average depth of 204 meters, and a maximum depth of 373 meters, at 2,194 meters above sea level. Chonji was most likely created in 1597 during a volcanic eruption. Two-thirds of the land around the lake is North Korean with a third in Chinese territory.

Paektusan is sacred to all Koreans. According to Korean mythology, Hwanung, the Son of the Lord of Heaven, descended to earth with some three thousand subordinates to found a divine city at the top of the mountain, establishing the first Korean kingdom. One day, as legend has it, a tiger and a bear that lived on the mountain approached Hwanung and begged him to make them human. Hwanung gave them each a bundle of mugwort and twenty pieces of garlic, asking them to eat these and avoid the sunlight for one hundred days as a test of their will. The tiger failed, roaming from its cave, but the bear followed instructions and became a woman. Taking pity on the now-human bear, who could not find a mate, Hwanung married her. Their son, Tan'gun, became the ancestor of the Korean people, uniting the scattered Tungusic tribes into a nation known as the Kingdom of Ancient Choson and establishing his capital at Asadal (now Pyongyang) in 2333 BCE.

Kim Jong Il's official biography states that he was born at Mt. Paektu in northern Korea on February 16, 1942. However, Soviet records show he was born in the Siberian village of Vyatskoye, near Khabarovsk, on February 16, 1941, where his father, Kim Il Sung, was a captain and battalion commander in the Soviet 88th Brigade, which was composed of Chinese and Korean exiles. It is believed that his "official" birth year and location were adjusted to a place deep in the souls of all Koreans, as well as in the year of his father Kim Il Sung's thirtieth birthday. North Korean history books record a double rainbow appearing over Kim Jong Il's birthplace on Mt. Paektu.

With North Korea long off-limits to visitors, normalization of South Korean and Chinese relations in the 1990s opened the door to South Korean tourist visits to Mt. Paektu from Manchuria. The South Korean National Tourism Organization estimates that one hundred thousand South Koreans have paid a visit to the mountain on the Chinese side. In July 2005, Kim Jong Il granted permission to the Hyundai Asan Corporation to begin opening the mountain for limited tourism on the North Korean side in a joint venture similar to efforts at Geumgangsan. The project, along with Hyundai's work at Geumgangsan, stalled when the North Korean government objected to the dismissal of Hyundai executive Kim Yoon Kyu, amid charges of misappropriation of funds, but the projects were back on track by the end of the year, and trial tours of Paektusan were optimistically scheduled for summer 2006.

OPPOSITE:
Eggs and corn are boiled in Mt. Paektu's
natural hot springs.

In the eastern Jilin Province of China, more than half of the 200,000-plus residents are ethnic Koreans, including this teenager who works at her family's Korean restaurant in Yanji. The Korean language is the official second language of the region. Koreans in this province carry on traditional culture, some of which has disappeared on the Korean peninsula. In the first half of the twentieth century, many Koreans moved to the Yanji area in order to evade Japanese colonial rule.

FOLLOWING SPREAD:
South Korean tourists make pilgrimages to Mt. Paektu from China. Roads are closed due to heavy snow in the winter and part of the spring, but a few intrepid visitors make their way on foot to Heavenly Lake with North Korean peaks in the distance. One-third of the lake is in China and two-thirds in North Korea. The mountain is the source of the Chinese Songhua and Tumen rivers, as well as the Amnok River that runs between the two countries.

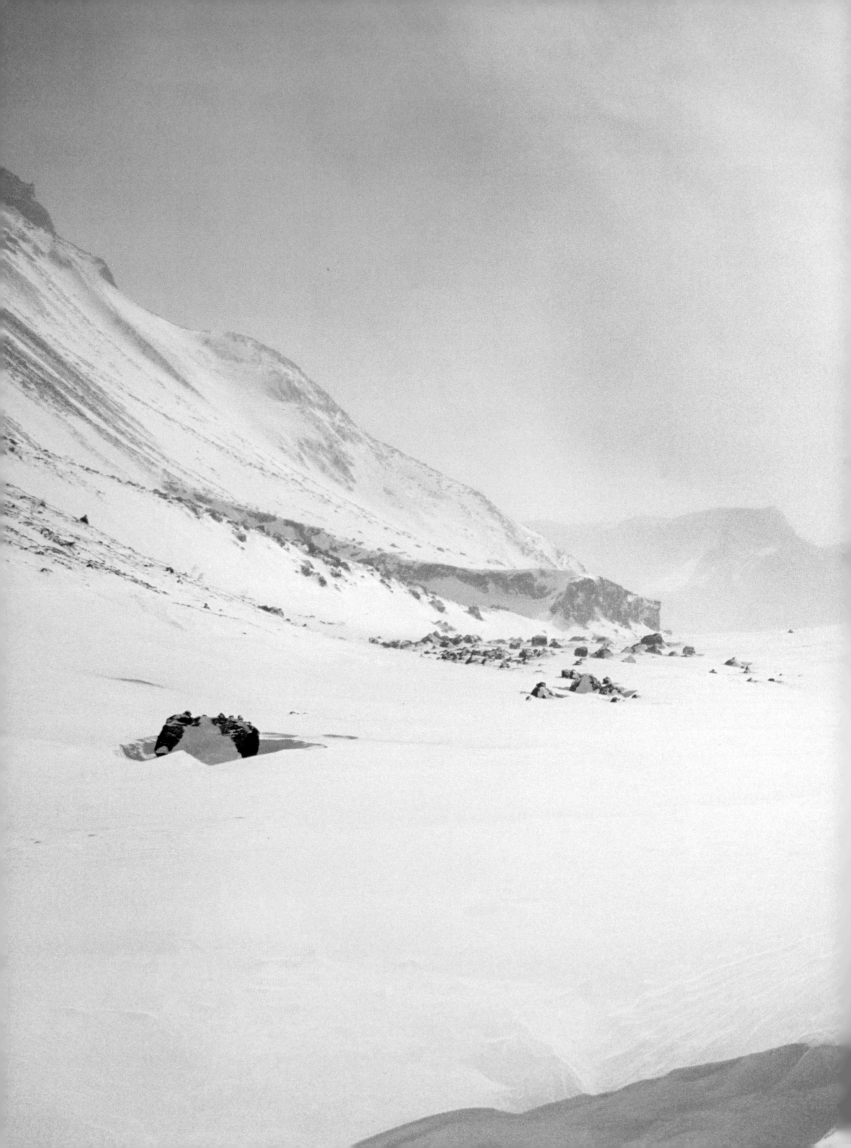

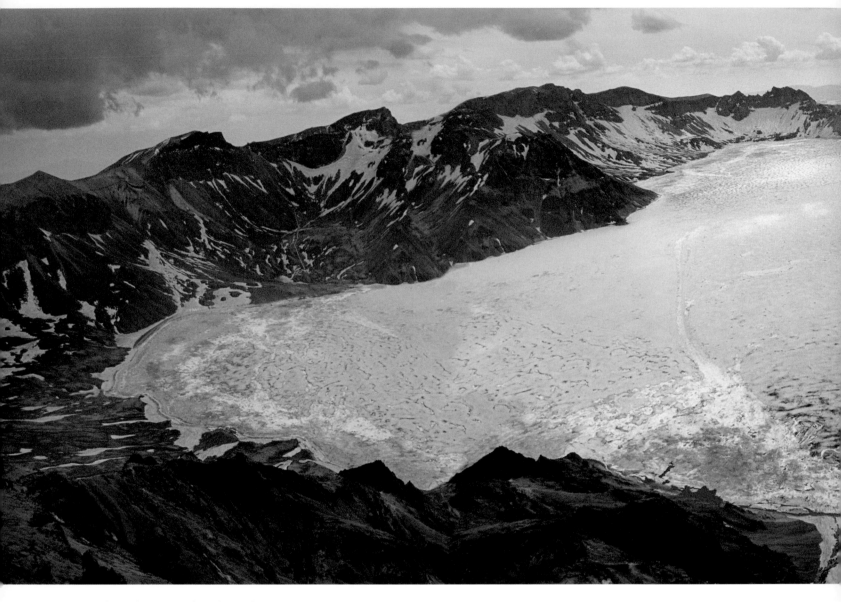

Mt. Paektu in late May, when the ice begins
to reveal the lake underneath.

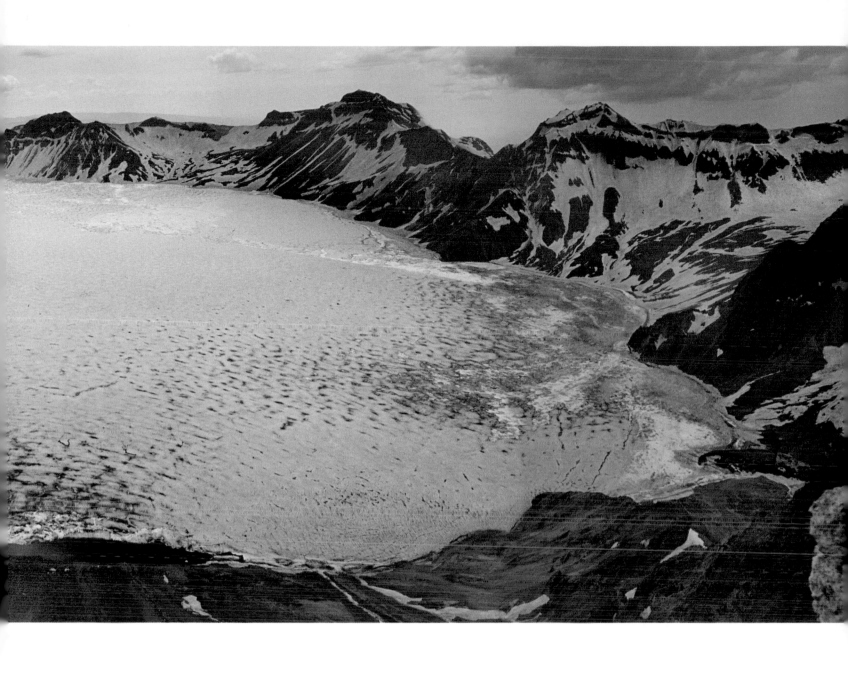

THE NORTHEAST BORDER AND THE TUMEN RIVER

THE TUMEN RIVER ORIGINATES AT Mount Paektu and runs 324 miles into the Sea of Japan (or the East Sea, as it is known on the Korean Peninsula), forming a natural border between northeastern North Korea and China and the few miles of border shared by the DPRK and Russia. The greater region around the river is rich in oil and mineral reserves, timber, and other resources that have led historically to fierce international competition. Recently, the three countries (along with South Korea, Mongolia, Japan, and the United Nations Development Program) have established the Tumen River Area Development Project with the goal of fostering cooperative trade development.

The river is relatively narrow, shallow enough to wade across in many areas in the summer and walk across when frozen over in the winter. It is the departure point for defectors from North Korea into China. In the second half of the 1990s, a famine in North Korea brought on by intense flooding killed between 220,000 and several million people (by North Korean and internationally accepted estimates, respectively) and led to massive defections.

While the end of the severe famine years has reduced the yearly exodus from an estimated tens of thousands (actual numbers are difficult to gauge), a number of North Koreans still take flight across the Tumen River into China. Those who successfully evade capture live as fugitives—often supported by ethnic Koreans who offer money, shelter, and advice on how to avoid detection—and either stay in China, make their way to southeast Asian countries who are known to accept them (Thailand, Cambodia, Vietnam), or move to South Korea. Beijing's official policy is to return captured refugees to North Korea, where they are subject to imprisonment and their families subject to harsh penalties.

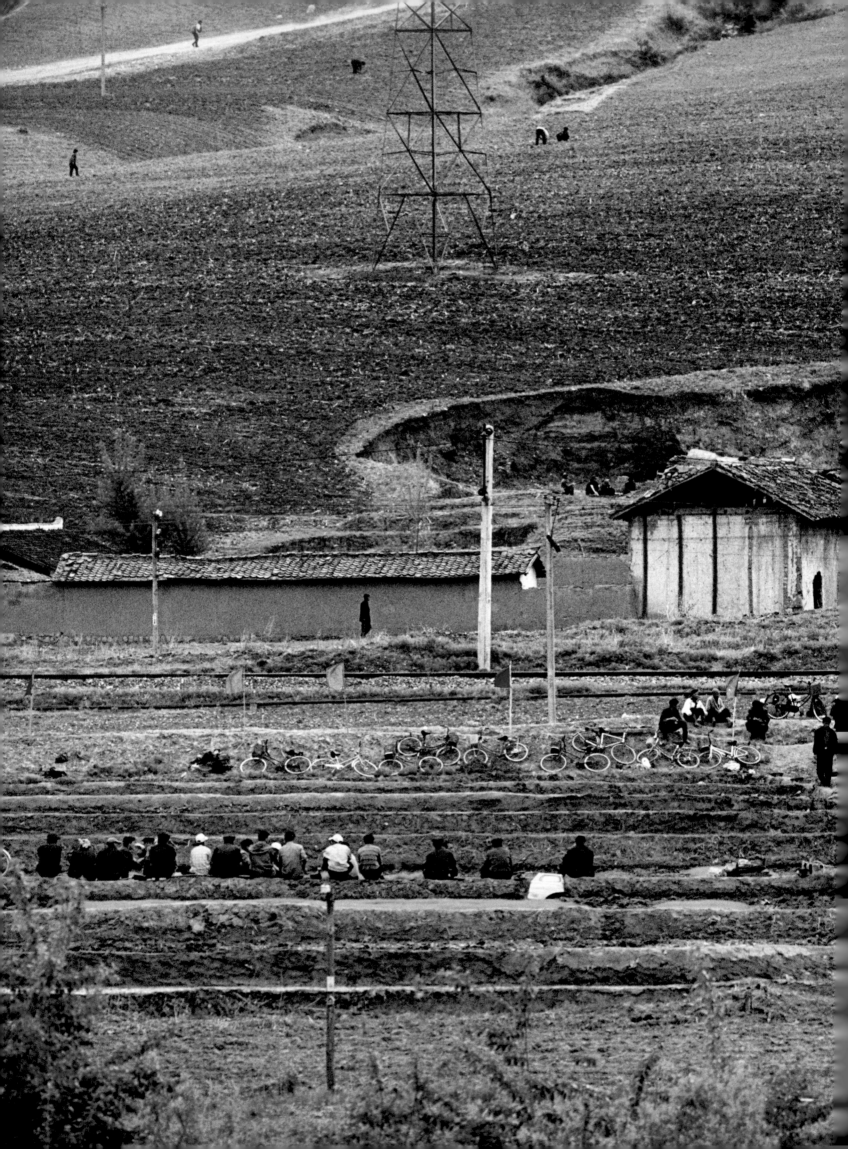

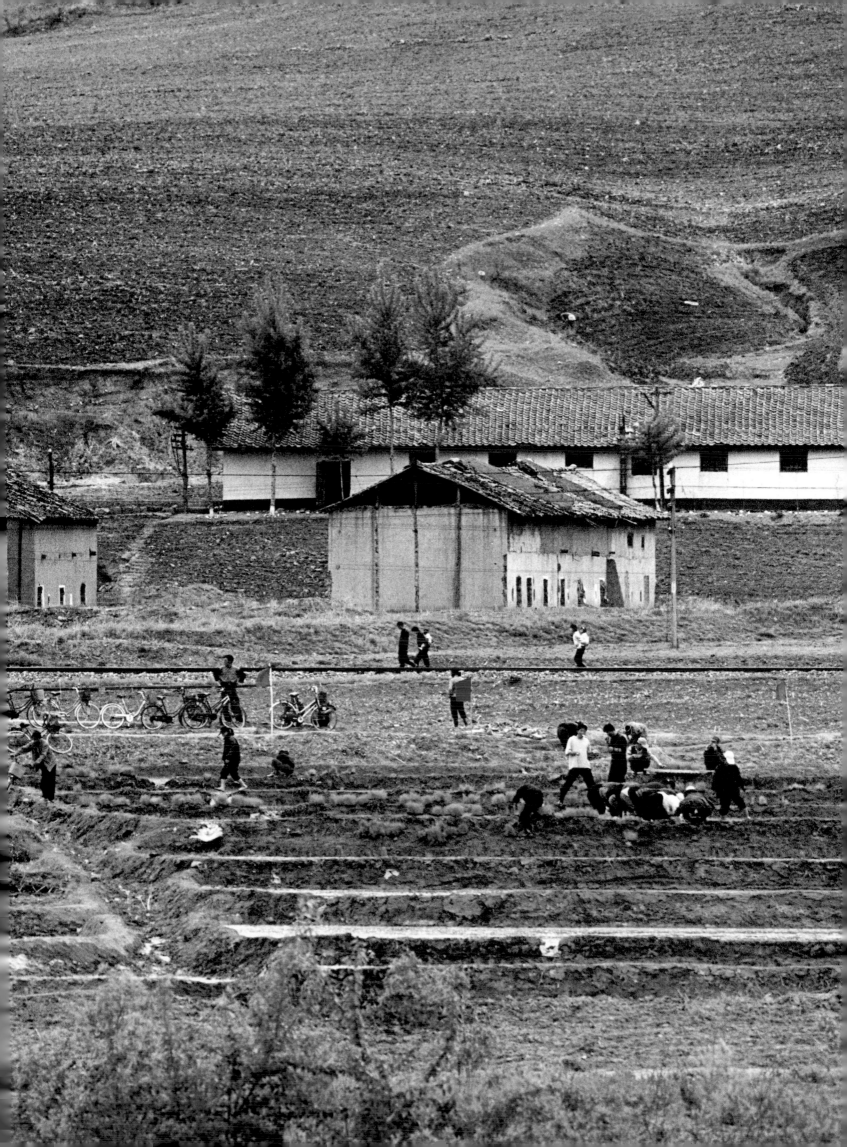

PREVIOUS SPREAD:
North Korean farmers tend the fields near
the Tumen River west of Namyang.

OPPOSITE:
A North Korean on the south bank of the
Tumen River just east of Namyang. In the
foreground is the Chinese side of the river.

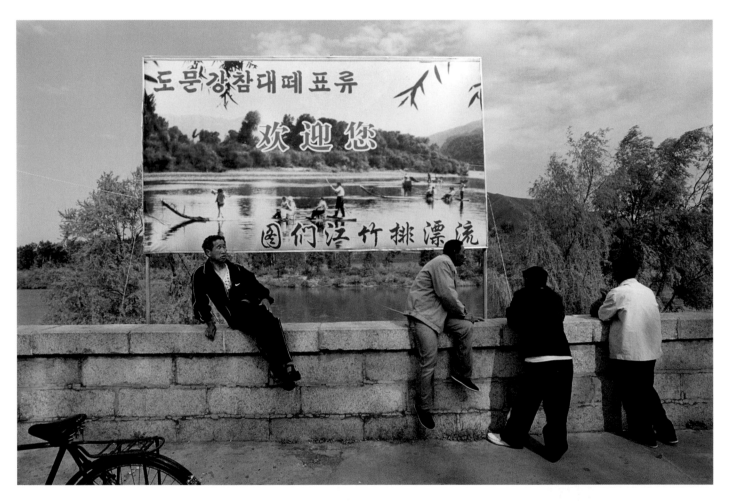

On the Chinese side of the river, Chinese
citizens relax near a sign in Korean and
Chinese, advertising bamboo rafting on the
Tumen River.

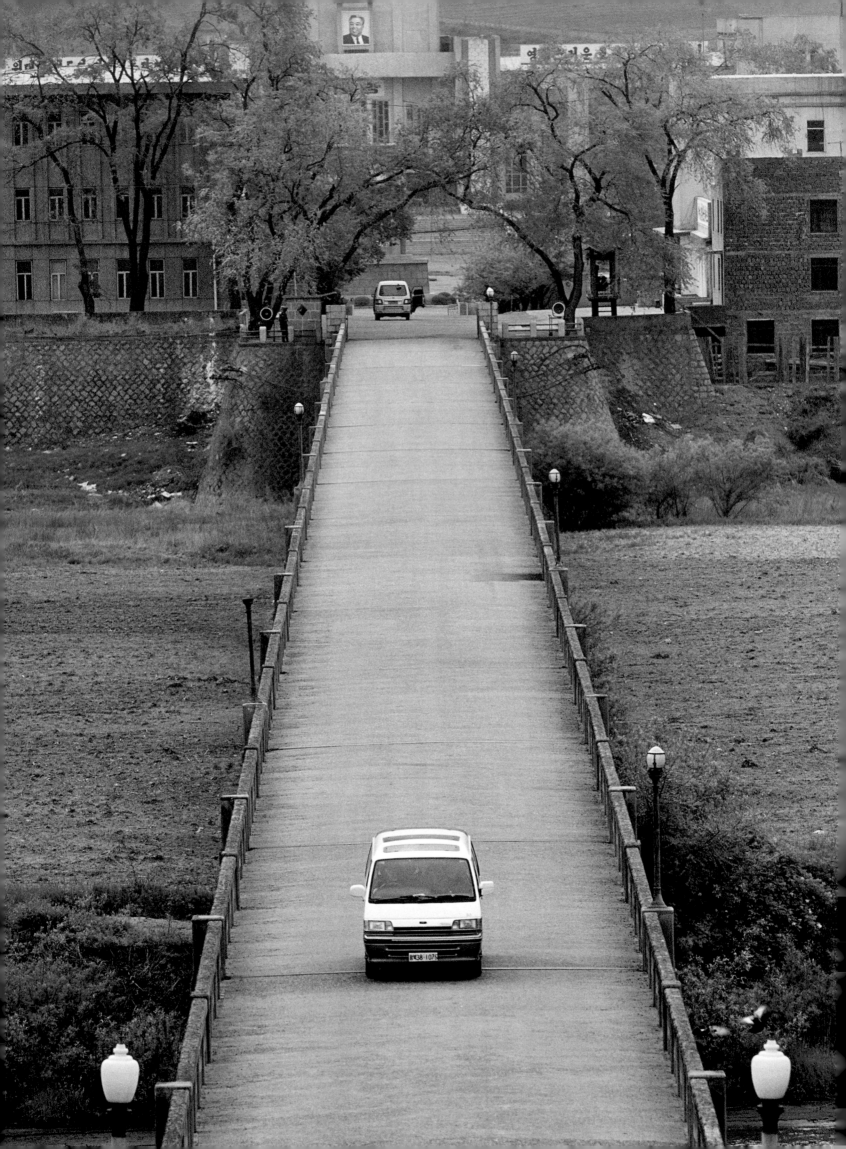

OPPOSITE:
Vehicles crossing the bridge between Namyang, North Korea (portrait of Kim Il Sung visible), and Tumen, China.

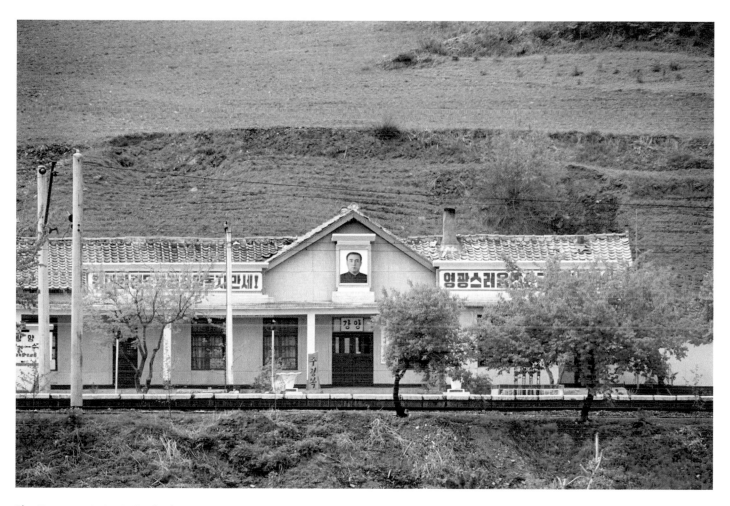

The Kangyang train station in the Onsung district of North Korea. The signs wish long life to Kim Jong Il and Chosen (North Korea).

FOLLOWING SPREAD:
A North Korean restaurant in the Manchurian city of Yanji. The waitresses/ performers, all North Korean, have come to Yanji from Pyongyang for three-year stints. They address each other with the polite ending *Tongmoo* (comrade).

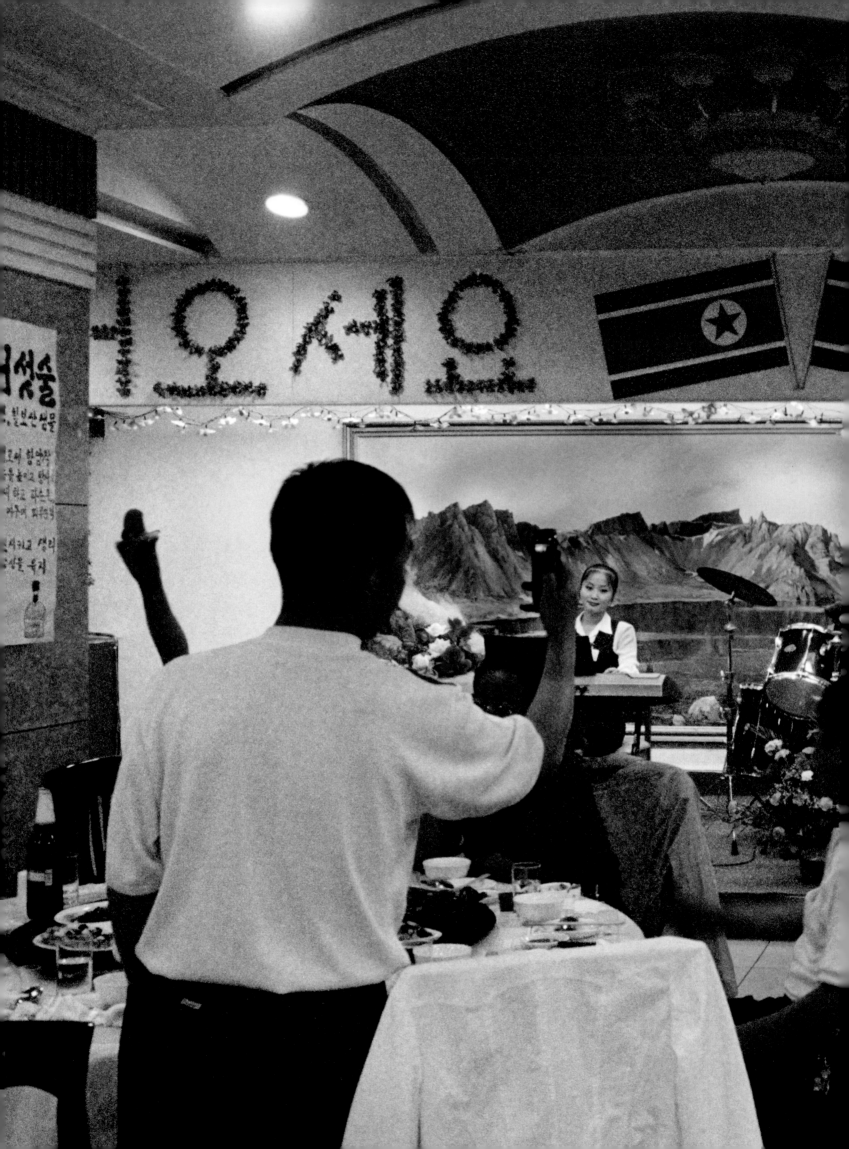

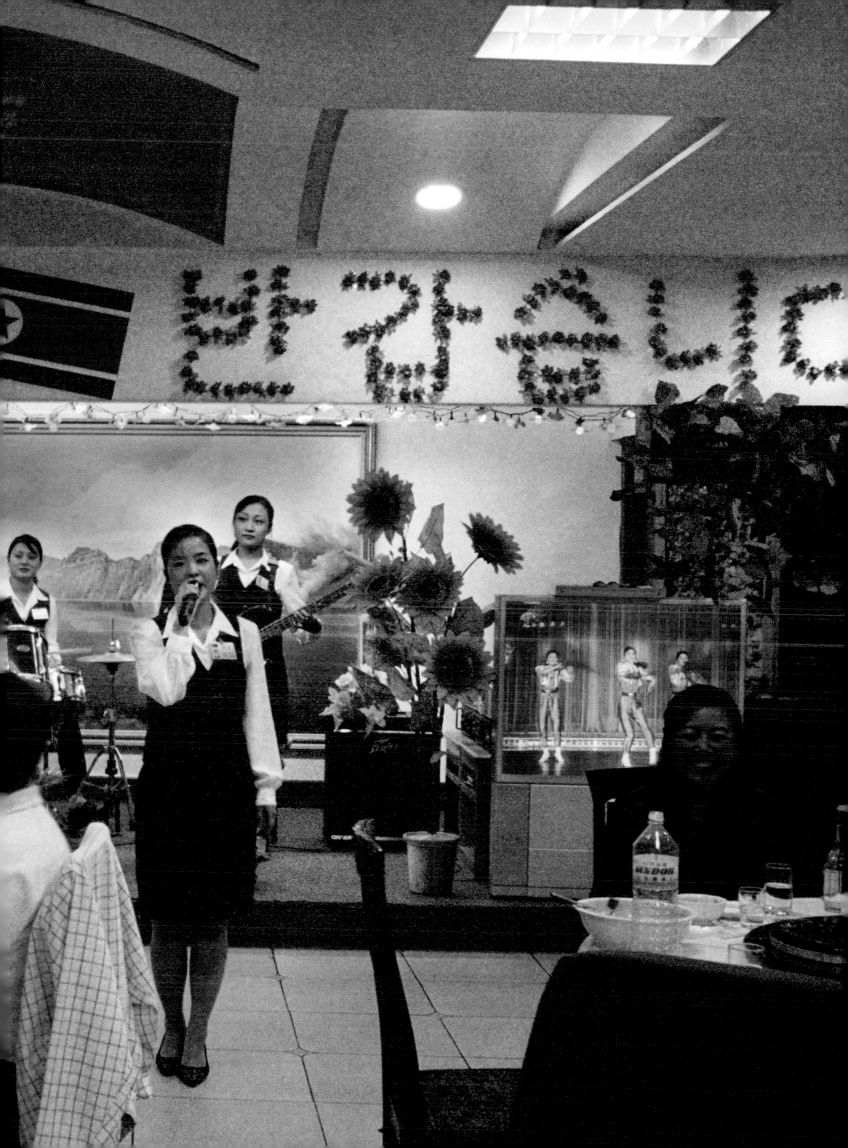

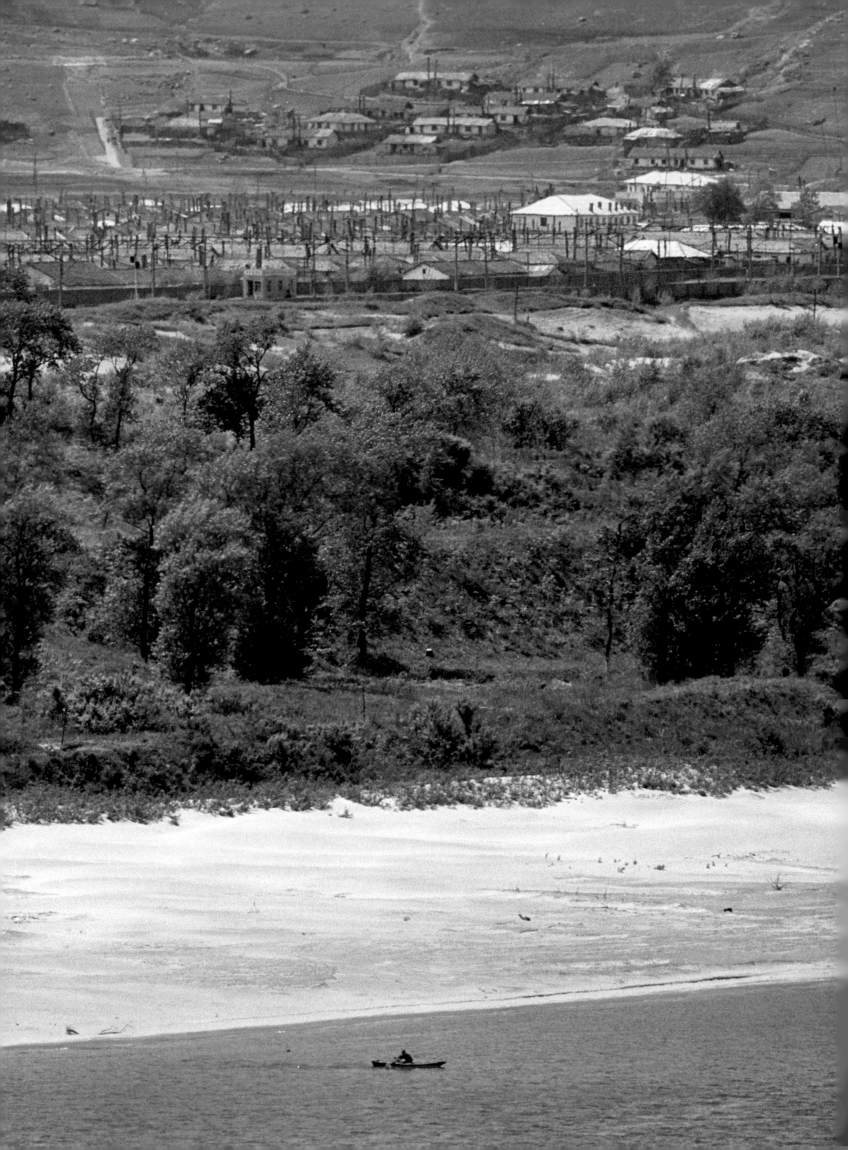

OPPOSITE:
A North Korean village near the Chinese–
Russian–North Korean border.

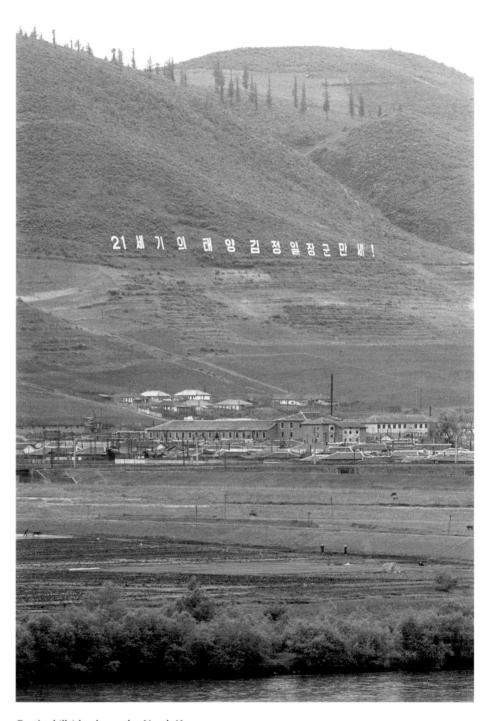

On the hillside above the North Korean
city of Sanbong are the words "Bravo
Mr. Kim who is the Greatest Sunshine of
the 21st Century!"

OPPOSITE:
A hillside sign between the North Korean cities of Namyang and Sanbong reads, "Hail to the legendary hero, General Kim Jong Il!"

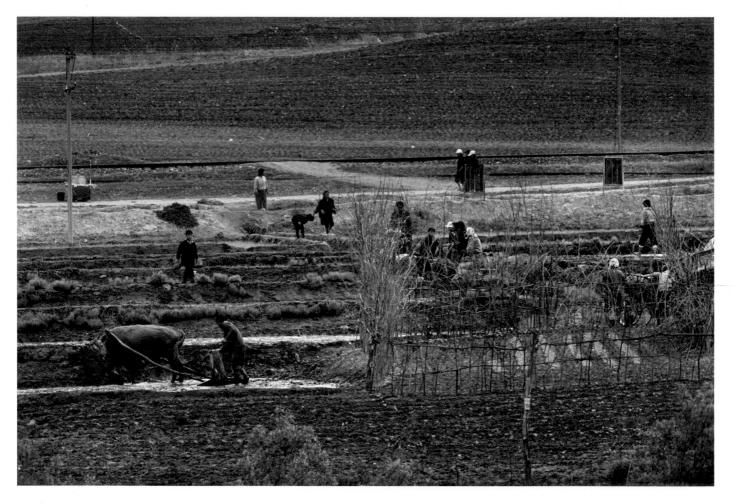

North Korean farmers east of the city of Namyang.

THE NORTHEAST BORDER AND THE TUMEN RIVER

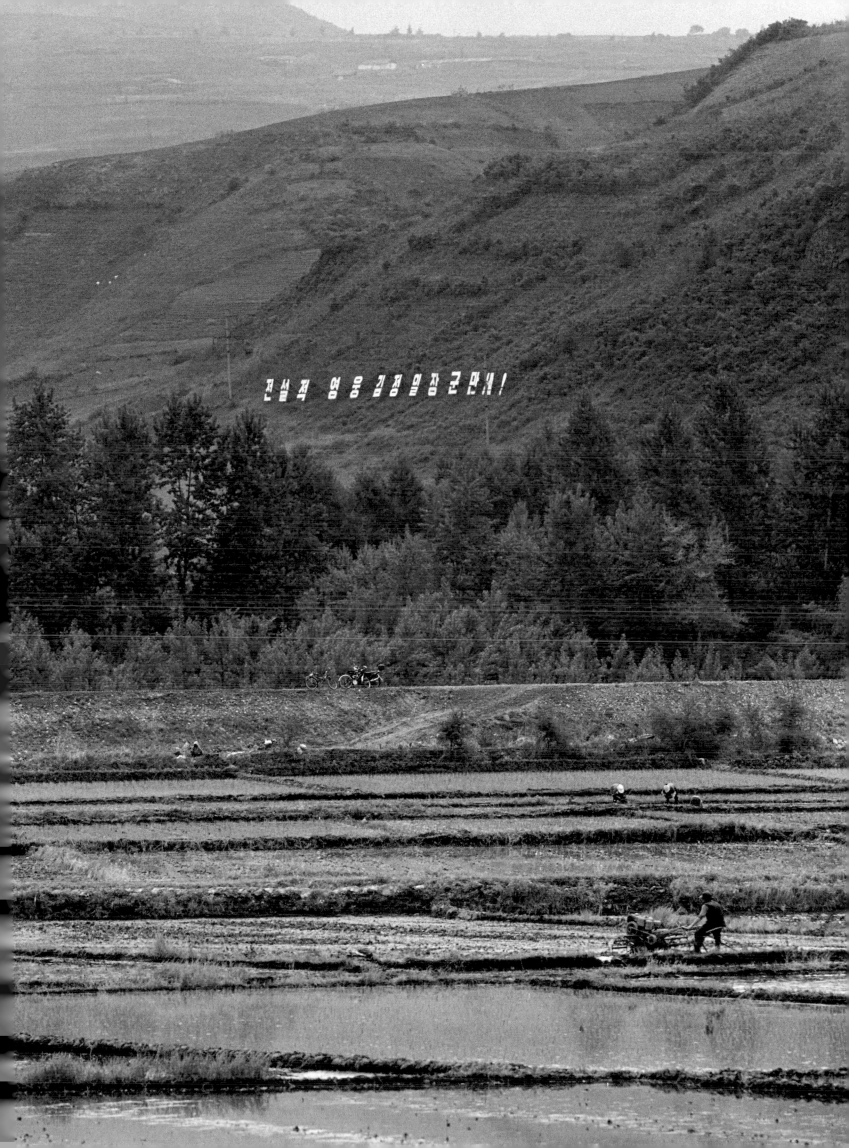

Panorama of the North Korean city of
Namyang from the Chinese city of Tumen.

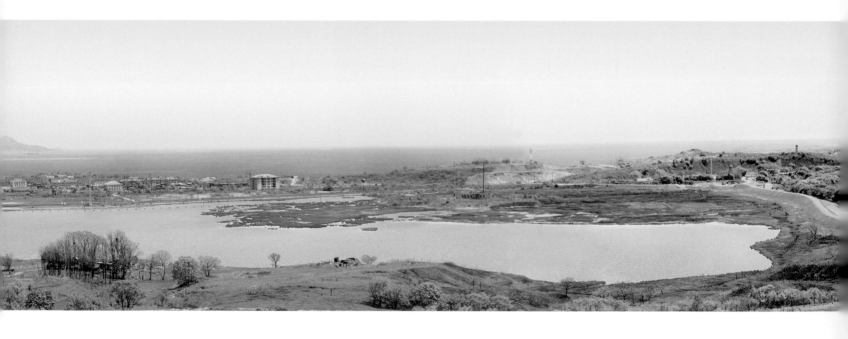

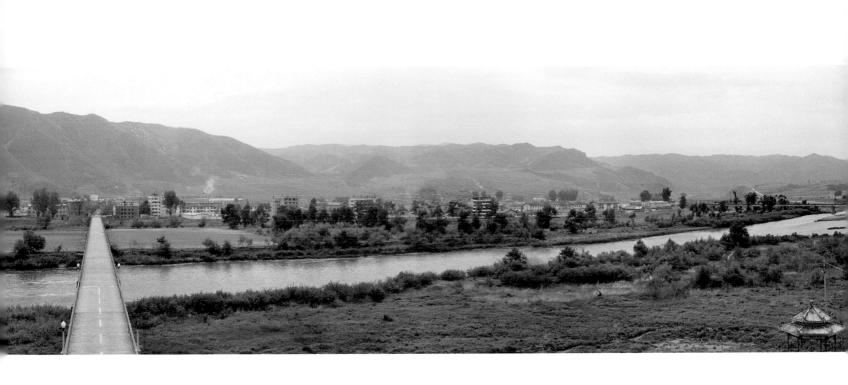

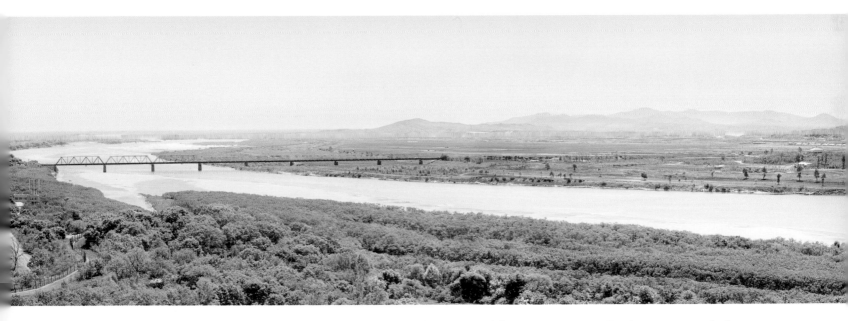

A panoramic view of the Russian (left), Chinese (foreground), and North Korean (right) border, with the Sea of Japan in the distance. The Russian town is Khasan.

It was here, in 1938, that the Battle of Lake Khasan took place between Japan and the Soviet Union, leaving more than 5,000 dead.

The Japanese, who had annexed Korea in 1910, accused the Soviet Union of tampering with the demarcation markers of the boundary set by the Treaty of Peking between Imperial Russia and Japan. After their demands were rejected, they attacked Soviet troops on July 29, and again on July 31, pushing into Soviet territory. Russian counterattacks from August 2 to August 9 forced them back out; the Japanese sued for peace, and by August 11 the fighting had ended.

While the Japanese and Soviets again engaged in hostilities at the Battle of Halhin Gol in 1939, it would not be until 1945, in the final days of World War II, that the Japanese and Soviet Union would engage in open warfare, leading to the Soviet occupation of the northern half of the Korean peninsula and the eventual formation of North Korea.

Border security in the area is much more evident between China and Russia than between China and North Korea.

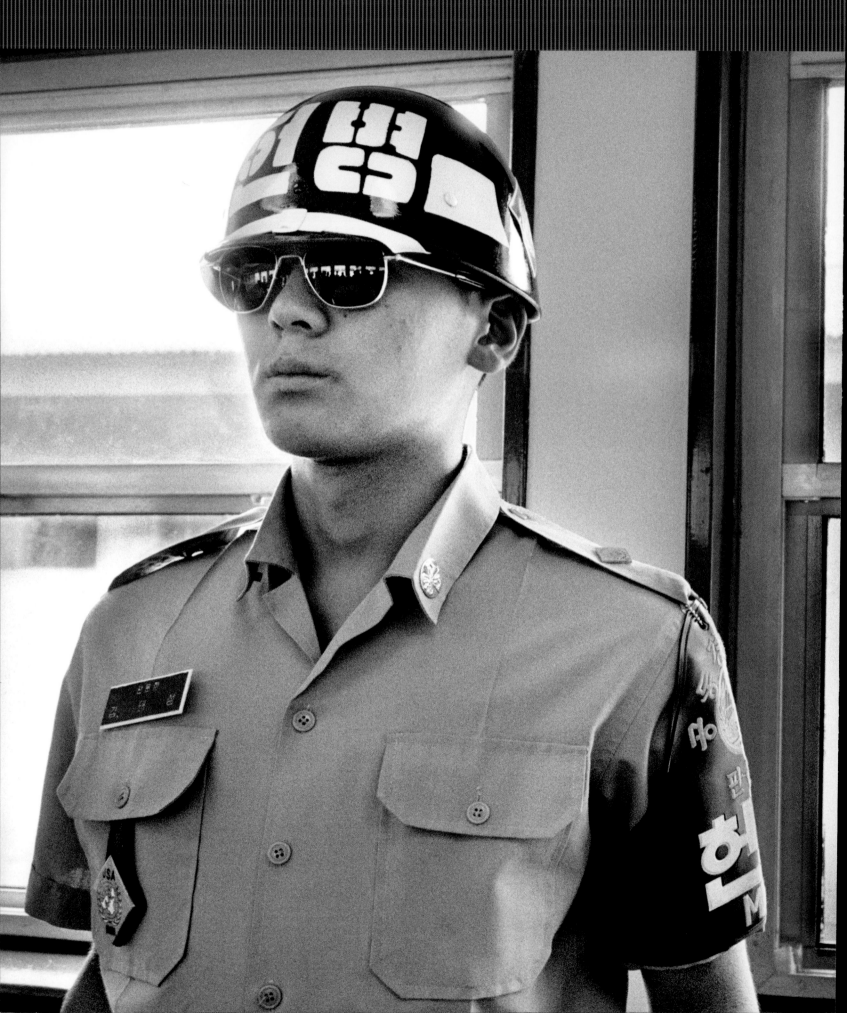

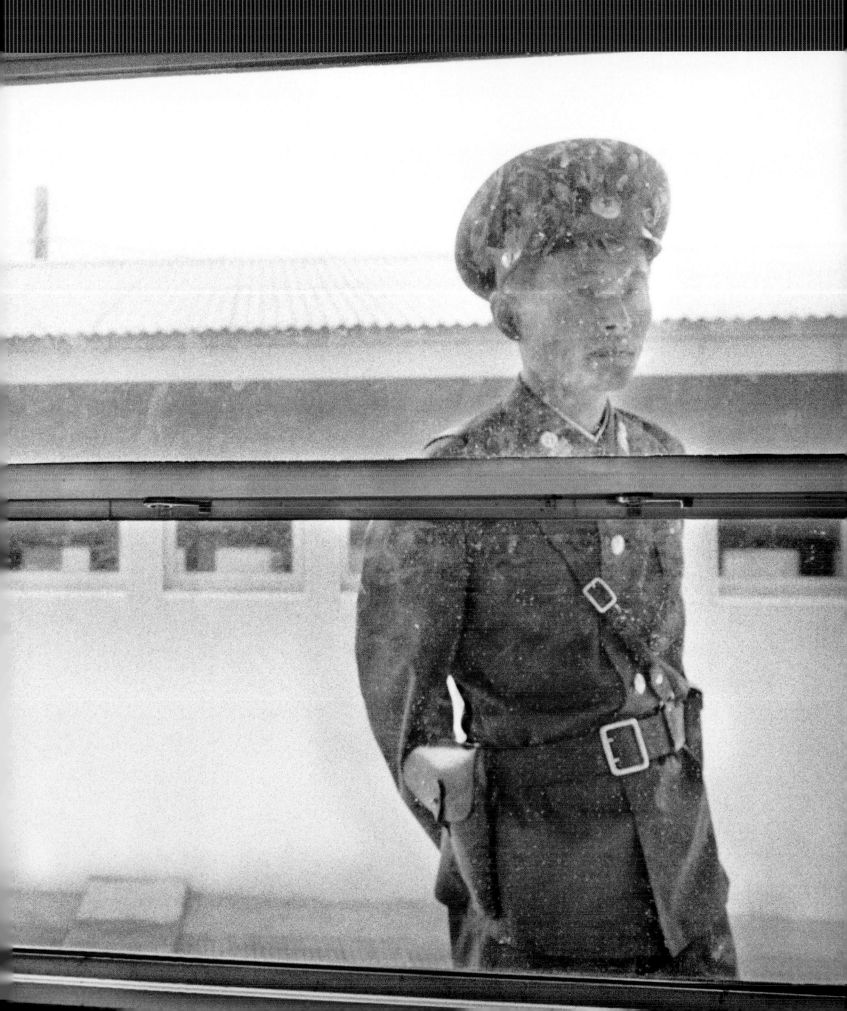

A South Korean soldier (left) inside the Joint Security Area (JSA)'s Main Conference Building and his North Korean counterpart (right) at the Military Demarcation Line (MDL) that separates the DMZ at Panmunjeom. Of the seven conference buildings in the MDL, three are under the control of United Nations Command (UNC) and four are under the control of the North Korean People's Army (KPA). The main conference building is under United Nations control and is open to visitors from both sides. This is the only place in Panmunjeom where people from both sides can cross the Military Demarcation Line, which cuts through a negotiations table at the center of the building.

PANMUNJEOM

AFTER THE SIGNING OF THE ARMISTICE Agreement on July 27, 1953, the village of Panmunjeom (originally called Neolmunlee but renamed for the convenience of Chinese diplomatic officials), where the truce talks were held, was designated as a Joint Security Area and headquarters of the Military Armistice Commission, under the shared management of the United Nations Command and North Korea. A complex of guard posts and administrative, meeting, and conference buildings, the JSA is divided down the middle by the Demarcation Line separating North from South. The military, economic, political, and humanitarian discussions that take place in this roughly 400-by-800-meter rectangular zone have helped keep the peace, however fragile at times, for more than half a century.

Deadly incidents and provocations have occurred in the JSA that have threatened to escalate into a full-scale shooting war.

On August 18, 1976, U.S. Army Captain Arthur Bonifas and Lieutenant Mark Barrett led a group of South Korean and U.S. soldiers to trim the foliage of a poplar tree that was obstructing the view between guard posts. North Korean soldiers objected to the trimming and attacked the American soldiers, injuring ten and killing Bonifas and Barrett with clubs and the blunt ends of axes. Secretary of State Henry Kissinger advocated punitive military action, but a more carefully limited response was carried out three days later as American and South Korean troops, on high alert, snuck back over to chop down the tree in a move they called Operation Paul Bunyan.

To minimize the chances of future conflicts in the JSA, both sides agreed to separate the sentries and split the area in half at the Military Demarcation Line (MDL). The United Nations portion of the complex, once called Camp Kitty Hawk, was renamed Camp Bonifas.

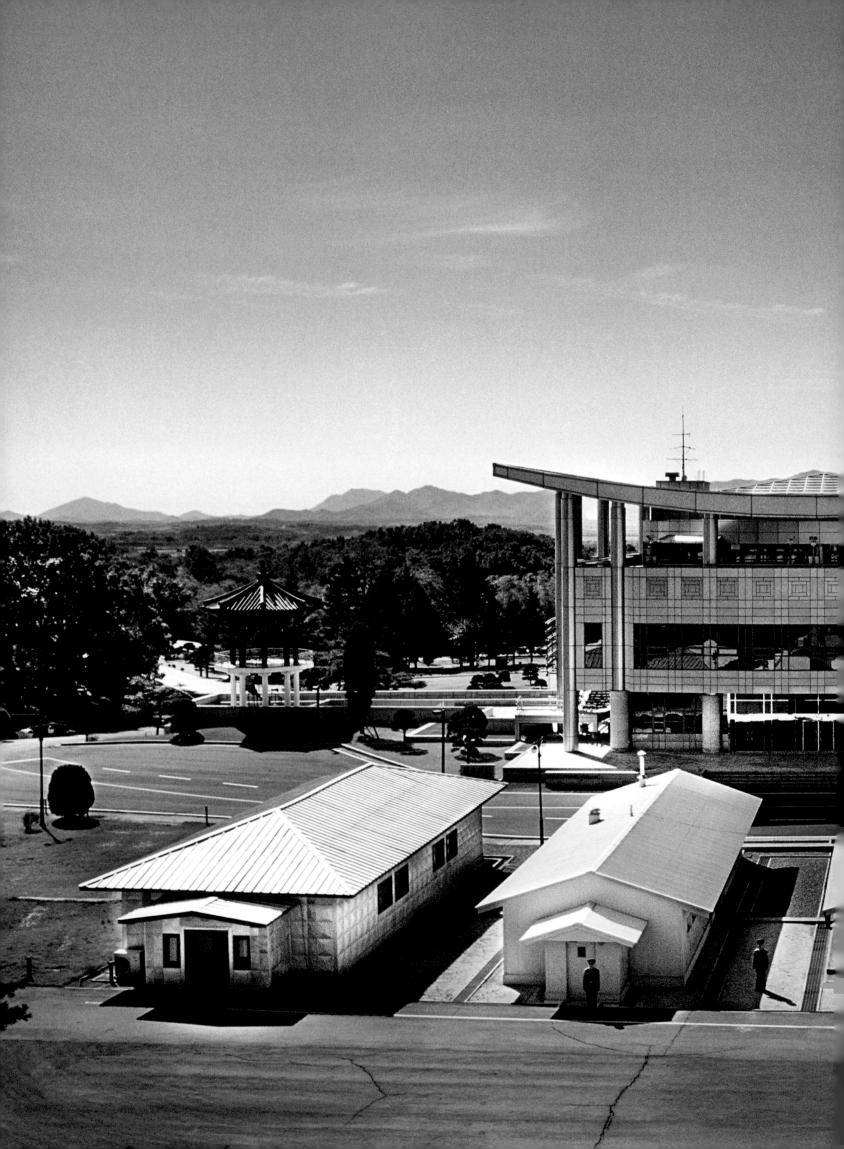

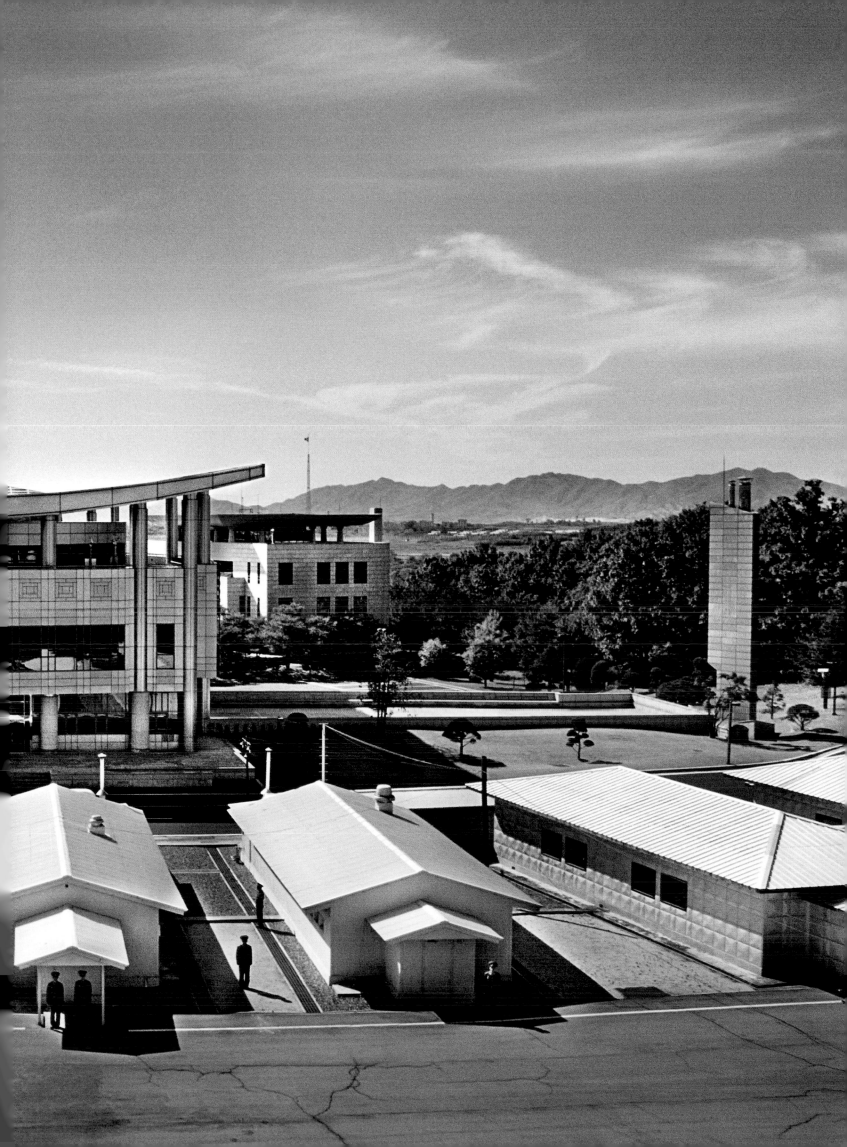

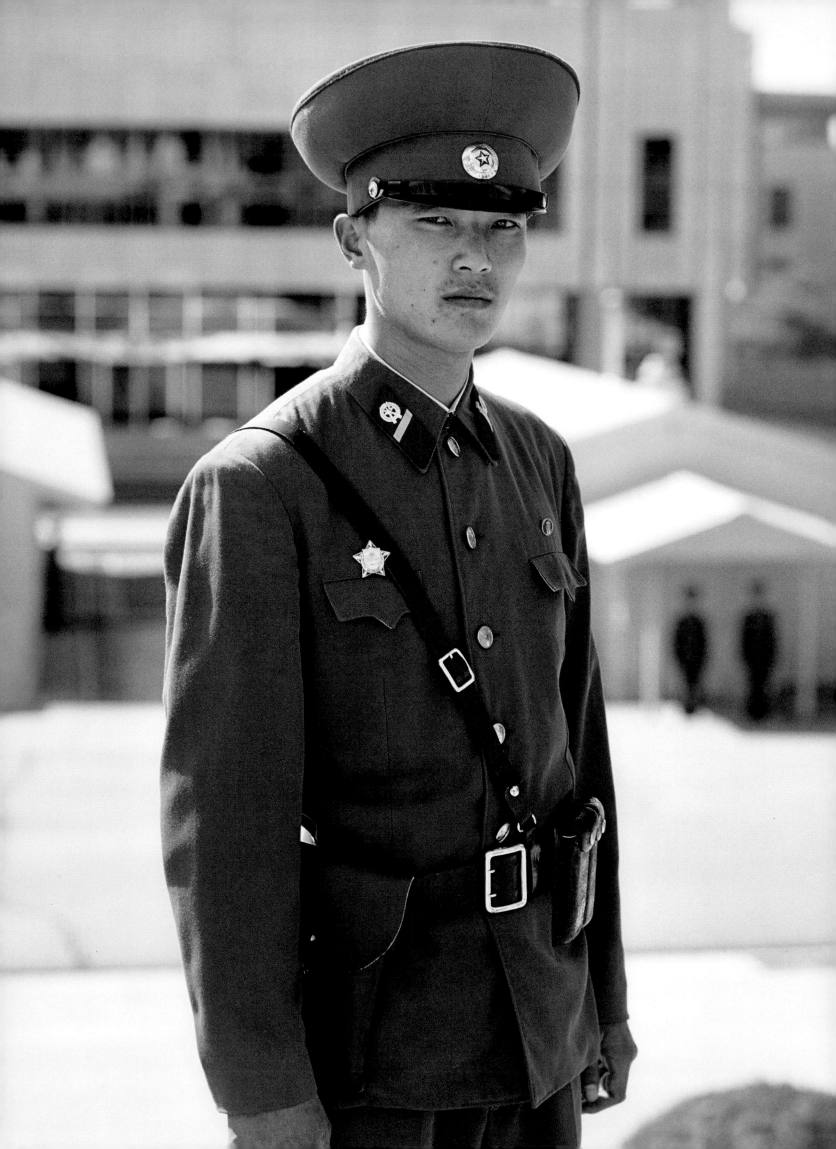

OPPOSITE:
A North Korean guard standing on the steps of Panmungak, the main building managed by the North Korean People's Army (KPA) in the JSA. Built in September 1969, it is located about 260 feet north of the South Korean Freedom House. It serves as an office and command post of the North Korean guard force and an observation area for visitors coming in from the North.

PREVIOUS SPREAD:
A view of Freedom House, constructed on the south side in 1998. It houses the South and North Contact Office and the South and North Red Cross Office and is intended as a venue for interchange and humanitarian support. Freedom House is also meant to serve as a point of contact for families separated between North and South, but the North Korean government has yet to allow any such meetings at this location.

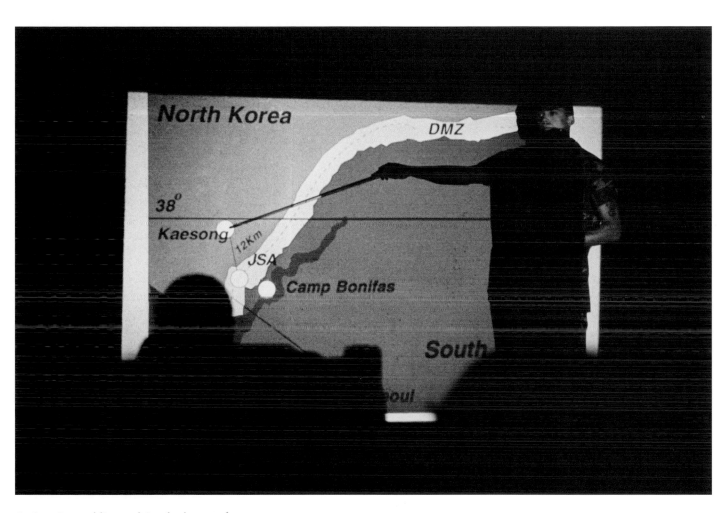

An American soldier explains the layout of the JSA and DMZ at Camp Bonifas.

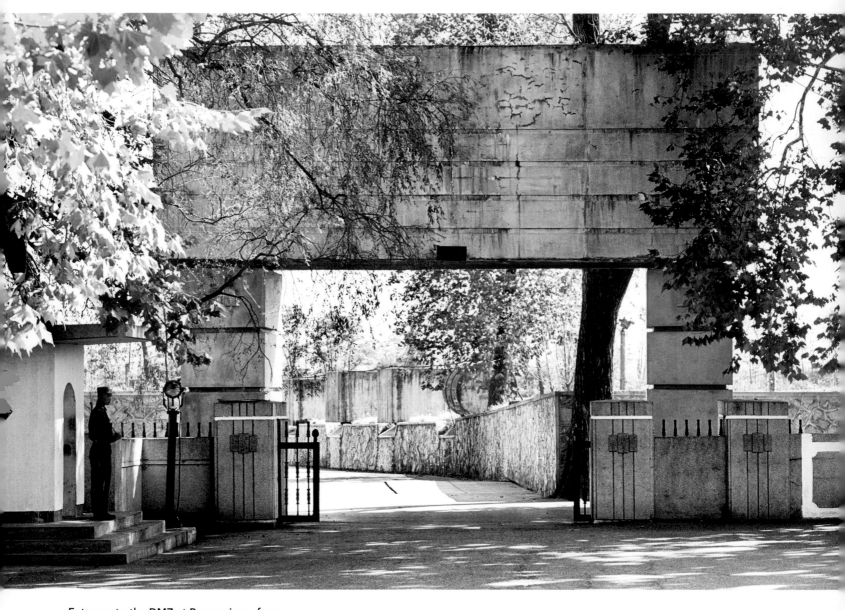

Entrance to the DMZ at Panmunjeom from
the North.

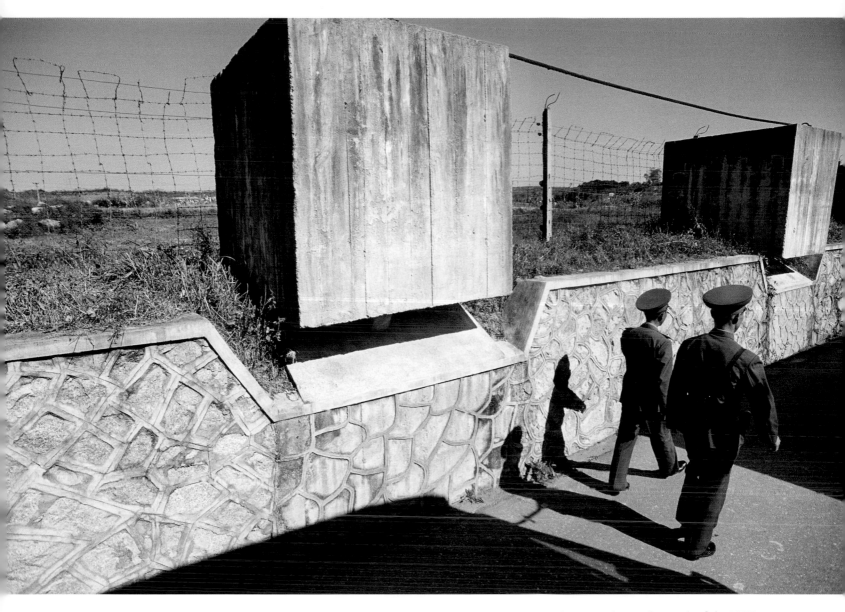

Access to the northern exit of the DMZ near Panmunjeom can be blocked by releasing concrete blocks into the road leading from Panmunjeom to the North.

OPPOSITE:
In the building where the armistice was signed, on the north side of the DMZ, are two copies of the document that stopped the fighting; one table features the North Korean flag, and another displays the flag of the United Nations, which has been allowed to fade from its signal blue to a dull brown.

Alejandro Cao de Benos, a Spanish citizen who lives in Barcelona, is the founder of the Korean Friendship Association and maintains the official Web site for the DPRK as a volunteer project for North Korea's Committee for Cultural Relations with Foreign Countries. A frequent visitor to the DPRK, he is the only foreign citizen allowed to represent the North Korean government as a guide to visitors on the North Korean side of the DMZ.

OPPOSITE:
A North Korean soldier in a staring match
with his South Korean counterpart at the
Military Demarcation Line that separates
the DMZ at Panmunjeom. Guards are
forbidden to cross over the MDL to the
other side, but staredowns are common.

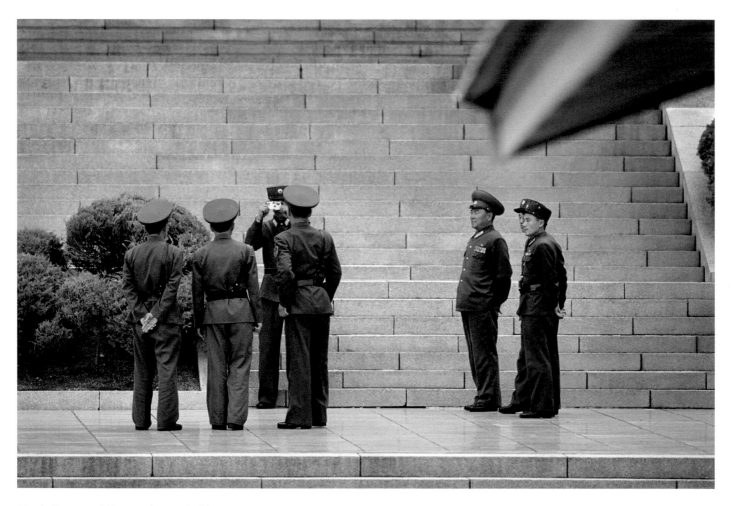

North Korean soldiers on the north side
of the MDL.

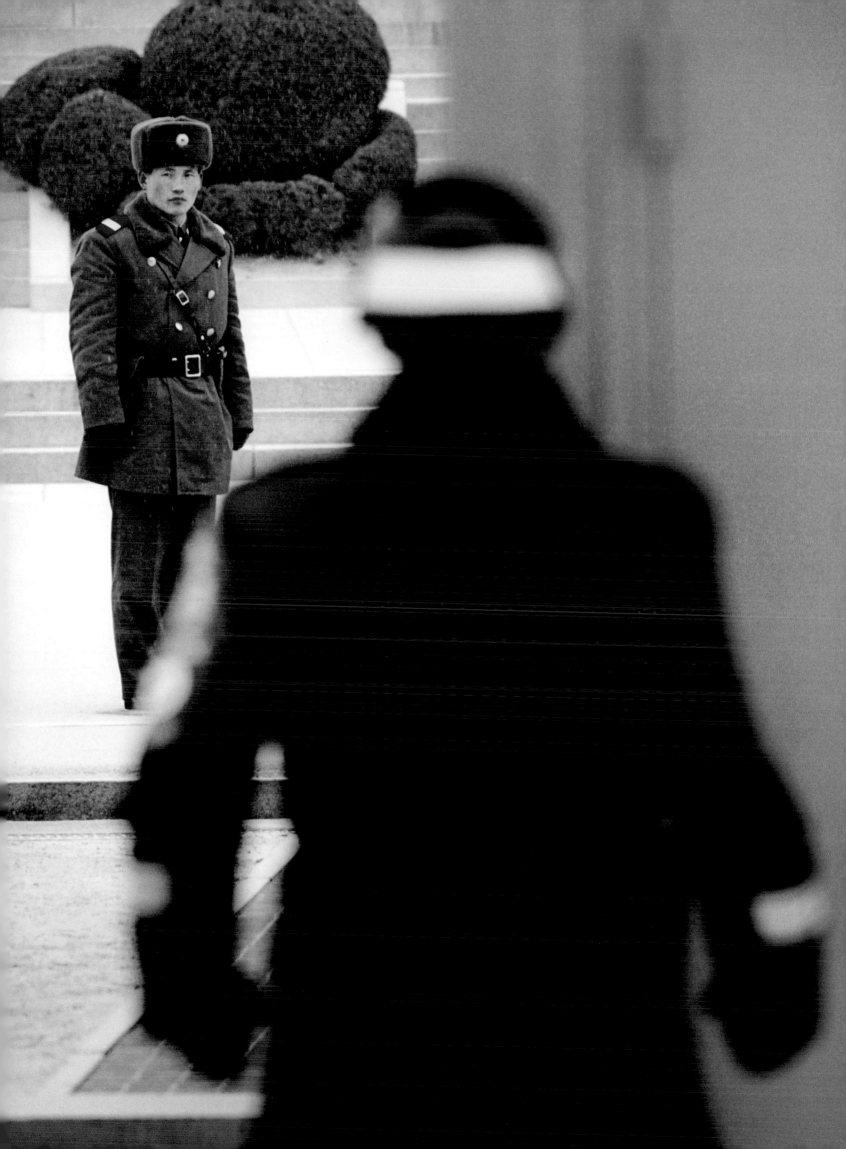

The hatchet and club used to kill two
American soldiers within the JSA in 1976,
an incident that nearly triggered open war
on the peninsula, on display in a museum
building on the North Korean side.

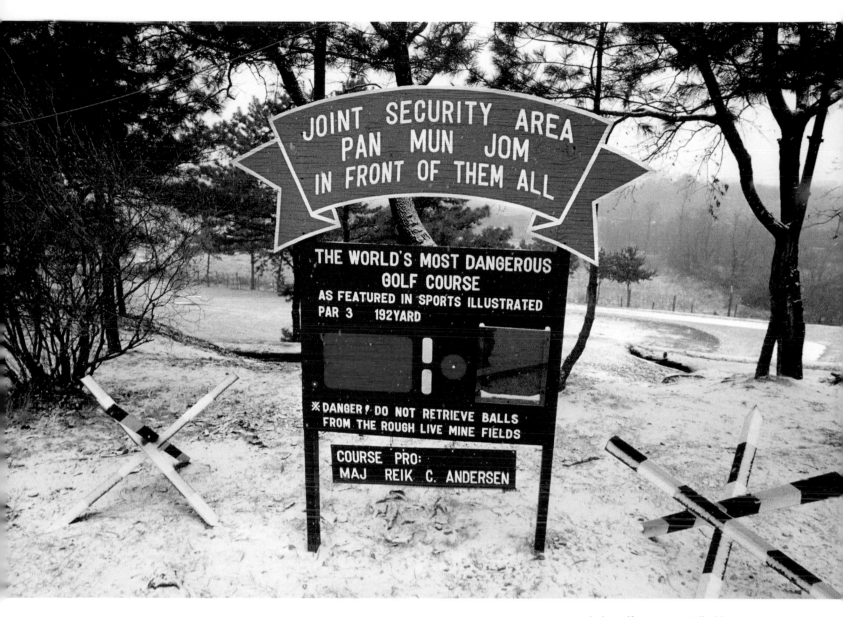

A one-hole golf course, installed by the United States on the south side of the JSA at Camp Bonifas, was featured in a 1988 issue of *Sports Illustrated* as "the most dangerous golf course in the world."

A panoramic view of the DMZ, including the Bridge of No Return (at right) where, in 1953, prisoners of war from both sides were allowed to choose whether to return to their places of origin. At the bottom left of the photograph is a memorial marking the spot where a poplar tree, which was the focus of the 1976 ax incident resulting in the deaths of Captain Bonifas and Lieutenant Barrett, once stood. Visible above left on the horizon is the towering flagpole of the North Korean village of Kichongdong.

TAESONGDONG AND KICHONGDONG

TWO VILLAGES HAVE BEEN AUTHORIZED to exist within the DMZ, one North Korean, one South Korean. In the South Korean DMZ village of Taesongdong, residents must be original inhabitants or direct descendants of the villagers who occupied it at the time of the Armistice in 1953. About 220 people inhabit the village, which is subsidized by the South Korean government and enjoys a relatively rich standard of education and living (with incomes about five times the South Korean norm) compared to other farm communities. Located directly opposite is the North Korean DMZ village of Kichongdong, which is tended by farmers during the day but is believed to be inhabited by only a small security force at night. Known as "Peace Village" in the North, it is referred to by U.N. staff at the DMZ as "Propaganda Village," because loudspeakers tout the quality of life in the DPRK. Americans call the South Korean hamlet "Freedom Village." Both villages are used as showpieces of life on the other side.

After years of the villages flying the flags of their countries on roughly equal-sized poles, South Korea installed a taller flagpole at Taesongdong in time for the 1988 Summer Olympics in Seoul. Pyongyang retaliated by constructing the world's largest flagpole, standing at 525 feet, at Kichongdong.

Despite living just a few hundred meters—literally a stone's throw—away from North Korea, and despite the fact that the two countries are still technically at war, Taesongdong's residents have lived a relatively safe and peaceful existence. There have been exceptions. In 1997, in what has come to be known as the "Acorn Incident," several South Korean farmers were captured and held in detention because they supposedly crossed into North Korean territory— across the Military Demarcation Line that runs through the DMZ—to gather acorns, an ingredient in some traditional Korean food. The farmers were released after four days with the gift of a baby cinnamon tree, which now grows in Taesongdong.

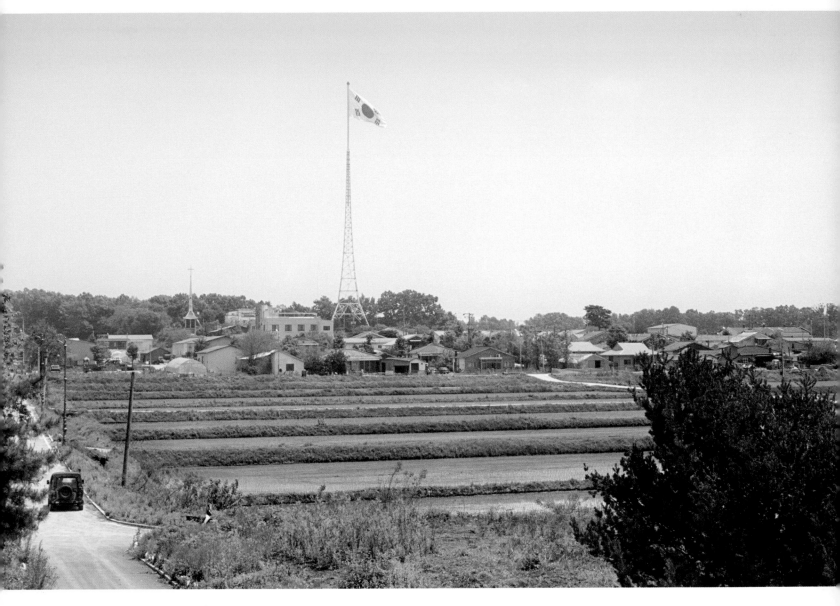

A view of Taesongdong and its
328-foot flagpole.

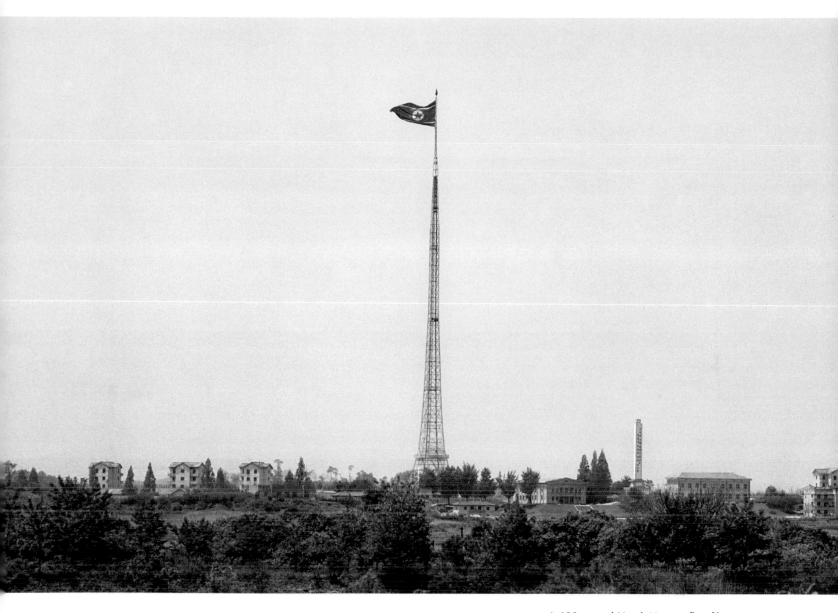

A 600-pound North Korean flag flies on the world's tallest flagpole, 525 feet above the village of Kichongdong in the DMZ.

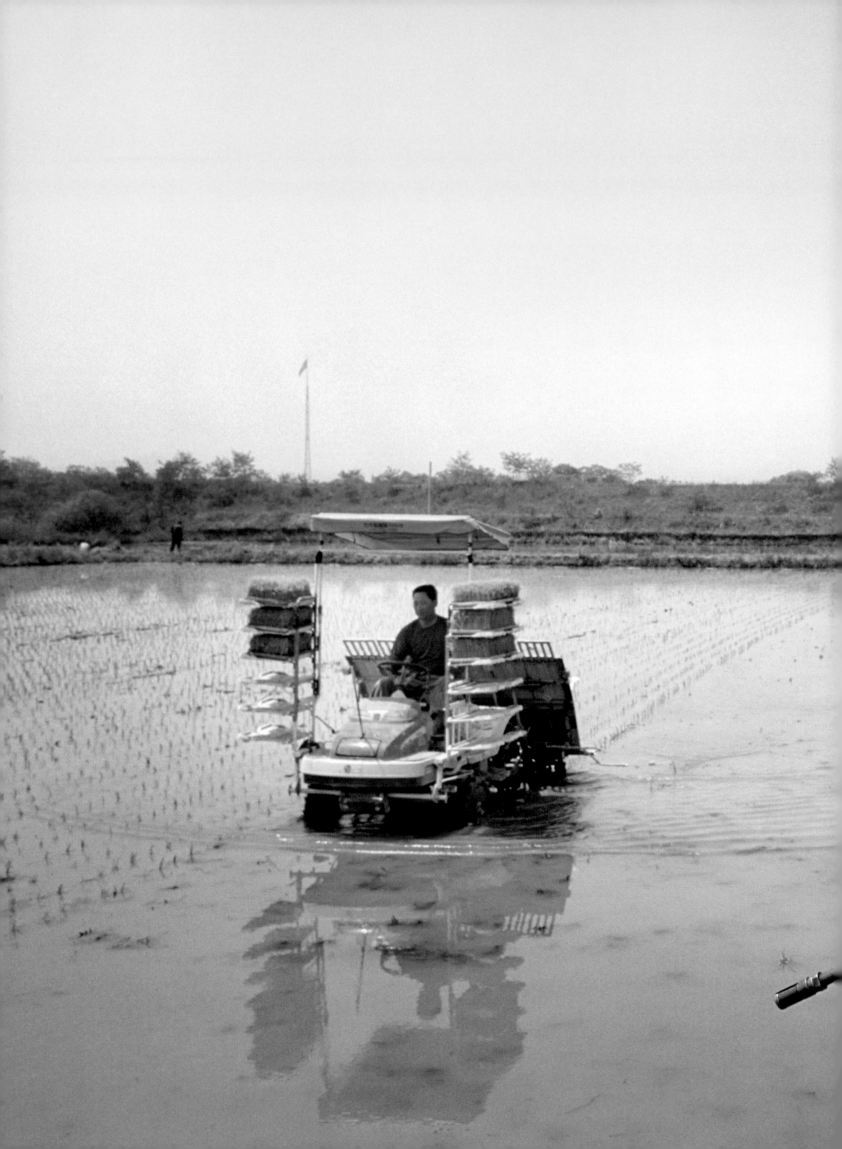

PREVIOUS SPREAD:
A farmer plants rice under the protection of a South Korean soldier. In the distance is the North Korean flag flying over Kichongdong. A platoon of 60 to 70 soldiers guards the 220 residents of Taesongdong.

OPPOSITE:
Seven-year-old twins at the elementary school in Taesongdong.

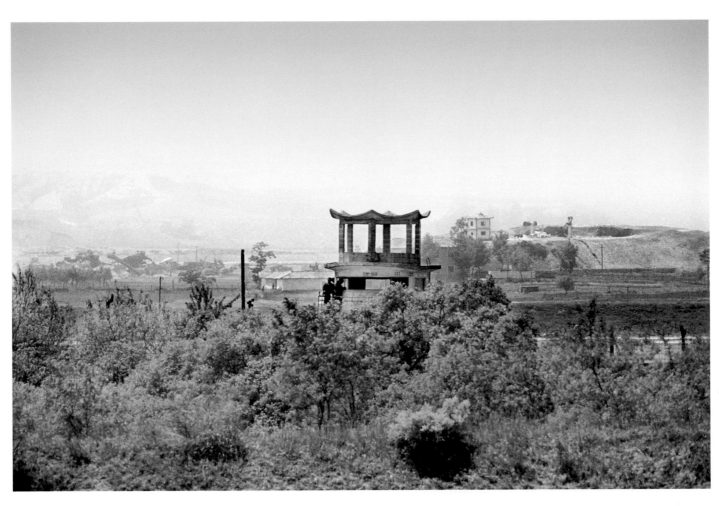

A North Korean guard post on the far side of the earthen mound that separates Taesongdong from the North.

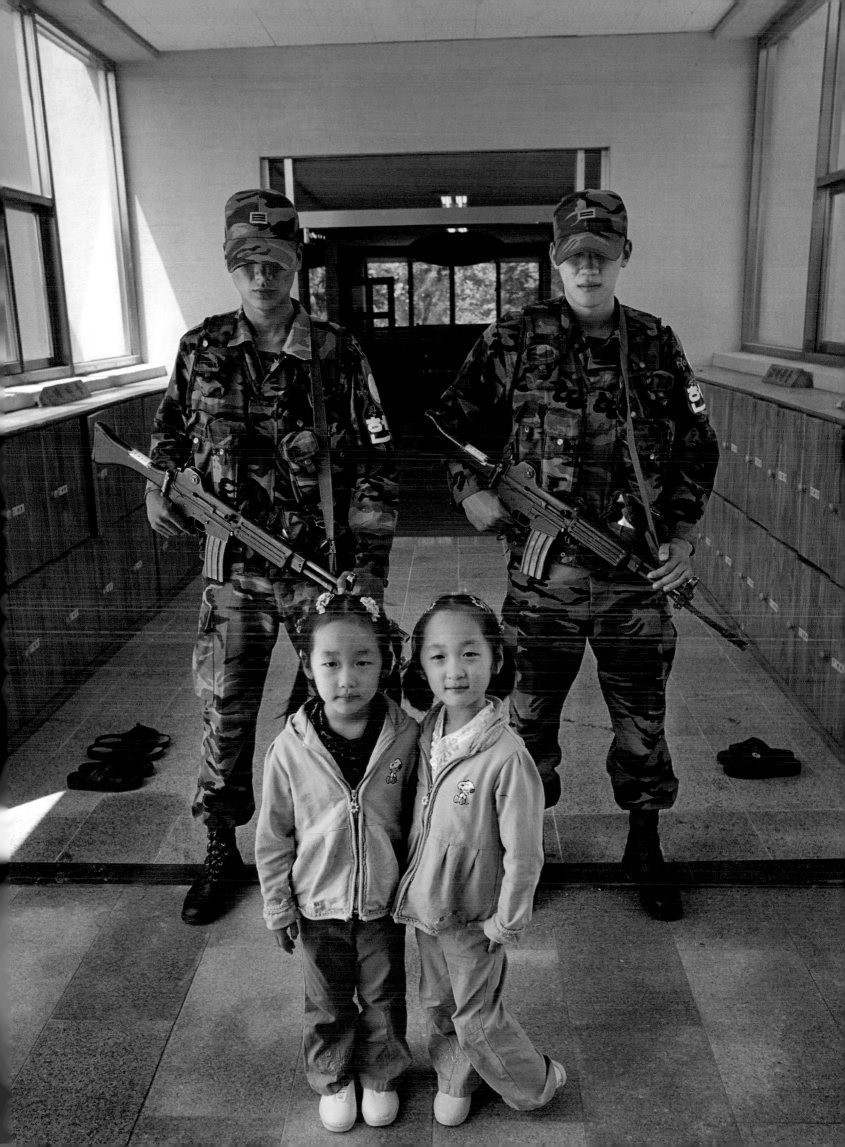

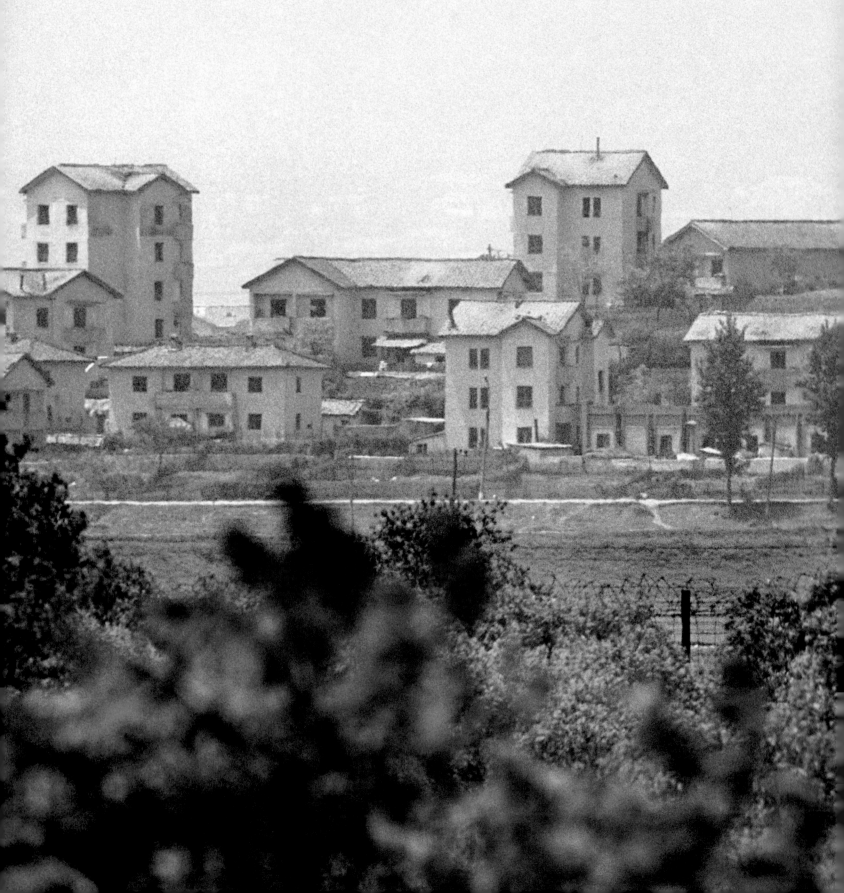

PREVIOUS SPREAD:
A view of the North Korean village
of Kichongdong from the South Korean
village of Taesongdong.

ABOVE AND OPPOSITE:
Brothers play on the virtually traffic-free
streets of Taesongdong, with the South
Korean flag flying overhead.

LIFE ALONG THE DMZ

CREATED AT THE SIGNING OF THE
Armistice Agreement, the Demilitarized Zone
(DMZ) is a 2.5-mile-wide buffer zone separating
North and South Korea, running 151 miles
across the Korean peninsula from the Han
River estuary in the west near the thirty-eighth
parallel to a point just below the thirty-ninth
parallel on the east coast. It is the world's
most heavily fortified border. Between one
and two million soldiers are situated above
the North Korean side of the border, and
roughly six hundred thousand South Korean
soldiers below, with an additional thirty-seven
thousand United States troops stationed in
the country overseen by the United Nations.
(The U.S. announced plans to withdraw a third
of these troops in 2006.) The DMZ itself is
land-mined and bordered with bunkers, tank
traps, and barbed wire.

Violent clashes and provocations have
occurred between the forces arrayed at the
DMZ. In 1963, North Korea forced down a
U.S. helicopter after it crossed into DPRK
territory and shot down another U.S. helicopter
in 1969, in each case releasing the crews after
they had signed confessions. There have also
been tense shooting incidents on the ground,
though not as frequently as in past decades.
South Korean forces have taken over regular
patrols in the area, keeping U.S. troops
(a particularly agitating presence to North
Korea) out of the potential front line of fire.
In 2001, 2003, and 2006, North and South
Korean forces exchanged gunfire across the
DMZ, each time with no reported casualties.

The DMZ, virtually untouched by humans
for more than fifty years, has become an
unusual and important unintended nature
preserve for native plants and some twenty
thousand migratory birds, black bears,
leopards, lynx, antelope, wild pigs, and other
animals, including—perhaps—tigers.
Considered holy animals in traditional Korean
culture, the Korean tiger is now believed to
have been driven to extinction on the
peninsula under Japanese occupation, but it is
hoped that they may still survive in this major
reserve of Korean natural heritage.

An estimated one million families on the
Korean peninsula are separated by the DMZ.

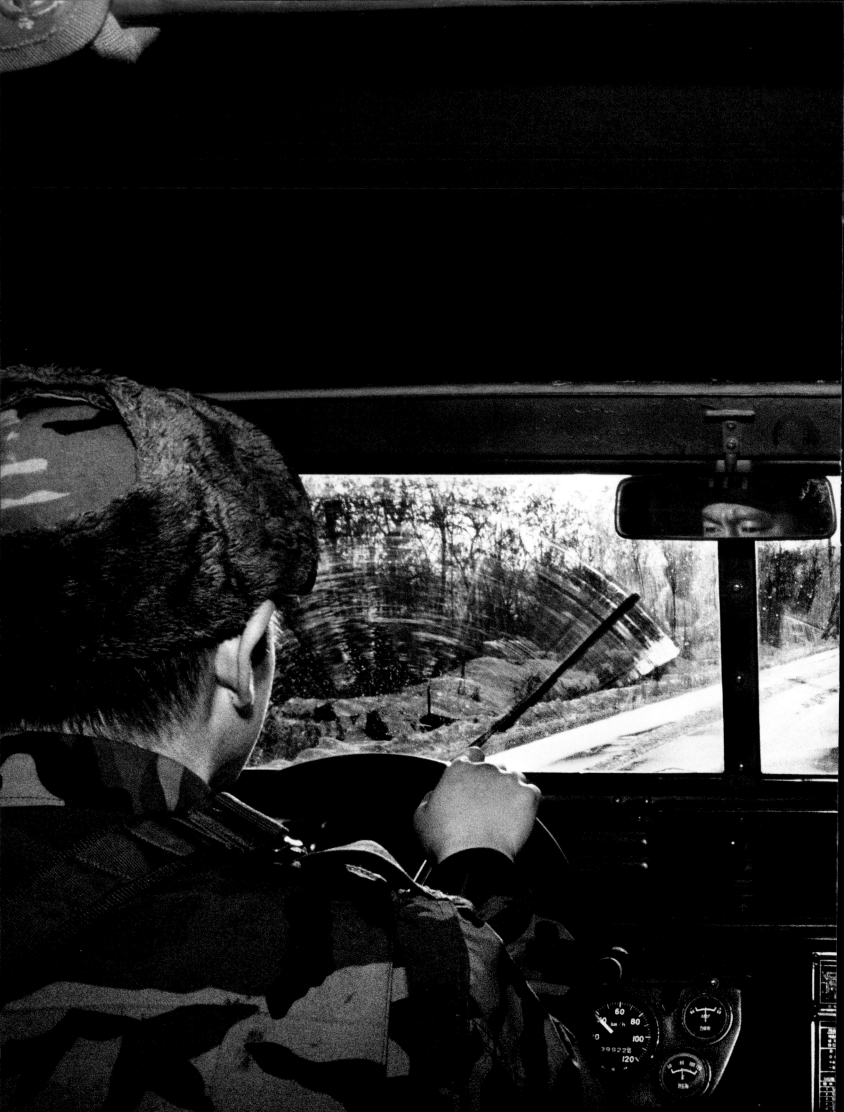

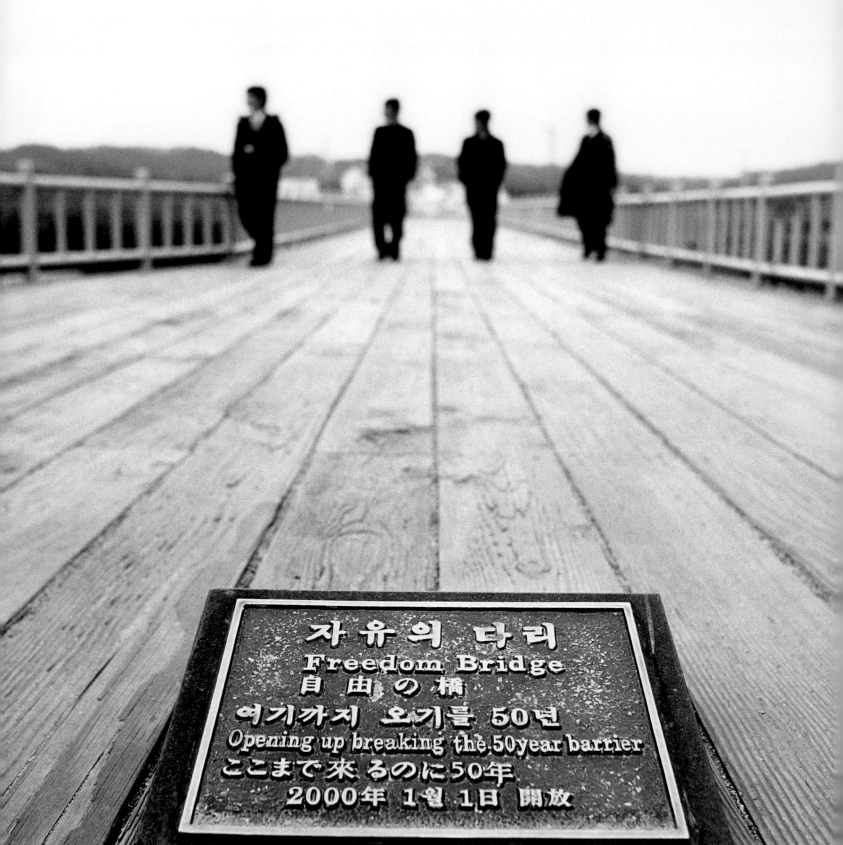

PREVIOUS SPREAD:
South Korean soldiers drive in the Civilian
Control Area just outside the DMZ.

OPPOSITE:
In 1953, prisoners of war crossed
the Imjingak (Freedom Bridge) after the
signing of the armistice.

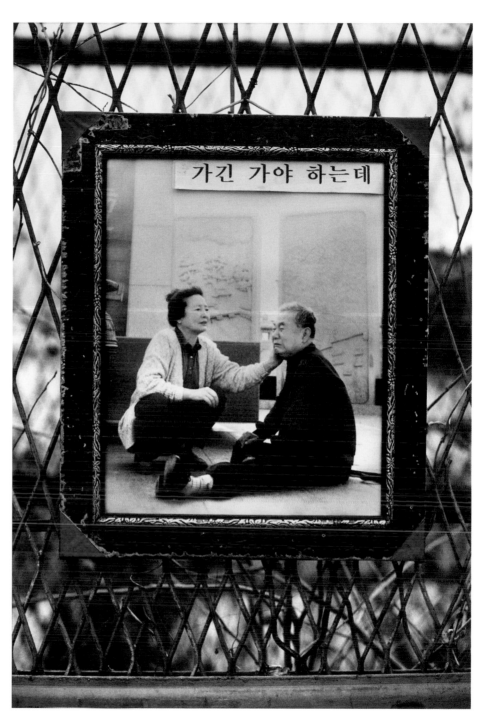

At Imjingak (Freedom Bridge) where
more than twelve thousand prisoners of
war crossed the Imjon River, a photo
of a man separated from his family in the
North hangs on the fence. The text reads:
"I must go, but…"

OPPOSITE:
South Korean tourists pose in front of a
war memorial off of Freedom Highway in
the South.

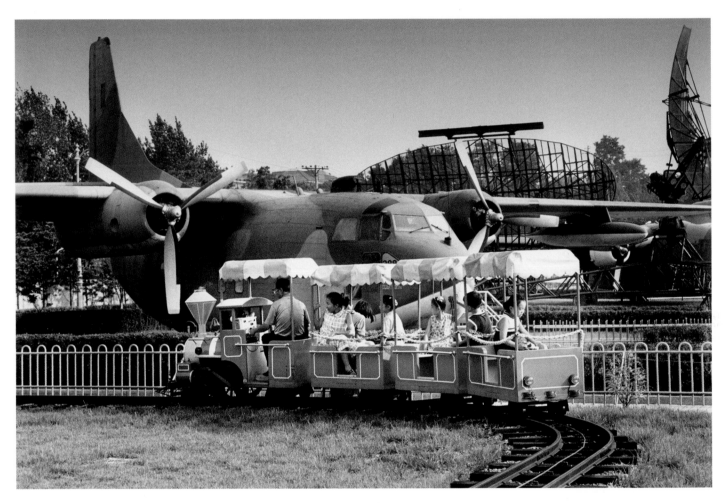

A children's train makes its way around a
track at the Korean War Memorial in Seoul
with military hardware in the background.

FOLLOWING SPREAD:
A child plays on an anti-aircraft gun at the
Korean War Memorial museum in Seoul.

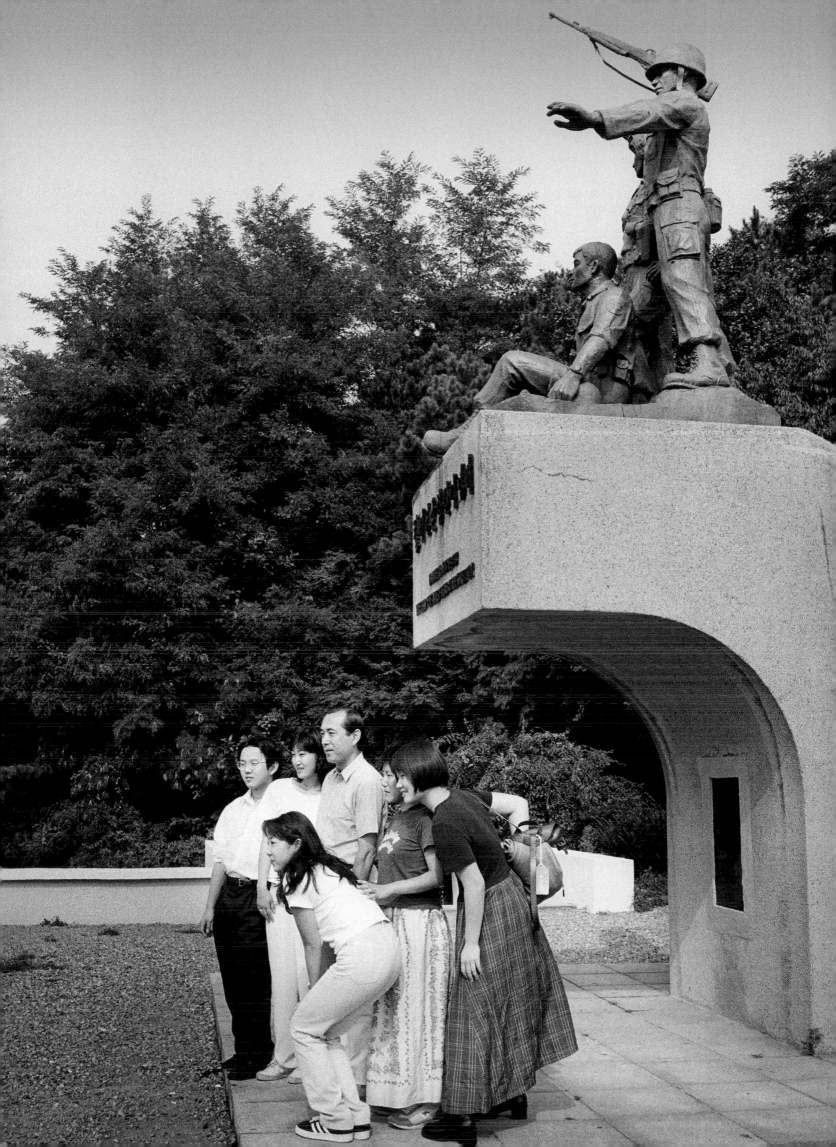

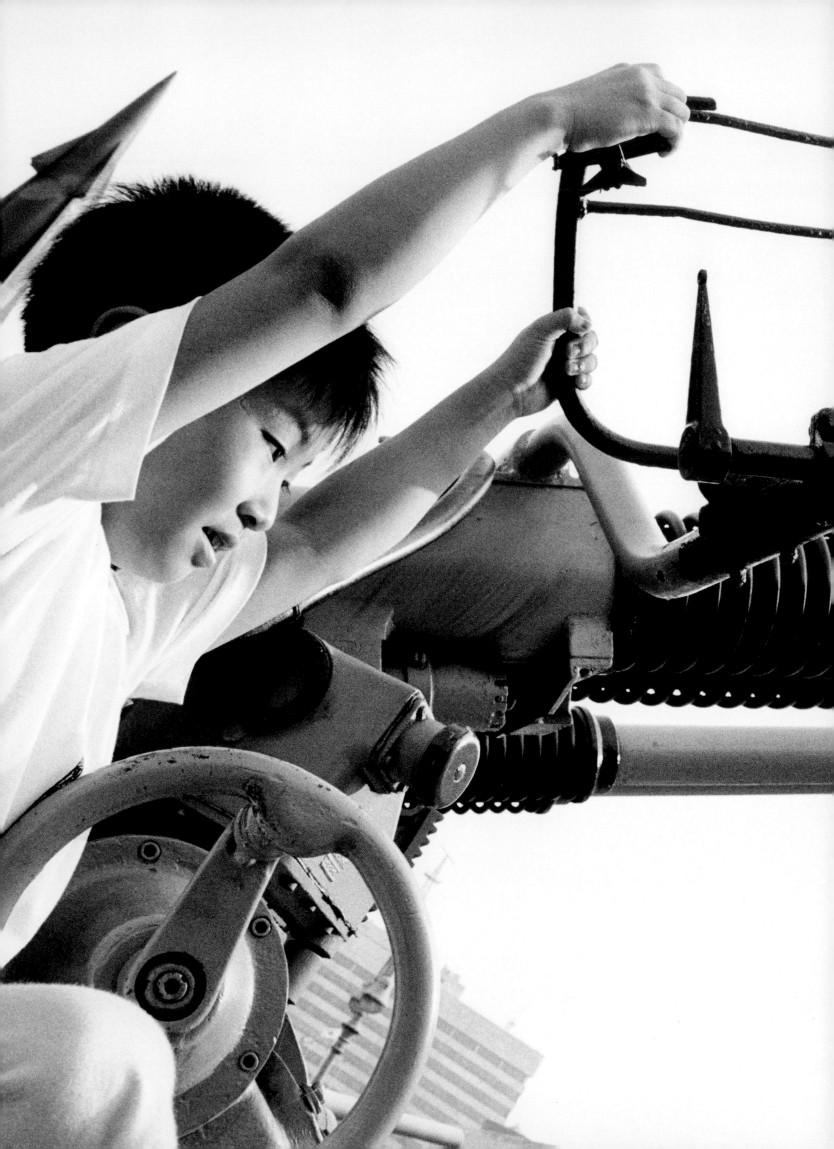

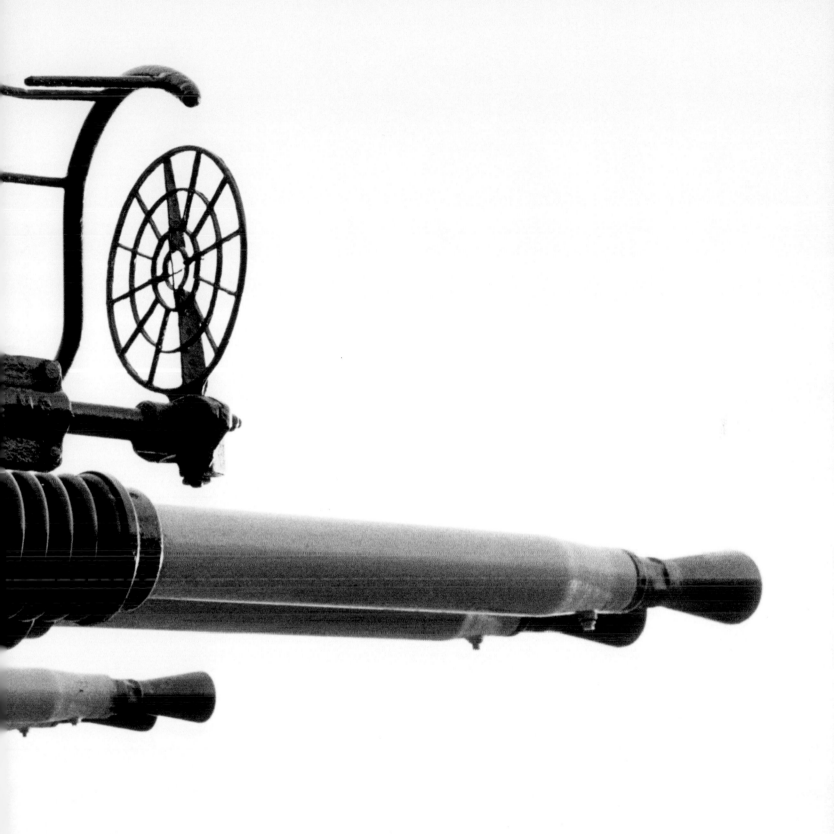

OPPOSITE:
A sign warning of land mines near the
Iron Triangle Battlefield.

A South Korean soldier.

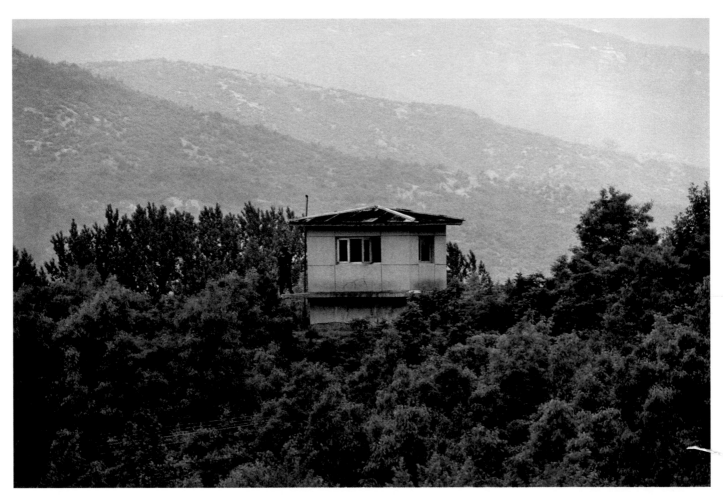

A North Korean guard tower.

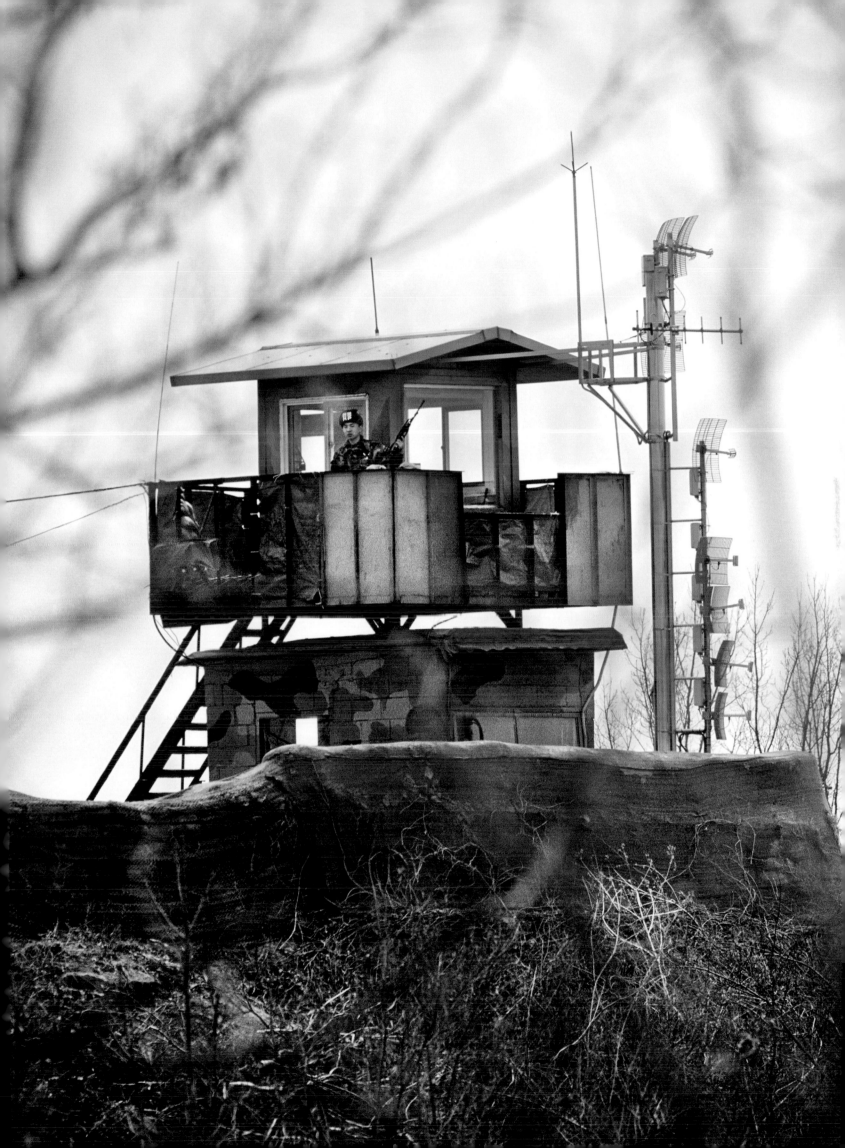

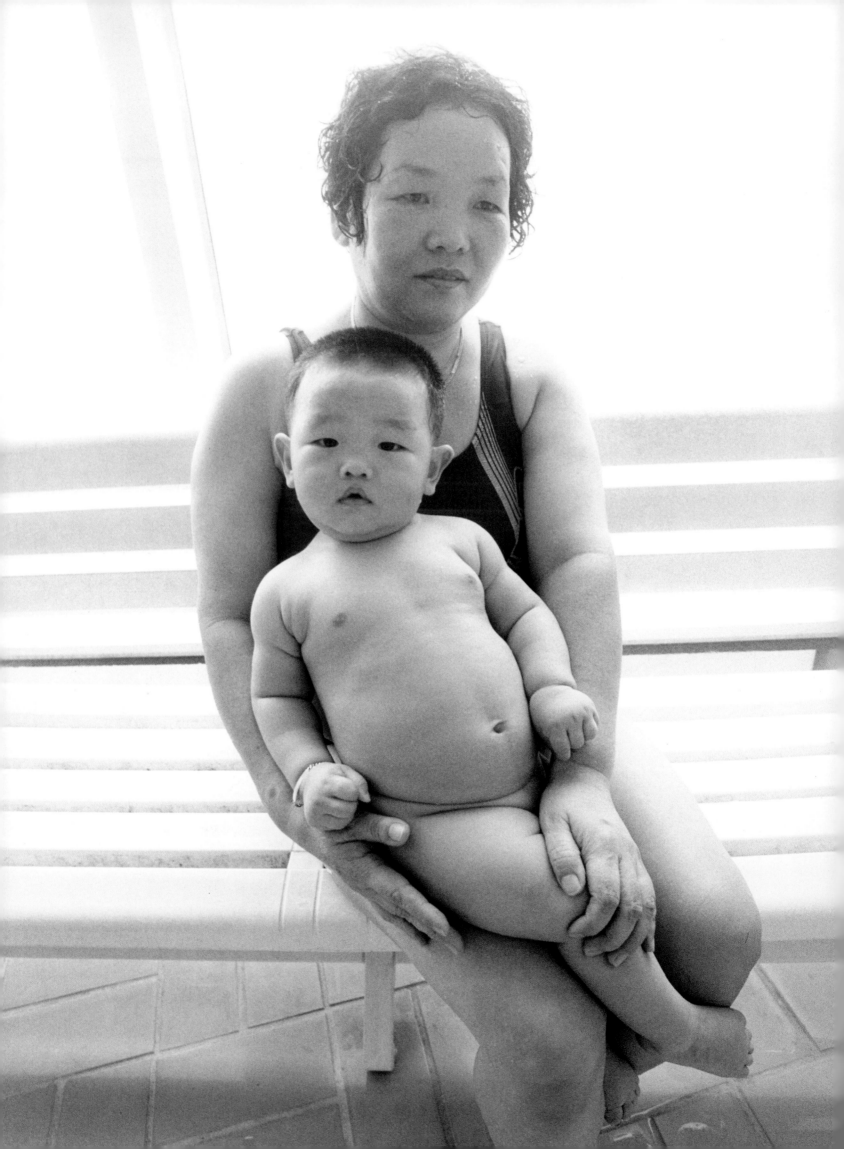

OPPOSITE:
A grandmother with her grandson at the Chulwon Spa Tourist Hotel a few miles south of the DMZ, near the Iron Triangle Battlefield. The hot spring is a germanium-content volcanic spa.

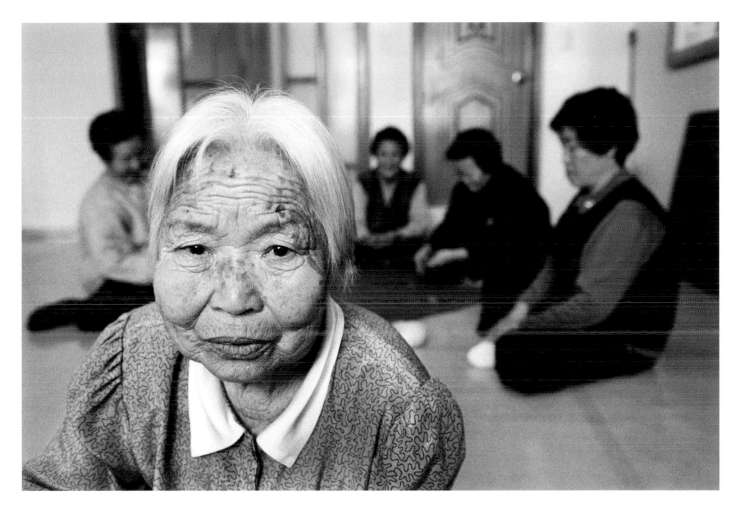

Soo Yeun Lee, eighty, in the village of Yanji ri, in the Civilian Control Zone just outside the southern border of the DMZ. Lee lived here until the Chinese entered the war in 1951, causing a mass exodus south. She returned to the village in 1973, the year South Korean President Park Jung Hee instituted a government policy to reestablish villages near the border. "We don't worry about any attack from the North," she says. "There are some inconveniences, but that's life." As she spoke, the women behind her, playing the card game Hwatoo, nodded in agreement. Special permission is needed to live in or visit Yanji ri.

FOLLOWING SPREAD:
The former communist Labor Party Building near the village of Yanji ri, which from 1945 to 1950 was under communist rule. A placard on the building reads: "Tortured bodies were buried in a trench behind the building."

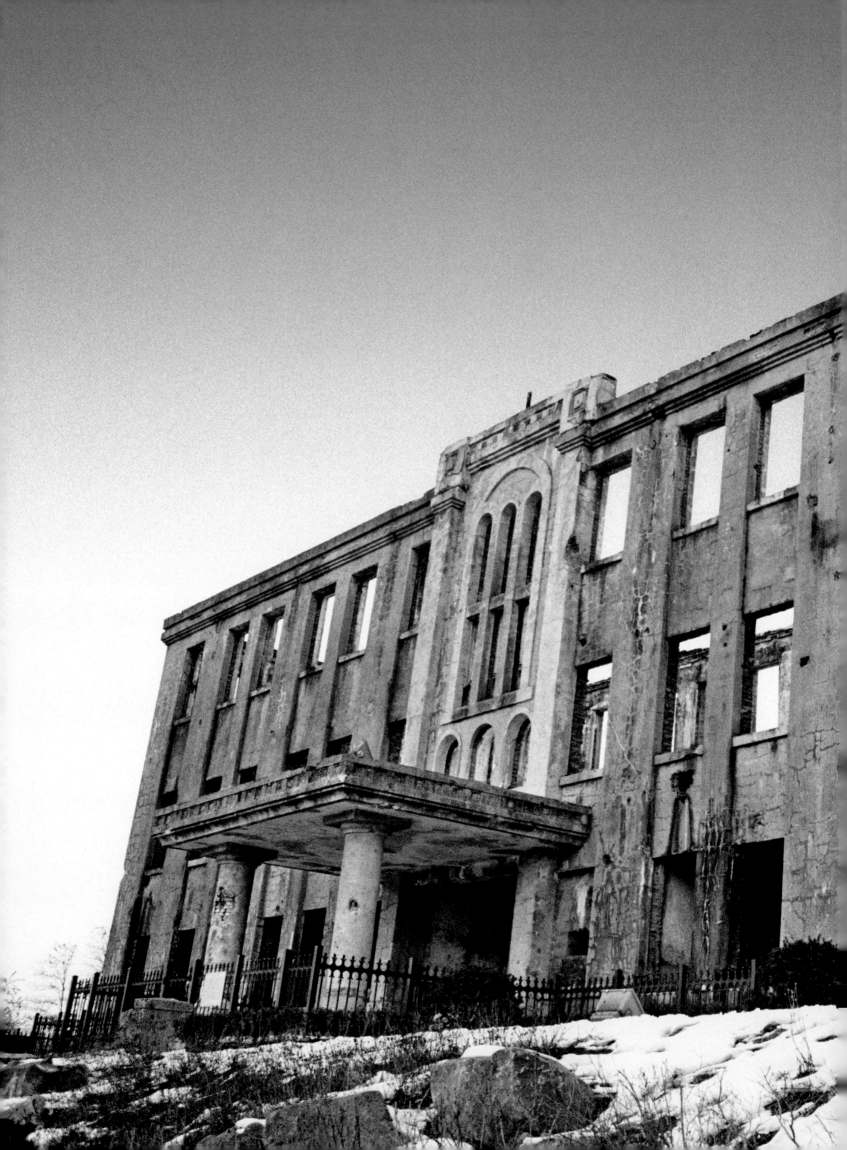

Rallies against the United States and the presence of riot police surrounding the American Embassy are obvious indications of tensions between some South Koreans and the U.S. government.

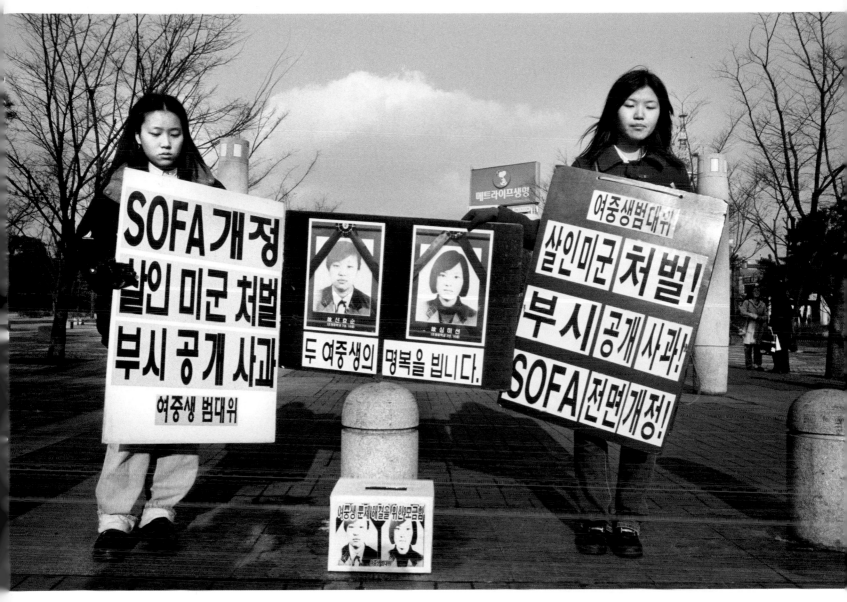

Near the heavily guarded American Embassy in Seoul, high school students Min Young Lee (left) and Mi Hyun Han (right) protest the Status of Forces Agreement between their government and the United States. The agreement limits South Korea's ability to prosecute American military personnel. On June 13, 2002, middle school students Hyo Soon Shin and Mi Sun Shim were struck and killed by a U.S. armored vehicle in the village of Yangjugun. The accident became a rallying point for anti-American sentiment. "We learned in school that the United States was a close friend, but after the two girls were killed and the soldiers could not be prosecuted by the Korean people, we realized maybe America is not our friend," says Mi Hyun Han. "The majority of us want the United States to live with us." Is she concerned about the prospect of North Korea developing nuclear weapons? "I'm not afraid of a nuclear war. Kim Jong Il is not that foolish. I don't think they can handle World War III. America is not that weak. North Korea wants a bargaining chip."

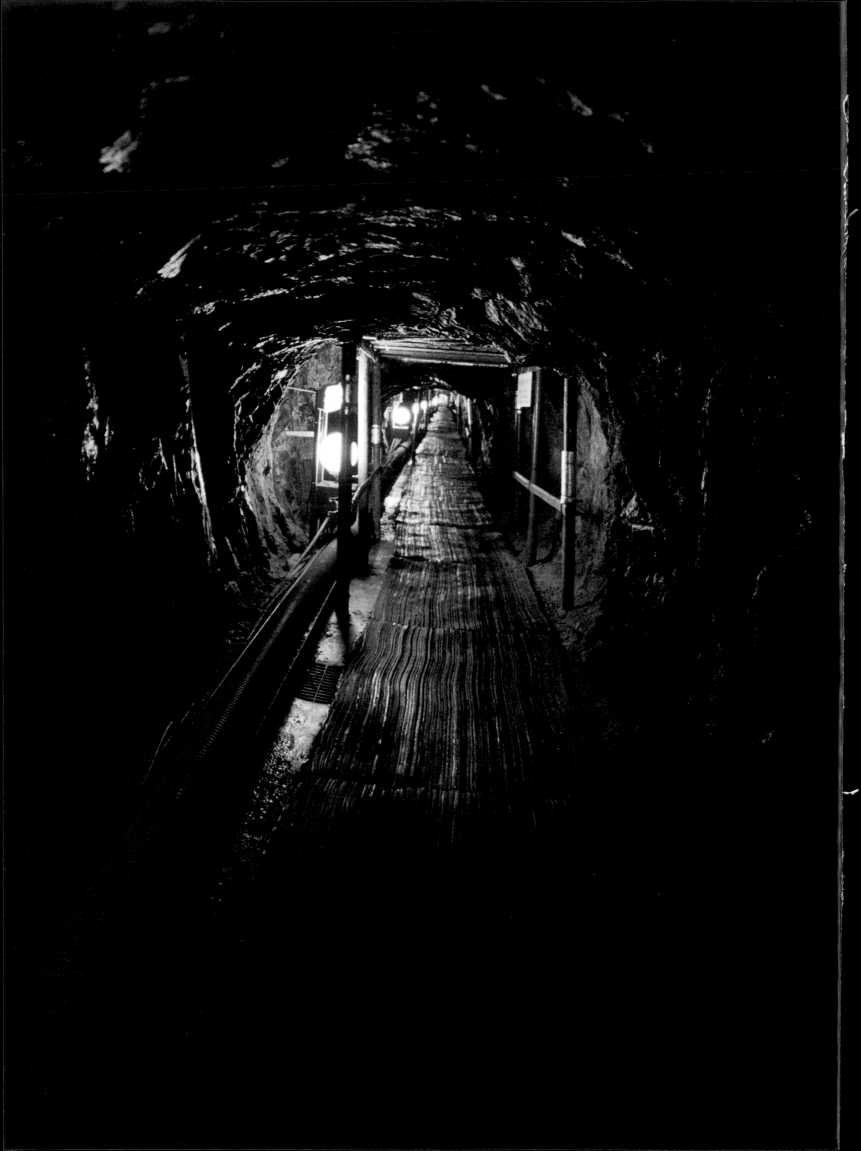

OPPOSITE:
The third of five known North Korean incursion tunnels was discovered in October 1978, 27 miles from Seoul. Carved out of bedrock at a depth of 240 feet, the 6.5-foot-high-by-7-foot-wide tunnel penetrates 1,427 feet south of the Military Demarcation Line at a point 2.5 miles south of Panmunjeom. The tunnel, which is just over a mile from an outpost defending the Munsan corridor leading to Seoul, is large enough to have a full division pass through in an hour.

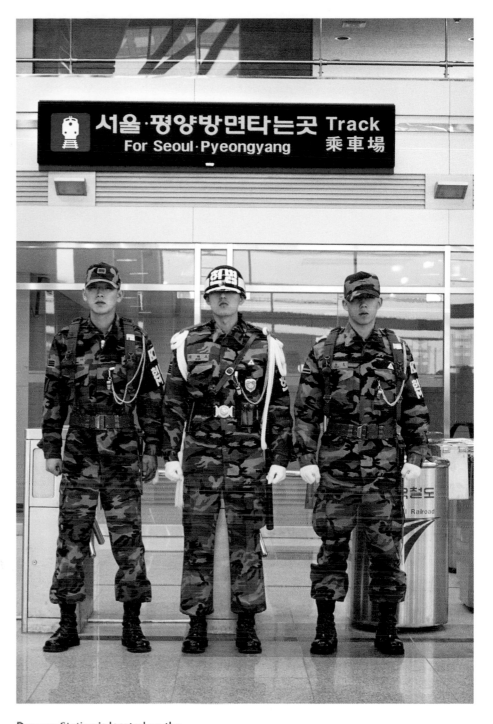

Dorasan Station is located on the southern boundary of the DMZ and is the northernmost station of the Kyongui (Gyeongui) railway line—the former main rail artery through the Korean peninsula. Hope for reunification is written on a sign at the station where the Kyongui train line ends. A sign directs passengers to a platform where, one day, passengers may be able to board a train for the North Korean capital of Pyongyang.

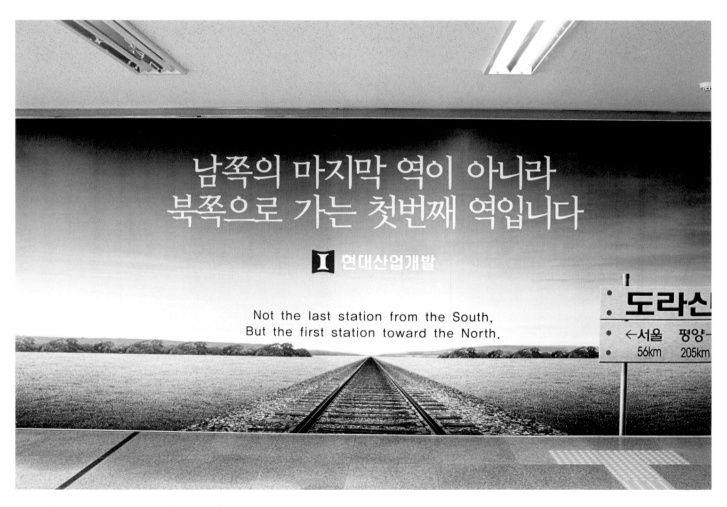

A mural at Dorasan Station reads, "Not the last station from the South, but the first station toward the North," with a mileage sign pointing to Seoul (56km, 24.85 miles) and Pyongyang (205km, 127.38 miles).